The current government's announcement to keep the ITT* fields in the Yasuní Park territory wo with both hope and happiness. It is an offer sup representatives who have worked in the country of achieving a political impact, to link the aspiratio construct spaces of peaceful resistance in defense o social and economic rights of all the peoples of the from our own day to day coexistence with the terribl exploitation of oil.

There are many arguments in favor of keeping Park below the ground. If we achieve this, not only enormously diverse area, home to the Tagaeri and the but also we will become a universal symbol that a n It really is. The success of the defense of the Yasuní overcoming the challenge which humanity faces in th climate change.

It is very difficult for a government to maintain a c of this magnitude. Great contradictions have already b the promotion of the multi-purpose corridor between Manta and Manaos, which could convert the river Napo into a motorway for flatboats and container ships destined for trade between Brazil and China, only a few kilometers away from the Yasuní Park.

This book, which we present to you with the wonders and complexities of our territory, and which is born from the support of many representatives from around the world, is like the point of the end of a palm leaf, which began its journey without return, sure of achieving its objective. We believe in the value of this dream which we all share in order to maintain the Yasuní Green Gold.

**Anita Rivas**, Mayor, Gobierno Muncipal de Francisco de Orellana.

*ITT is the name of the oil block in the Yasuní.

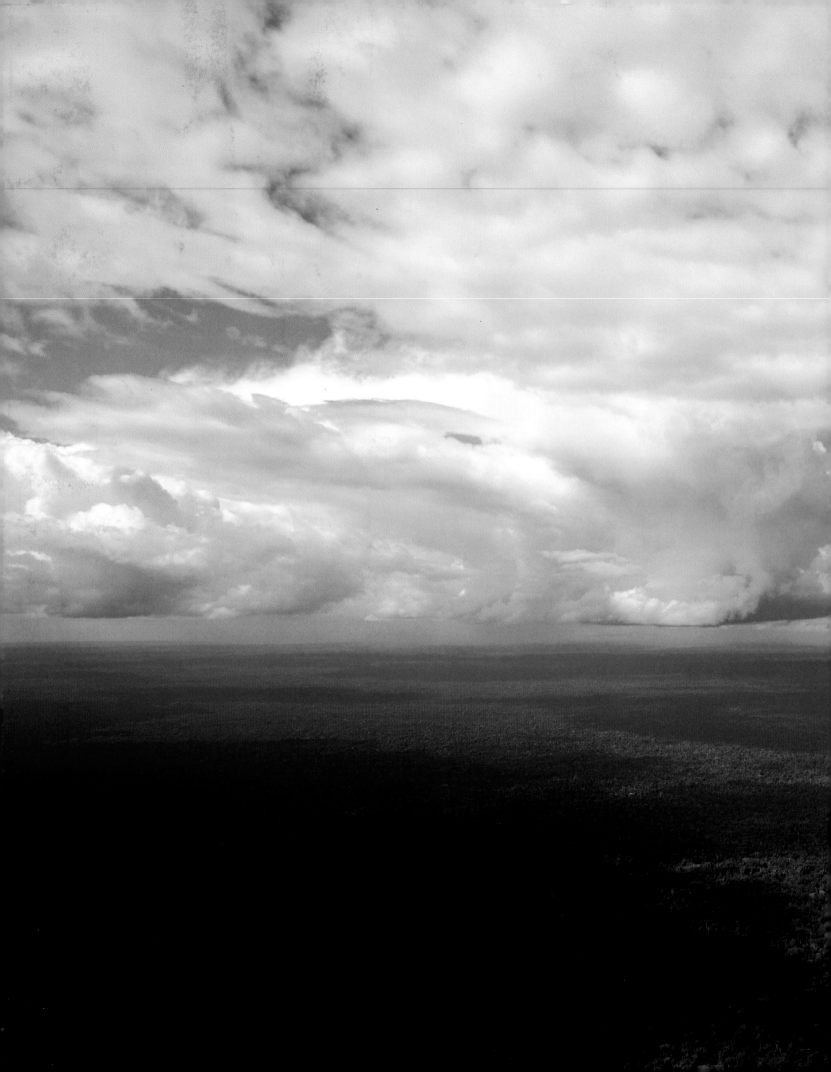

By Ginés Haro Pastor and Georgina Donati
With Troth Wells

# YASUNÍ
# GREEN GOLD

## The Amazon fight to keep oil underground

 **New Internationalist**

**Yasuní Green Gold: The Amazon fight to keep oil underground**
First published in the UK in 2008 by
New Internationalist™ Publications Ltd
Oxford OX4 1BW, UK
**www.newint.org**

By Ginés Haro Pastor and Georgina Donati
With Troth Wells

**Mixed Sources**
Product group from well-managed
forests and other controlled sources
www.fsc.org  Cert no. SGS-COC-003548
© 1996 Forest Stewardship Council
**FSC**

British Library Cataloguing-in-Publication Data.
A catalogue record for this book is available from the British
Library.

Library of Congress Cataloguing-in-Publication Data.
A catalogue for this book is available from the Library of Congress.

ISBN 978-1-906523-01-5
Yasuní campaign
www.yasunigreengold.org
www.yasunioroverde.org

**Previous page. View over the rainforest, Ecuador.**
**Right. Forest canopy.**
**Overleaf. Hummingbird and insect.**

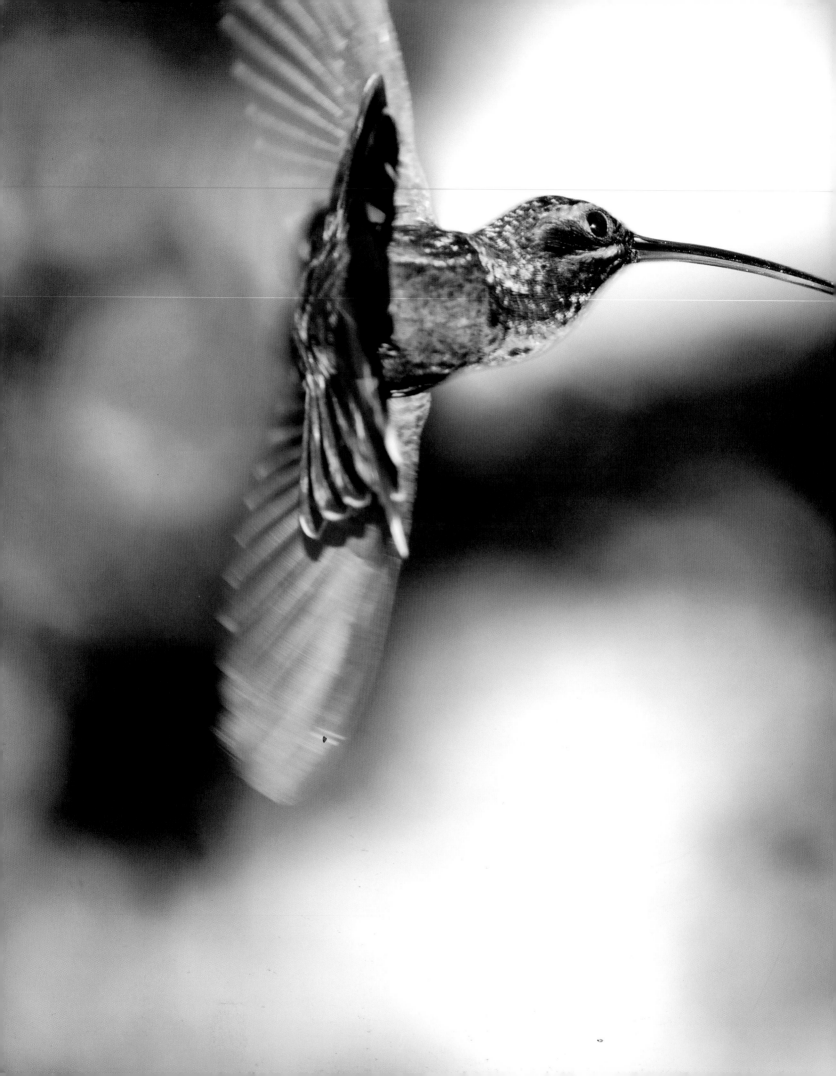

# Yasuní Green Gold
## The full statements can be seen at www.yasunigreengold.org

Yasuní is a true jewel of nature, and represents some of the most biologically important real estate on the planet. Allowing it to be degraded and diminished would be an international travesty. I am proud to stand with those who have declared that 'enough is enough'. Yasuní must forever be protected.

**Dr William F Laurance**, Senior Staff Scientist, Smithsonian Tropical Research Institute, Panama.
Former President, Association for Tropical Biology and Conservation.

Another world is possible, but it doesn't mean it will be easy to achieve. Conserving Yasuní National Park is not only important in order to protect the native people living there, nor simply to save the immense biodiversity which it protects.

**Professor José María Tortosa**, Institute of Social Development and Peace, University of Alicante, Spain.

I support campaigns such as the Yasuní Oro Verde/ Yasuní Green Gold. Their battle should be our battle, the existence of these people and their environment does not stop being the heritage of all humanity.

**Professor Antonio Romero Romero**, Social Psychology of Conflict and Interpersonal Relations, University of Granada, Spain.

We hope that the campaign to spread the name of the 'Yasuní Green Gold' may permit a reduction in the impacts of damaging activities such as deforestation, pollution, extinction of species and the destruction of our social fabric – but that principally it might avoid the destruction and extinction of ancestral cultures and forms of human life which are the basis for this struggle, and that it might ask for recognition under the thesis of pluri-nationality from the political constitution of the state.

**Lourdes Tiban**, Secretary of State for Indigenous People (CODENPE, Council for Development of Nationalities and Peoples of Ecuador).

As a scientist, I can easily list the values of the Yasuní ecosystem: extraordinary biodiversity, a role in maintaining climate cycles and soil, potential as a source of medications, and an enormous wealth of research possibilities. For an entomologist like me, Yasuní is a taxonomic treasure trove... I can only imagine the passion with which the native residents of Yasuní must love their land, and I strongly support their efforts to protect it.

**Amy Mertl**, Biology Department, Boston University, USA.

Beyond the close history with the project, the conservation of the Yasuní cannot be seen as just one more cause that we help to defend, but as a question of planetary importance, of vital transcendence for the generations that will follow us.

**Ramon Bartomeus**, Iwith Foundation, Spain.

It is vital that we protect Yasuní now; it is vital we support projects such as Yasuní Green Gold. Many groups and individuals are working together to save the forest and to let the world know before it is too late. I hope you will join us.

**Professor Salvador García**, University of Barcelona, Spain and founder of Eutôpia-Consultores Sin Fronteras (Utopia-Consultants without Borders); **Dr Richard E Bilsborrow**, Carolina Population Center and Curriculum in Ecology, University of North Carolina at Chapel Hill, USA; **Dionisios Youlato**, Department of Zoology, Aristotle University of Thessaloniki, Greece; **Professor José Augusta Padua**, Federal University of Rio de Janeiro.

This fragile world is coming under threat from international oil companies, who see the Yasuní area as nothing more than a source of profit. I hope that like many other groups and individuals, you will support the Yasuní Green Gold project and protect one of the last unspoilt regions of the world.

**Nick Caistor**, journalist and broadcaster specializing in Latin America.

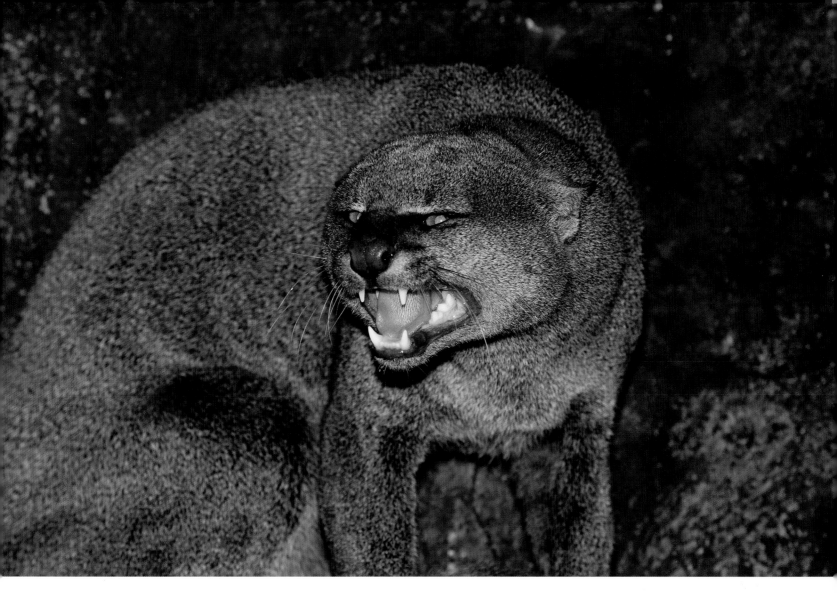

**Jaguaurondi, related to the cougar.**

Yasuní Green Gold will not only help bring the world's attention to this ecological jewel, but will serve as an educational tool and catalyst for worldwide efforts to save this region and its cultural and biological heritage.
**Dr Carl Ross** and **Dr Matt Finer**, Save America's Forests, USA.

There is no room for indifference or delay; time is on the side of the powerful. Because of this it is essential to support campaigns such as Yasuní Green Gold, which operates locally in the inalienable task of the building of another possible world.
**Professor Jesús López Megías**, Center for Initiatives in Cooperation for Development (CICODE), University of Granada, Spain.

I consider it not a duty but a privilege to join the cause in the defense, protection and conservation of the precious biological diversity of the Yasuní.
**Professor Javier Retana**, Center for Ecological Research and Forestry Applications (CREAF), Autonomous University of Barcelona, Spain.

This campaign aims to contribute to a broader global debate that will lead to specific actions to protect the many other places threatened by the need to meet the growing energy consumption of a small fraction of the planet's population.
**Joaquín Avilés López**, Millennium Villages Project, The Earth Institute, Columbia University, New York, USA.

# Yasuní Green Gold – continued

At Yasuní, we found almost 150 different epiphyte species on not more than 0.1 hectares of rainforest. Worldwide, this is the highest epiphyte diversity ever recorded for an area of that size – further evidence for the enormous biodiversity of Yasuní and a reason to support the Yasuní Green Gold campaign.

**Nils Köster**, Epiphyte Working Group, Nees Institute for Biodiversity of Plants, Bonn, Germany.

Because our research on the link between oil extraction, road-building, and the forest canopy fauna is so closely related to the theme of the Yasuní Green Gold book, we wholeheartedly support its publication. We hope that Yasuní National Park will remain a pristine forest ecosystem where researchers and students can come to study tropical biology and biodiversity. The Yasuní Green Gold campaign will show the world what irreplaceable treasures of diversity Yasuní rainforests truly are.

**Dr Christy Jo Geraci**, Entomology Department, and **Dr Terry L Erwin**, Curator of Coleoptera and Head of the Department of Entomology, Smithsonian Institution, National Museum of Natural History, Washington DC, USA.

While working with FORMIA, part of the Secretary of State for Indigenous People (CODENPE), to strengthen the rural areas, I was fortunate enough to meet and work with some of these local groups. I witnessed how they are coming up with inclusive development proposals that are respectful of their land by strengthening the organizational and participatory processes of their societies.

The initiative to launch this campaign to save the Yasuní was born in this tumultuous, yet hopeful, atmosphere. A place where conflict, dialogue, and change intermingle. From here, I wish to call upon both national and international actors who have a stake in Yasuní to listen. Let us open our ears to the proposals of the local people while retaining our capacity to provide constructive criticism. And let us join them in the processes that they themselves have initiated. Yasuní is Green Gold.

**Luis Robles**, National Project Director for Ecuador, Spanish Agency for International Cooperation (AECI), Ecuador.

Both the indigenous peoples today, recognized as individual nationalities, campesinos, and all Ecuadorians, are people of peace, who strive for peace, and who want to live in peace. All these nationalities do not just strive for improvement, but we do it also for national and international interests.

The indigenous people of the Amazon have their own proposals for conservation, change and sustainable development, but there remain people and sectors who do not want to accept this. Making these proposals known on an international level and looking for support in order that they might carry them out is a positive thing for everybody. Because of this we support campaigns such as Yasuní Green Gold.

Human Rights Committee of Orellana, Ecuador
Red de Líderes Comunitarios Angel Shingre
Federation of Campesino Organizations of Orellana, Ecuador (FOCAO)
Comunidad Huaorani Dícaro, Province of Orellana, Ecuador
Oil Politics Forum of Orellana Province, Ecuador

Nature is paradoxical. So strong, vigorous and wild in itself, yet so fragile and vulnerable in the hands of humans. We should all help, so that it should not be necessary to lose even an inch of its wealth. Yasuní is Green Gold: because of this I support the campaign.

**Miguel Ángel Martín López**, Head of International Cooperation, Córdoba Diputación, Spain.

The government of Ecuador signed the Millennium Declaration and has endorsed the 8 Millennium Development Goals (MDGs) that came out of this

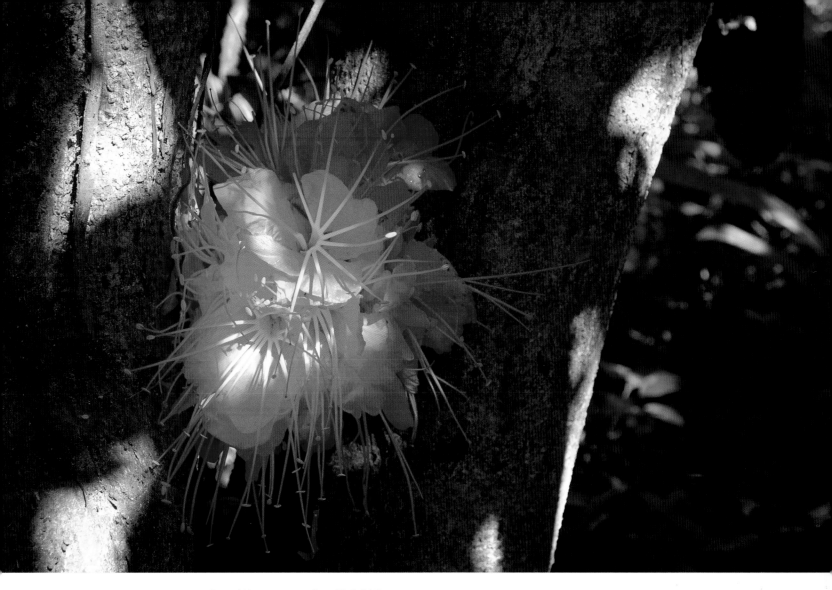

**One of the many species of bright flowers.**

international agreement. The Millennium Goals clearly show that reducing poverty and achieving sustained development must be done in conjunction with a healthy planet. The MDGs recognize that environmental sustainability is part of global economic and social well-being.

Exploitation of natural resources such as the Yasuní National Park can cause alarming changes in our environment and can harm the most vulnerable people in the world who depend on natural resources for their livelihood. Outreach efforts such as the one promoted by the Movimiento Idun to protect the Yasuní are necessary to bring the issue to the public attention, and I support such efforts.
**Jordi Llopart**, United Nations Millennium Campaign, New York.

This book *Yasuní Green Gold* leads us to the Yasuní Park, using the attractive and concrete language of art and photography. Yasuní's amazing natural endowment and people, their conflicts and expectations are beautifully presented. The short albeit concise text explains the conflicts, contradictions and hopes of the Park and its peoples, and their global significance."
**Professor Carlos Larrea**, Universidad Andina Simón Bolívar, Quito, Ecuador. Advisor on the ITT proposal.

For the full text of all the *Yasuní Green Gold* endorsements, and to add your own, go to **www.yasunigreengold.org**

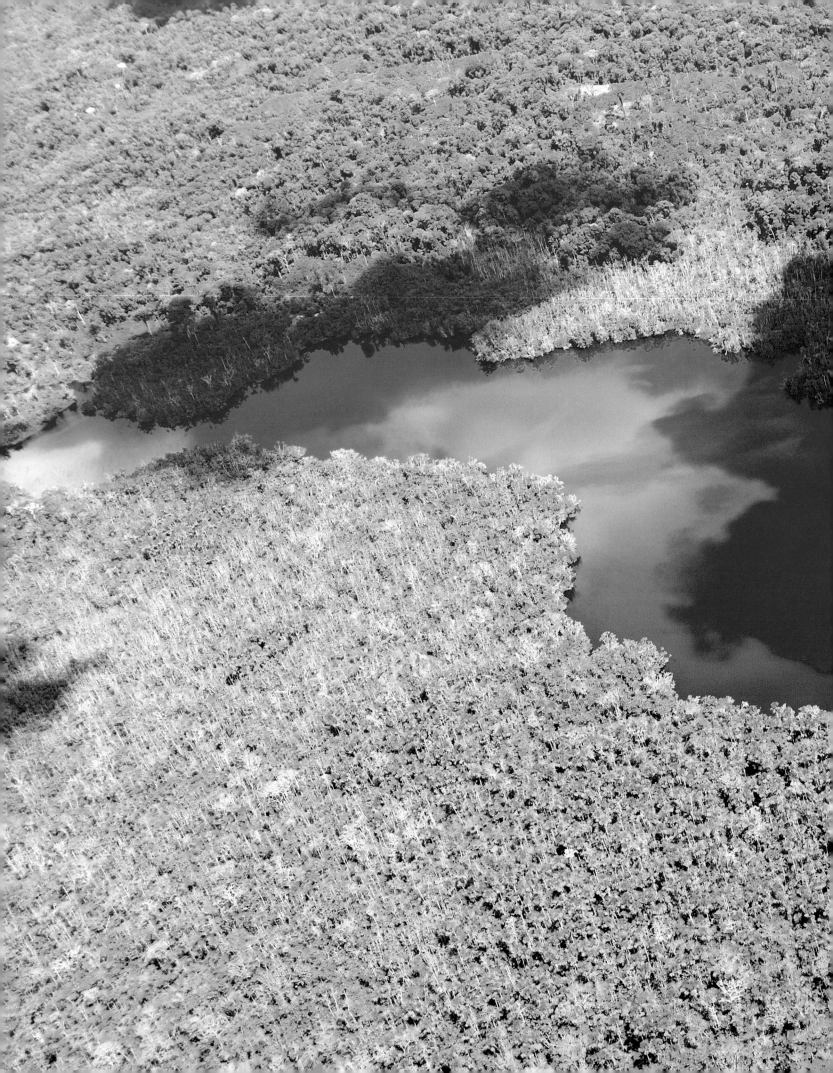

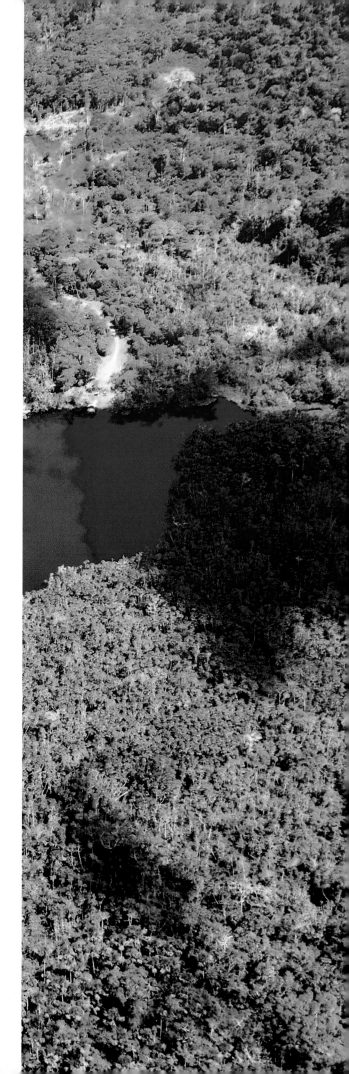

# Contents

Lake in Yasuní area.

# Preface

I first heard about the Yasuní when I went to work for the local government of Coca. The first thing I did was to go and look for it in an atlas, but to my surprise could not find one reference to 'El Coca'. I managed to find some information about the region on the internet but it took me a while to realize that the official name of 'El Coca' was Francisco de Orellana and that the two names referred to the same place. I was beginning to grasp that it is not easy to understand the complexities of the Yasuní region.

The idea to contribute our little grain of sand by trying to raise international awareness of what is going on in the Yasuní was forged when Georgina came to stay in Orellana. During strolls along the banks of the Napo and the *malecón* (promenade) in Coca, we talked with local and indigenous people and developed this project – which from there often seemed like a utopian idea. As a local leader said to us, 'Why would people so far away care what happens here?' It is true that sometimes, immersed in the local reality it feels that there is little international interest in the region. Fortunately it is not like this. Everyday we meet more people and find more organizations that are concerned about the area, and some have been for a long time.

The protection of the Yasuní and any other place on the planet relies on the support of the indigenous population. There can be no sustainable solution without this. This is the vital underpinning for a structure of international support and solutions. Without it, the enterprise can fail.

In the Yasuní region are local movements that have their own proposals for the sustainable development of the region; many of them are very worthy of support. The people peacefully protect their environment, their social and economic rights. Unfortunately, both outside Ecuador and even within their own country, these voices do not have the platform they deserve. This injustice extends beyond their local situation as the issues they are dealing with have global implications, such as human rights, climate change, poverty and inequality, the loss of biodiversity, transnational organizations, the global economy and corruption.

We began this venture with the conviction that it is better to do something than nothing, even if the work is not going to be perfect. We have produced this *Yasuní Green Gold* book in record time with the hope that it will be useful for the Amazon battle that is taking over. All the mistakes are our exclusive responsibility and we apologize for them in advance. We will correct them and update them on our campaign webpage.

We have tried to act as a loudspeaker for the local and indigenous people, to raise the volume of their voices and their concerns so that these can be heard at an international level. We know that as people become acquainted with the Yasuní, its beauty, its people and its problems, they will be inspired, as we were, to help protect it. For us it is already a small triumph that you have this book in your hands. It is our grain of sand. But also, we want to keep the support for there is still a lot of work to do.

When we look at the Yasuní, we see so many problems and so many struggles – yet there are also so many solutions. We intend to support, help develop and put into practice these solutions, improving and developing an international network of people and organizations who also believe the region of Yasuní is Green Gold. It will not be easy but we have to try: will you join us?

**Ginés Haro Pastor** and **Georgina Donati**
Yasuní Green Gold
yasunigreengold.org

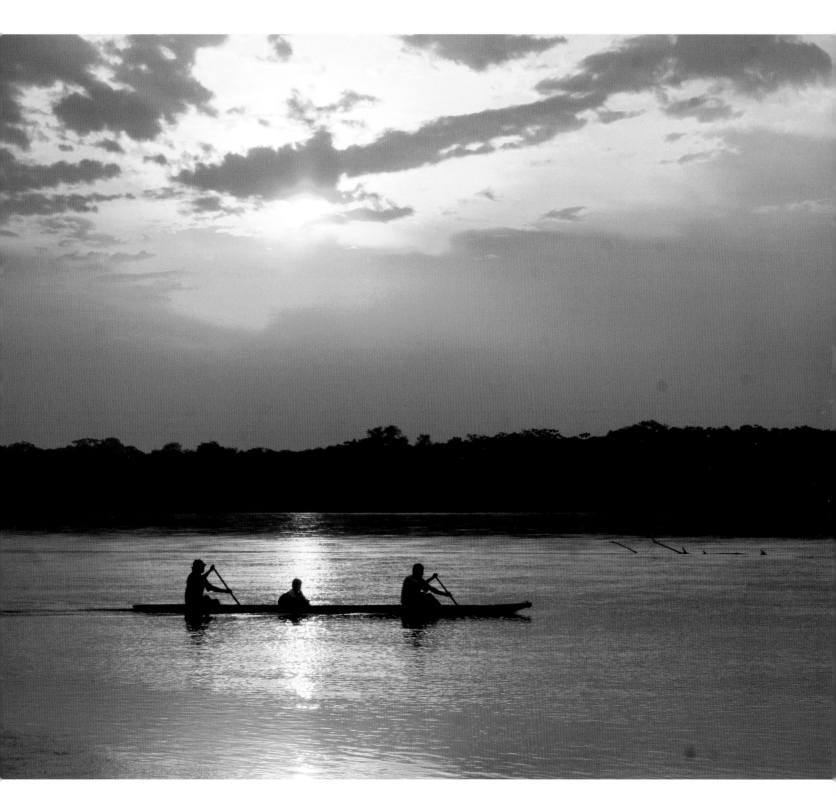

Kichwa family taking their daughter to school.

# Foreword

## Yasuní: Where free indigenous peoples live in harmony with nature

The Yasuní Park, set up in 1979, became a UNESCO World Biosphere Reserve in 1989. This is some indication of its importance, not just in the Amazon region or in South America but in the entire world. We all know of the mighty river Amazon and the lush rainforests through which it flows, but few are aware of the enormous riches of the Yasuní Park in terms of social and biological diversity. The three main indigenous groups who live there – Waorani, Kichwa and Shuar – are the protectors of the forests. Their traditional way of life is in harmony with the rhythms and seasons of the animals and plants around them. However, that diversity is now threatened by the existence of another type of wealth: oil.

In order to understand the issue, it is important to highlight that Ecuador's recent history has to a large extent focused on the blind pursuit of modernization and development, having become a sad example as a failed experiment of World Bank and IMF policies. The country has followed, step by step, all the recommendations imposed on it regarding the economic exploitation of natural resources. The result shows the failure of such policies and their impacts on the country and its peoples.

In spite of its vast natural wealth, Ecuador is ranked as number 89 in the UN's human development index and is now facing a severe subsistence crisis, importing a large part of the food needed by its population while continuing to export primary products. Although the political scenario has experimented with huge changes over the years, the economic model has remained unchallenged by the successive governments, which have continued to support the same type of development path that has failed to improve the country's situation both in social and economic terms.

Within that context, the Yasuní Park is the scenario of a new confrontation. Over the centuries this region has seen Spanish conquistadors, missionaries, traders, settlers and loggers; today it is the oil companies who wish to seek their type of gold. Taking oil out of the ground is always a dirty business. It is damaging for the environment, for the people, plants and animals that live there.

Until now, the Yasuní area has been spared the intensive and destructive extraction of resources witnessed in other parts of the Ecuadorian Amazon, mostly as a result of practicalities, including: distance and lack of adequate road systems, low quality of oil deposits, and the presence of warrior indigenous groups – notably the Tagaeri and Taromenane – who prevent outsiders from entering their territory.

As a result of the oil threat, things are now rapidly changing and the territory is facing two contrasting approaches to development. On the one hand, an economistic approach including industrial logging, bio-prospecting for the biotech industry, the commodification of nature under the form of sale of environmental services – including carbon-trading with the North – and the

exploitation of its low quality, but abundant, oil reserves. On the other hand, a totally opposite approach promotes the maintenance of the existing oil under the earth, the full respect of the territorial rights of the indigenous peoples and the protection of nature.

The need to protect the Yasuní Park is vital for many reasons. The region holds a number of world records in terms of biodiversity of amphibians, birds, reptiles, mammals, primates, plants and insects. It is home to 44 per cent of the Amazon Basin's total number of bird species. Some 25 endangered mammals including the puma and coati live there. Iguanas, sloths, snakes, beetles and macaws are part of the scenery. Frogs – the 'canary' species that is one of the first to suffer from climate change – are currently abundant and manifold.

But, above all, Yasuní is part of the home of the Tagaeri and Taromenane indigenous peoples living in voluntary isolation – the 'free peoples' as their Waorani cousins call them. Given that illegal logging of precious woods and oil exploitation within the ancestral territories of these peoples had put them on the verge of extinction, the State created in 1999 the Tagaeri-Taromenane Untouchable Zone, which barred entry of outsiders to the area, as a means of protecting them. As a result, this also banned oil and timber extraction from the area.

In spite of that, illegal logging has continued unabated, and several killings have been reported since 2003, both within and outside the Untouchable Zone. The Tagaeri and Taromenane – who are part of the Waorani nation – have expressed through different means their opposition to the entry of outsiders to their territory. During the past five years they have attacked illegal loggers to prevent them from extracting wood from their territory. It is important to underscore that the territory of these nomadic peoples includes not only the designated Untouchable Zone but also the entire Yasuní Biosphere Reserve and parts of the Peruvian Amazon.

But illegal logging is not the only threat. Oil concessions have already been allocated by the Government within the Park. The Yasuní has thus now become the locus of a radical confrontation between these two conflicting approaches to development. Depending on the result, the area will either see the same social and environmental destruction witnessed in those parts of the Ecuadorian Amazon opened up to oil exploitation or will become the starting point of a new post-oil country, respectful of life and responsible with the planet.

There are few places left in the world where people live in harmony with nature. Yasuní is still one such haven. We must do everything we can to ensure it continues being that.

**Ricardo Carrere**
International coordinator
World Rainforest Movement
Montevideo, Uruguay

# Introduction
# El Dorado

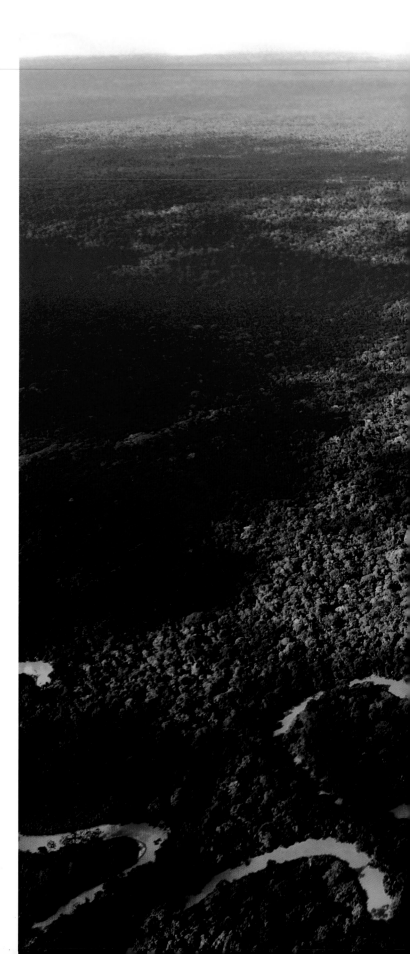

## The Yasuní national

Park is one of the few wild places of untouched nature that remains in the Amazon. It is situated in what is now Ecuador, at the intersection between the high Amazon and the mountain range of the Andes. The region is a haven of an extraordinary and often unrecorded biodiversity, protected by people descended from ancient warriors: the Tagaeri and the Taromenani. These are two of the last communities to live in isolation from the rest of the world.

The history of the Amazon has been written largely around the tales of its rivers. These are the arteries of life and communication for the forest and its people. They have brought explorers, colonizers and missionaries in pursuit of dreams, myths and legends about what lies deep in the forest. Each group has left a deep footprint, changing the fate of the Yasuní forever.

Among those adventurers enticed by the secrets of the Amazon was the Spaniard Francisco de Orellana, who in 1541 left Quito with Francisco Pizarro and eventually reached the mouth of the Amazon River. They were driven by the lure of gold. Orellana had heard the stories of a kingdom of gold, minerals and precious stones hidden deep in the forest – 'el dorado'. In time, 'el dorado' – the golden

**Ecuador's Amazon region. Within just one hectare of Yasuní 644 species of tree have been found – this is almost equal to the entire indigenous tree population of North America.**

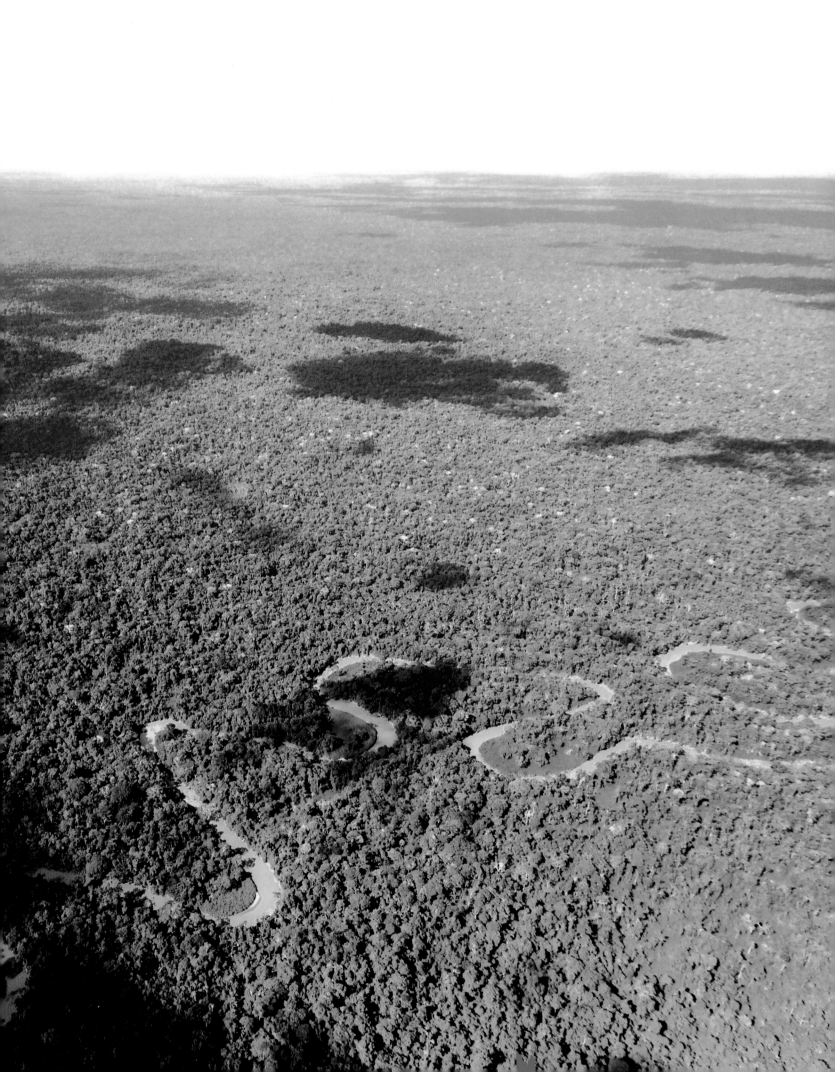

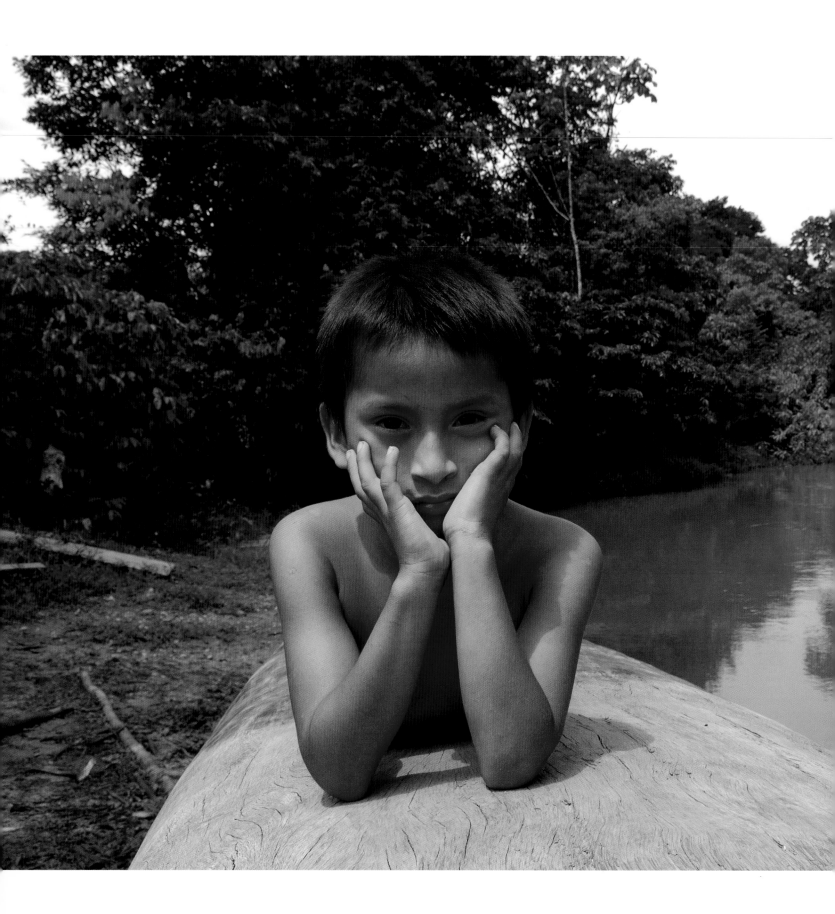

one – came to mean a kingdom or place where gold is so common that the native people find no value in it.

It was the search for this golden city that led Orellana along the Napo Rriver to the Yasuní region in 1542. On his journey he came across different communities of indigenous people such as the Tupiguaranis, Ticunasa and the Omaguas who have inhabited the Amazon for over 5,000 years. The ruins and remains of some of their former civilizations are still found today dotted along the River Napo.

Their descendants, including *Naporunas* (Amazonian Kichwa) and Waorani, live on in the depths of the Yasuní. These are the last, authentic guardians of the region; they constitute a cultural patrimony of extraordinary value, the heirs of lost civilizations.

Traditionally Waorani are semi-nomadic hunters and gatherers, living in harmony with the forest. Their home is a sphere of protection where they have fought to resist conquistadors and other intruders down the centuries. Indigenous people continue to struggle against the trespassers: rubber-tappers, loggers and oil companies, and also the epidemics that come with them.

**Kichwa boy and canoe. Rivers wind their way through Amazonian history, the arteries of life and communication for the people of the forest – and for those who came from the outside including explorers, colonizers and missionaries.**

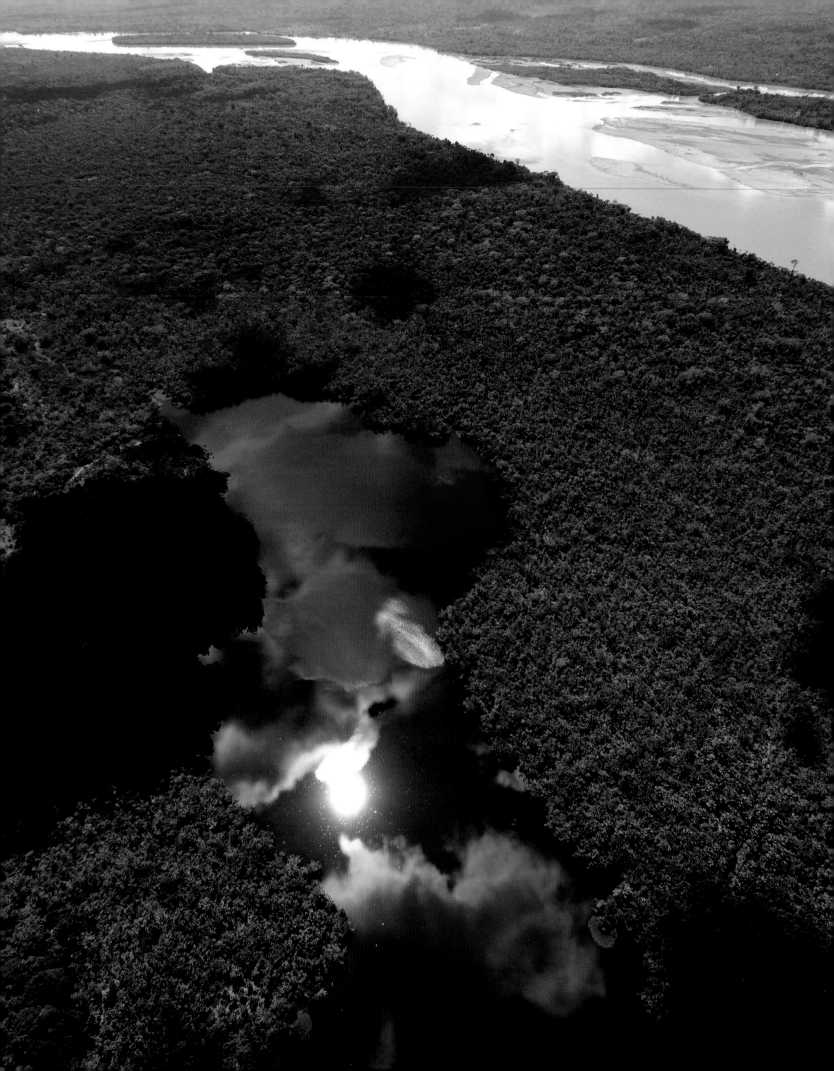

Up until the last century these indigenous communities had been virtually the only permanent human occupants of the region. The occasional outsiders were mainly religious groups whose settlements were established at the time of the Spanish colonials.

Orellana's expedition has become one of the most famous pieces of Amazonian history. He continued his journey along the Amazon until he reached the Atlantic coast of Brazil, where the river disgorged its millions of gallons of water. Orellana was feted as the 'discoverer' of the Amazon River, and although he may have been the first to travel its length, of course local people had intimate knowledge of parts of it long before. In honor of the explorer, the region was named Francisco de Orellana. The story of the expedition gave further impetus to the myth of 'el dorado' and attracted even more adventurers to the zone.

**Sunlight reflection on a lake near the River Napo, Orellana Province (opposite page).**

**Map of Ecuador, showing the town of Francisco de Orellana (also known as Coca) and the Yasuní Park.**

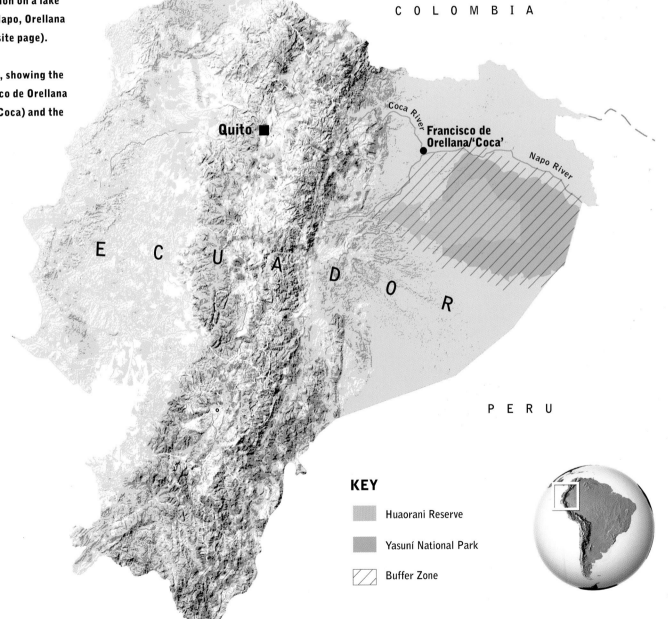

COLOMBIA

Coca River

Quito ■

Francisco de Orellana/'Coca'

Napo River

ECUADOR

PERU

**KEY**

Huaorani Reserve

Yasuní National Park

Buffer Zone

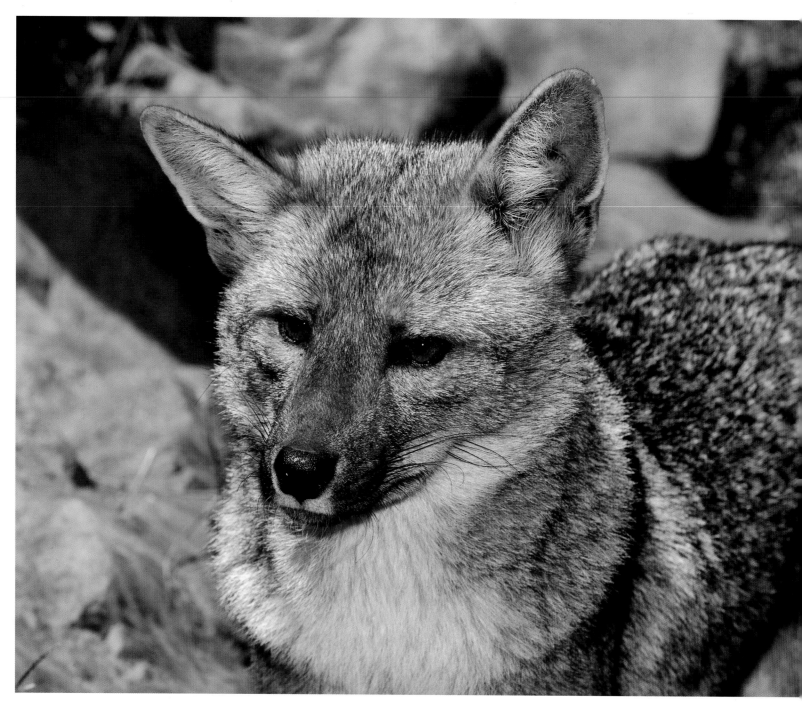

'False fox' whose common name is Zorro, from the Spanish word for fox. It is a type of wild dog.

Kichwa boy with cocoa pod (opposite page).

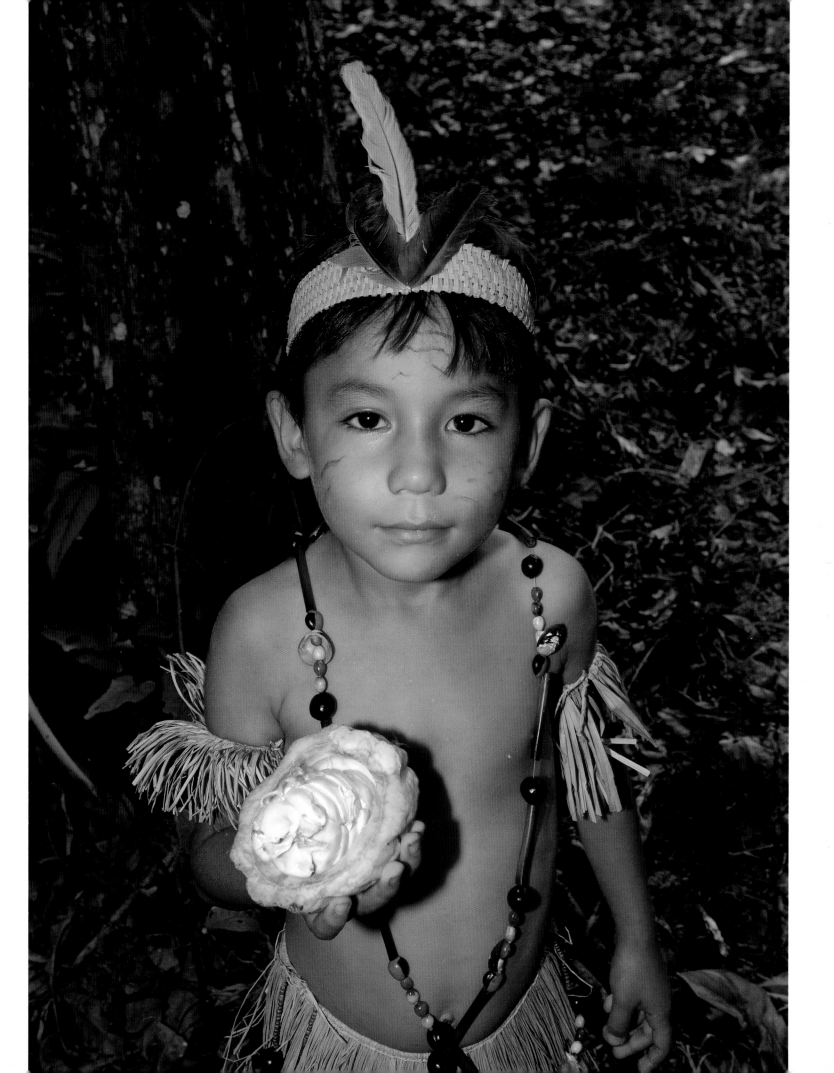

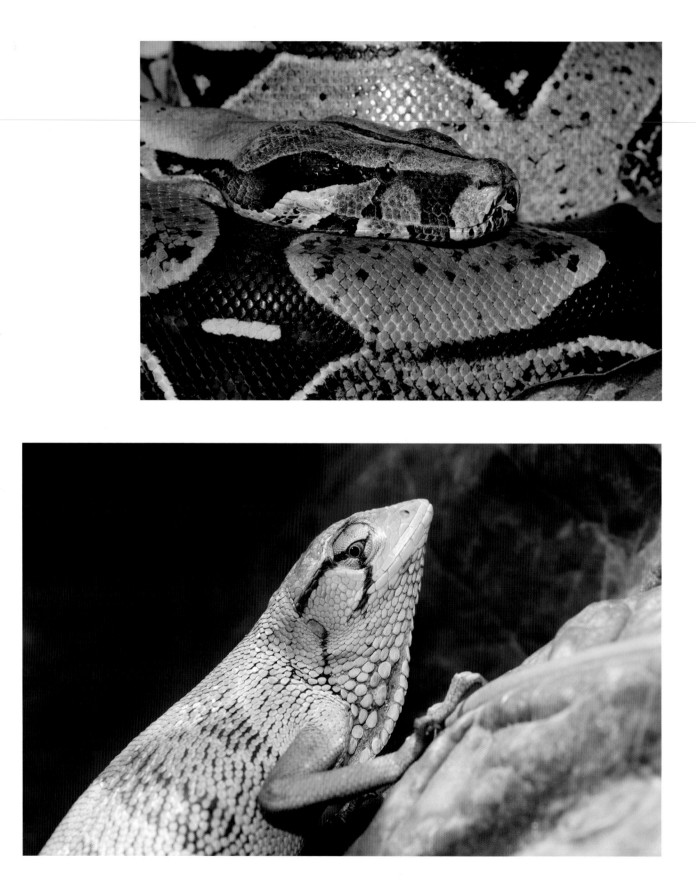

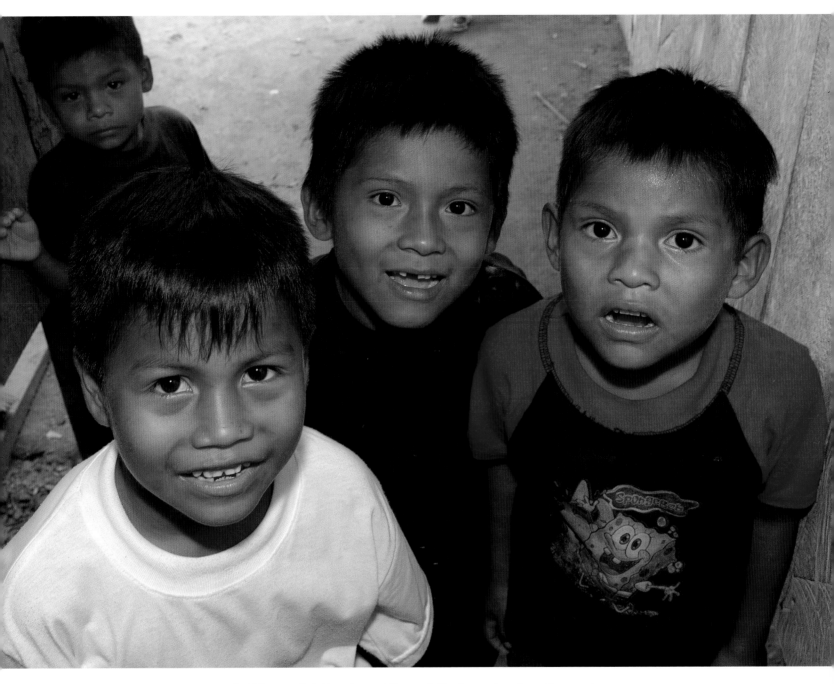

There are about 12 million people in Ecuador, and its population is growing at over 2 per cent per year, one of the highest rates in the world. This is one of the pressures on the forest resources, along with farming, ranching, logging, mineral and oil extraction.

Boa constrictor imperator, the common boa, is found from Central America down to the Amazon Basin. It likes to soak in the forest waters, but is also an adept climber (opposite page, above).

72 species of reptiles have been recorded around the scientific station in the Park (opposite page, below).

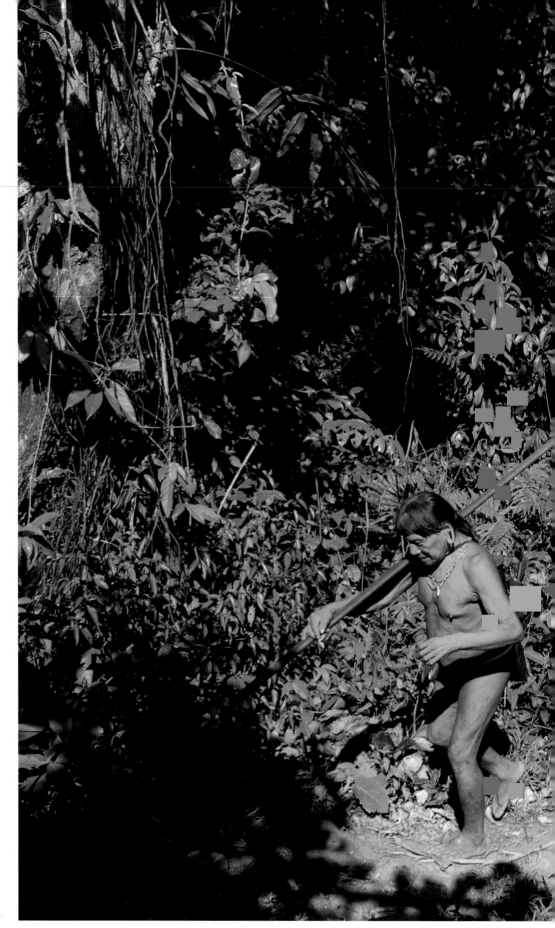

Enqueri Ehuenguime, speaking on behalf of
his community, the Waorani Enguis, said: 'We
the natives have become the defenders of our
biodiversity and we take care of our forests and
do not let them log the trees. So these armed
[forces], must kill us to plunder the trees.'

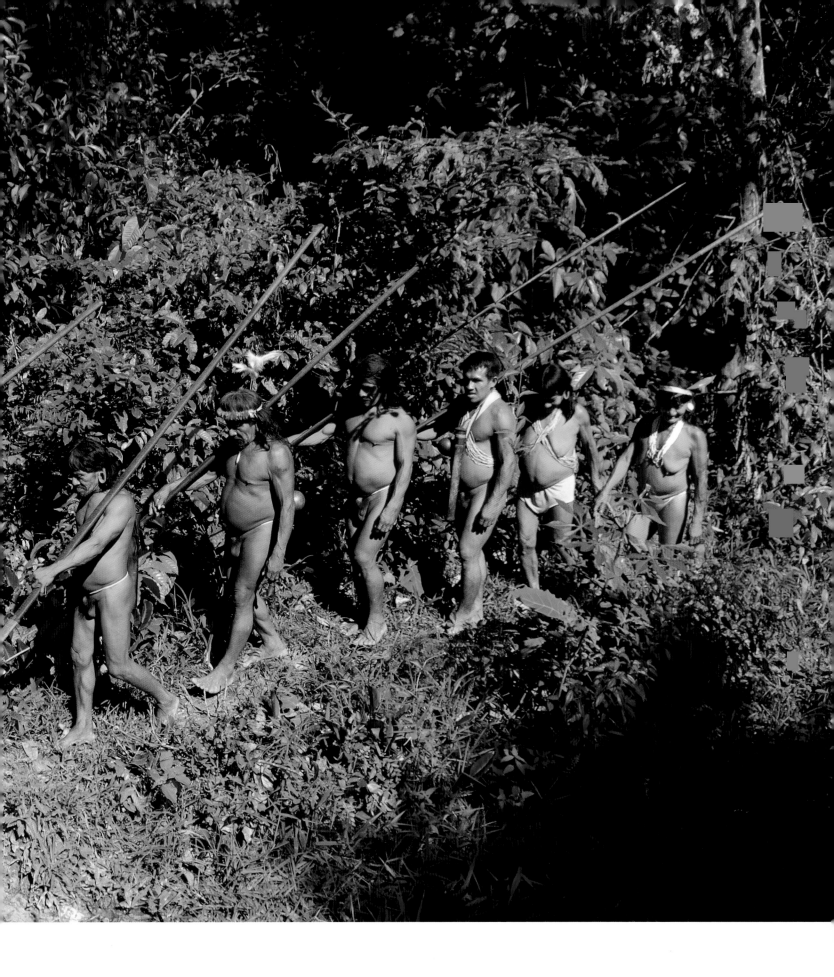

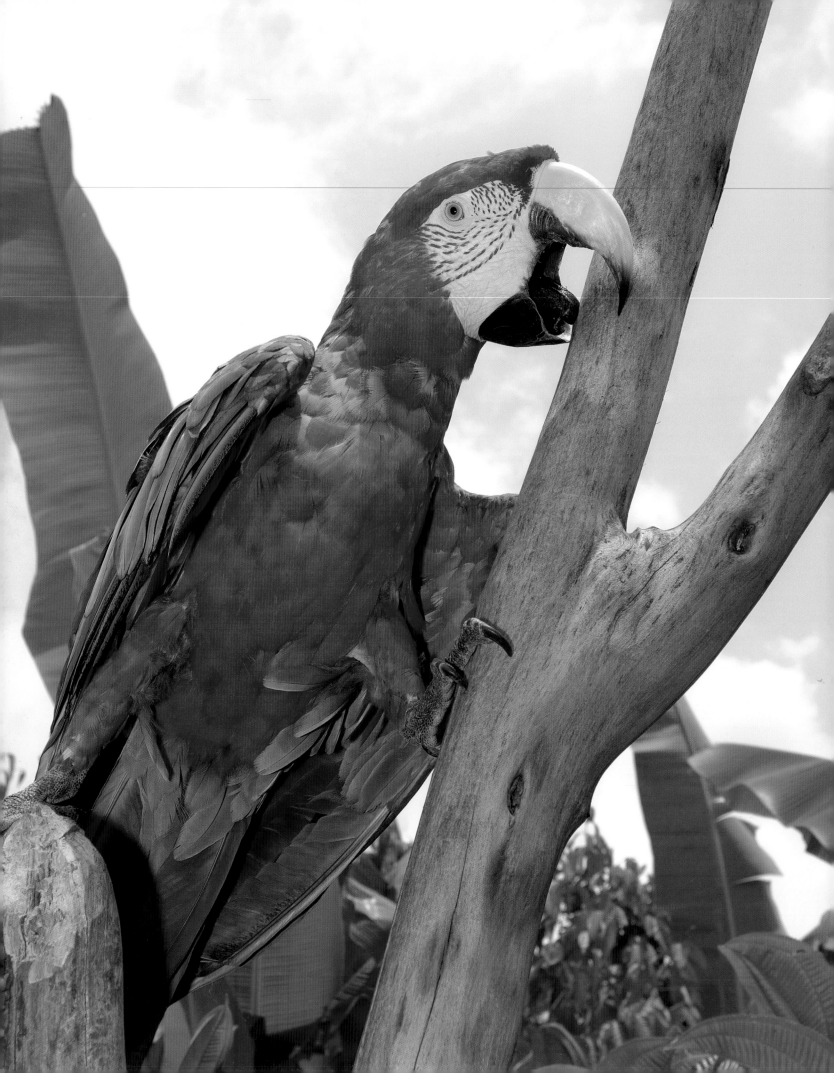

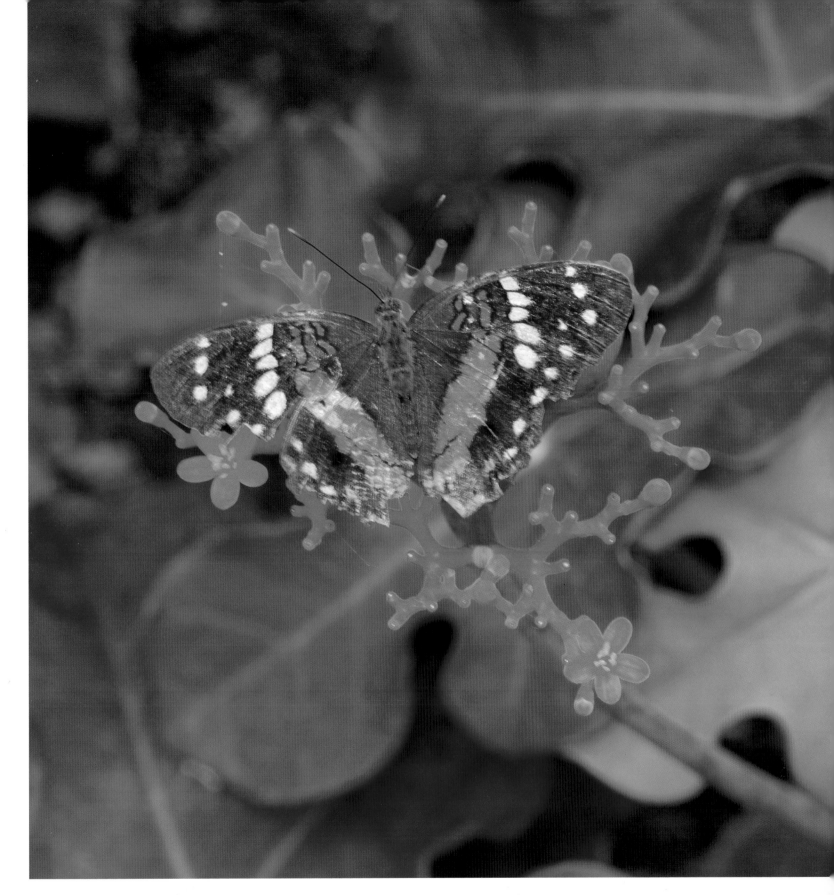

Some butterflies have caterpillars with special organs which can produce proteins which are exchanged with ants for protection from the wasps that prey on them.

Red and green macaws feed on fruits and seeds. Its striking plumage puts it at risk from the illegal trade in caged birds (opposite page).

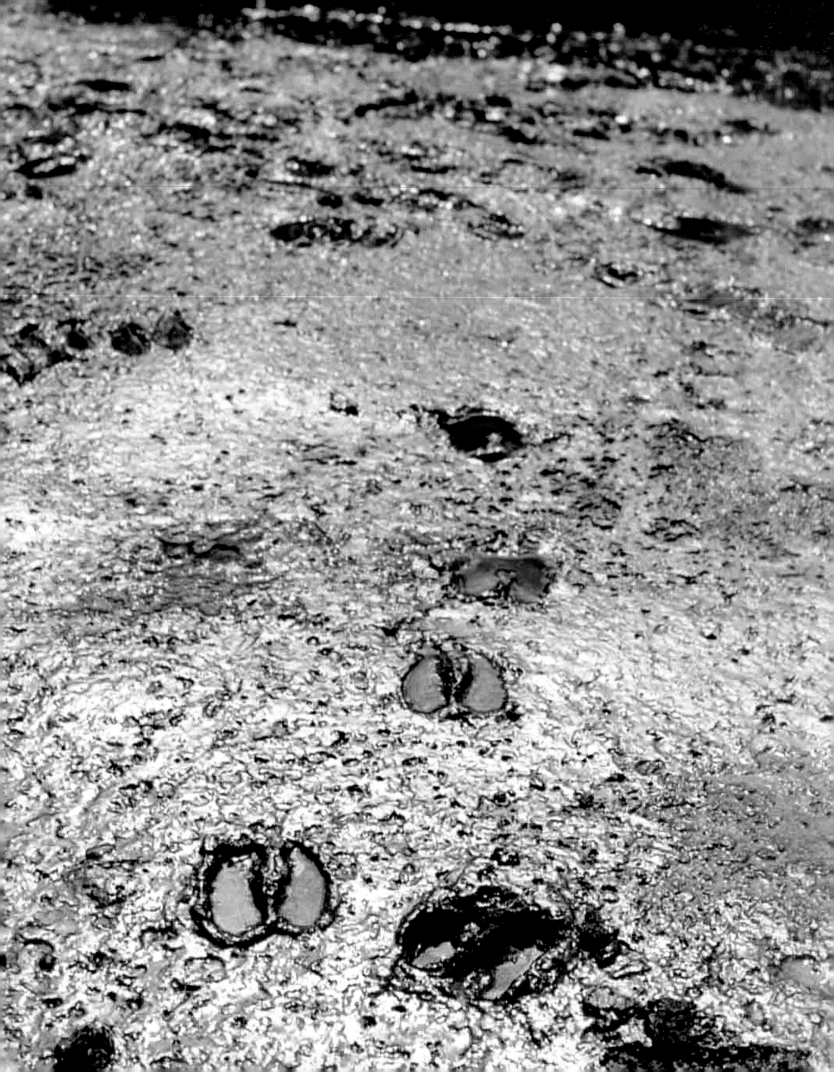

# Oro negro (black gold)

## The discovery of

large deposits of oil has completely transformed Orellana and Sucumbíos provinces. The main exploration in the 1960s and 1970s led to waves of colonization which were encouraged by the Ecuadorian Government. Like its golden predecessor, oro negro (black gold) has enticed legions of oil workers, settlers and adventurers, along with their fellow-travelers of disease, greed and corruption.

To get the oil to the Pacific coast a 420-km pipeline was built right across the Andes. However, achieving this amazing feat meant prising open the area, hacking down forest to bare the ground to build roads. Through this open wound poured thousands of farmers and people from other parts of the country, dramatically changing the landscape as they cut down more trees to create fields and oil-palm plantations.

Some 20 years later, new oil deposits were found in the Pastaza and Napo valleys. These included a reserve of 920 million barrels of heavy crude oil lying beneath the Waorani Reserve and Yasuní National Park.

Once the forest protection was breached for oil extraction, the numbers of people and settlements rose quickly. Lago Agrio was the main town during the years

OSCAR FRANCINO / ALI SUPAY

Cow hoof marks in the oily mud. Animals come to drink at the contaminated pools left by the spills; such pools sometimes remain for years. This has led to a high mortality rate in the wild and domestic species living in areas affected by oil leakages. When cattle die like this, there is a major impact on the local people who are affected not just in their pockets but also in their stomachs (opposite page).

An attractive reflection, at first sight. But oil exploration has ruined many water sources.

OSCAR FRANCINO / ALI SUPAY

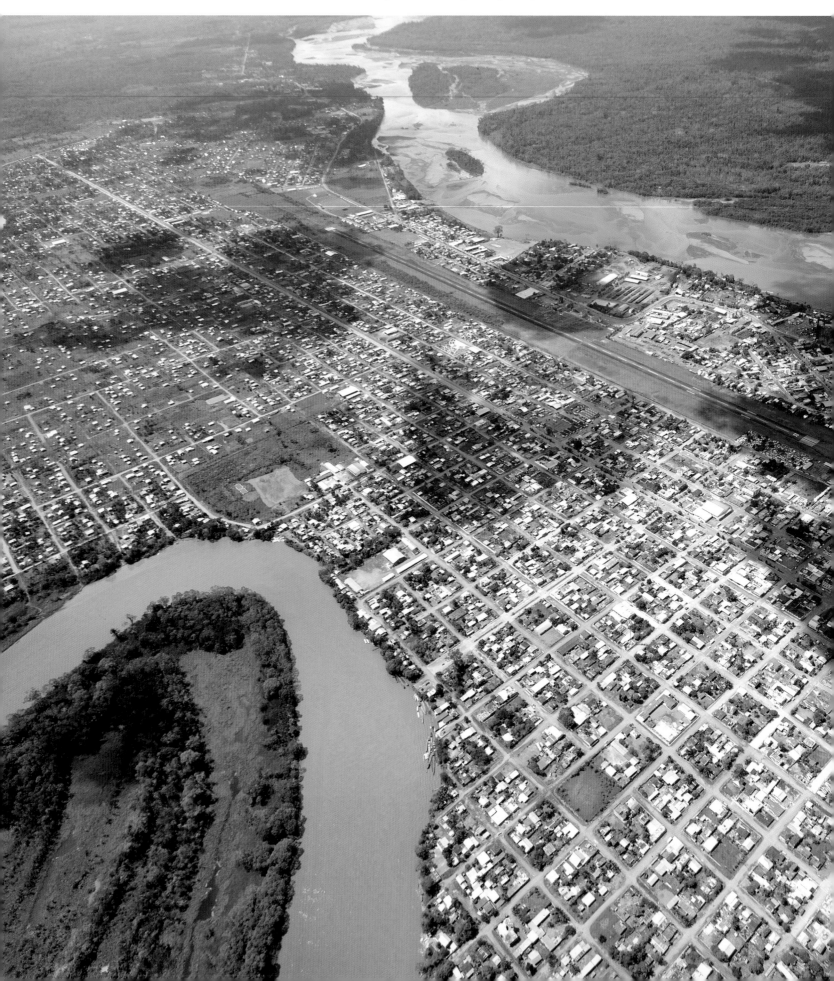

The town of Francisco de Orellana, known as Coca, is the gateway to the Yasuni Park.

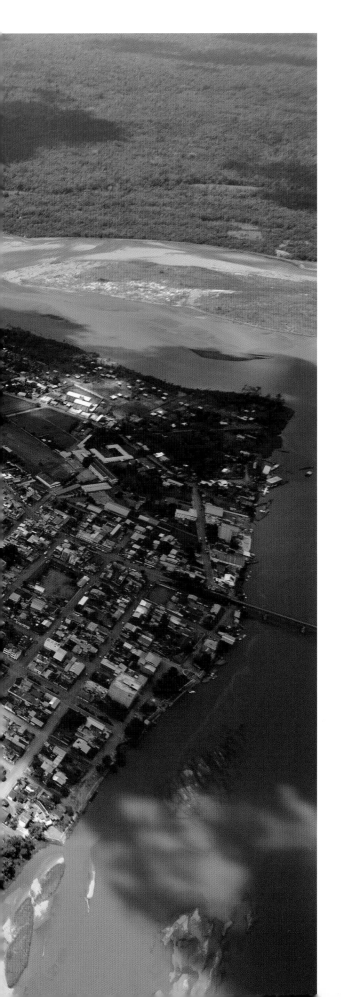

when Texaco dominated oil exploration. But in the 1990s and 2000s, the oil frontier advanced south-eastward, leading to the expansion of 'Coca' – as the city of Francisco de Orellana is known. Lying at the confluence of the Coca and Napo rivers, it was named after Orellana as it is thought to be one of the places where he camped on his expedition. Indigenous people there call it 'Coca' because for them it was a place where their ancestors once carried out rituals for curing the coca leaves that were then, as now, chewed as a mild stimulant.

Today, the town is not only the capital of the Ecuadorian Amazon but also the capital of the oil industry and the gateway to the Yasuní National Park.

The consequences of colonization have created deep and lasting impacts on the local ecosystems.

Unregulated exploitation by multinational oil companies; widespread illegal logging; indiscriminate and unsustainable hunting as well as infectious diseases have all contributed to the devastation of the forest, its people, plants and animals. Through the pollution of water sources,

deforestation and toxic contamination, people's traditional ways of life are put in peril, while plants and animals are forced from what was a safe haven to the brink of extinction.

On top of this, the indigenous local population has faced serious repression, threats and even death when they have tried to challenge the consequences of the obsession with oil.

Multinational companies have used a variety of strategies to penetrate into the indigenous territories of the Amazon. For example, they have promoted the presence of tourists, missionaries, development anthropologists and ecologists. This has been done under the guise of interest and concern for the people and environment, but beneath it all lies the intention of undermining the indigenous people's traditional way of life so that they leave the forest. But the people have fought back.

**The Yasuní has five protected species of freshwater mammals, including the extremely rare giant otter. It has disappeared in other parts of the Amazon as a result of indiscriminate hunting, oil pollution and motor boats on the rivers and swamps.**

**Delicate balances between nature and humans are being destroyed.**

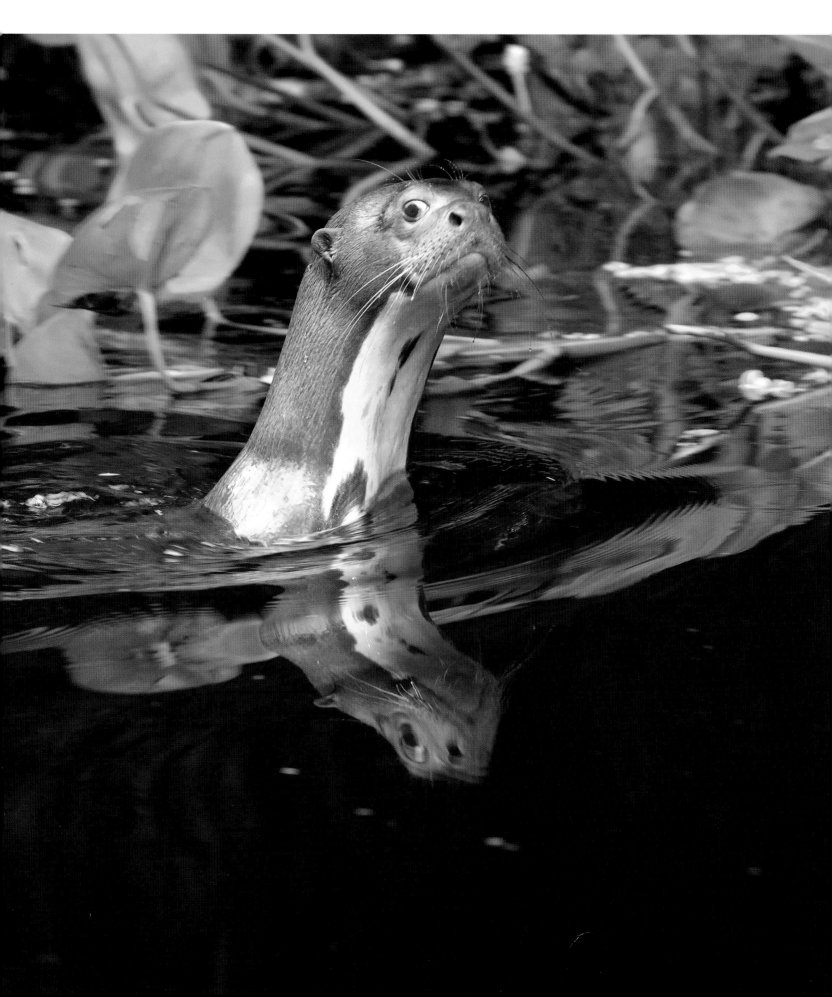

Oil is the reason for the creation and the expansion of many of the Amazonian cities. The infrastructure of the oil industry becomes part of the landscape and people live in its shadow, with not even basic health and safety standards.

Woolly monkeys feed on small invertebrates, seeds, nuts and flowers. Deforestation and water contamination has resulted in the extinction of some species of spider monkey and woolly monkey in this area. They can now only be found in the eastern section of the Yasuní (opposite page).

OSCAR FRANCINO / ALI SUPAY

One of the most famous episodes of resistance took place in the 1940s when the warrior Moipa led a protest against an oil invasion by Shell. Using their spears to fend off the company's people, many were killed. Since that time, there have been sometimes violent incidents of retaliation.

The first time the Waorani people were peacefully contacted was in 1958. Up until then they had resisted such 'incursions' which they saw as colonizing and likely to have unwelcome repercussions on them and their way of life.

Not all the Waorani groups were contacted. The Tagaeri and Taromenane people decided to remain in voluntary isolation and consider themselves to be the last free beings of Ecuador. They continue to protect the heart of the Yasuní from illegal loggers and oil surveyors, who have come into their lands and sometimes abused their women and children, on occasion resulting in some deaths. The

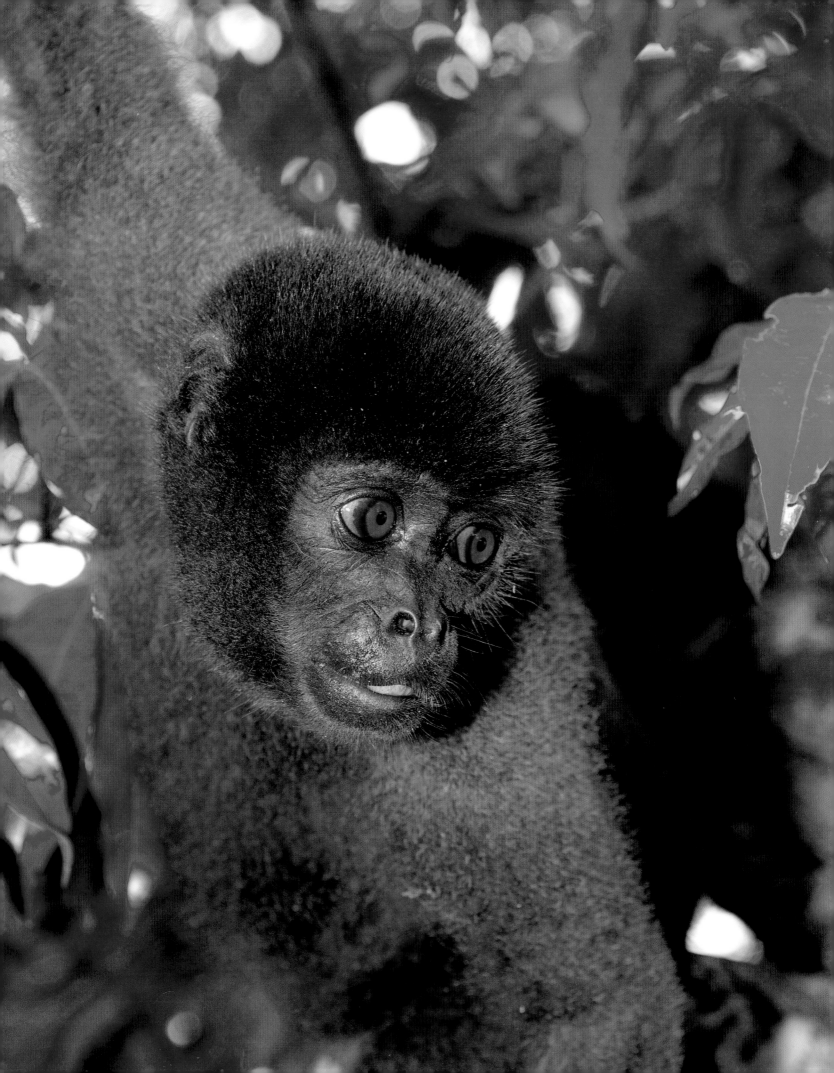

About three-quarters of the population is believed to use polluted water. It is used for cooking, bathing and drinking. Attempts are made to decontaminate the water supplies, but generally this is not successful and toxic substances remain in the rivers. Often these are bio-accumulative – building up in the bodies of animals, fish and people that consume them – resulting in various illnesses.

situation is so grave that on 10 May 2006 the Pan-American Commission of Human Rights drew up measures to protect the rights and lives of these people. However these measures are not always respected.

The deep physical and psychological scars caused by the search for oro negro have always been justified by saying that the benefits of the oil industry will be channeled into alleviating the problems of poverty and inequality in Ecuador. In the last four decades, the country has become completely dependent on oil exports for the bulk of its income. But the oil revenues have not helped diminish hardship, or spread health and education services to those most in need. Black gold has not lived up to the promise of reducing inequalities in Ecuador. Oil revenues go towards paying the national debt.

OSCAR FRANCINO / ALI SUPAY

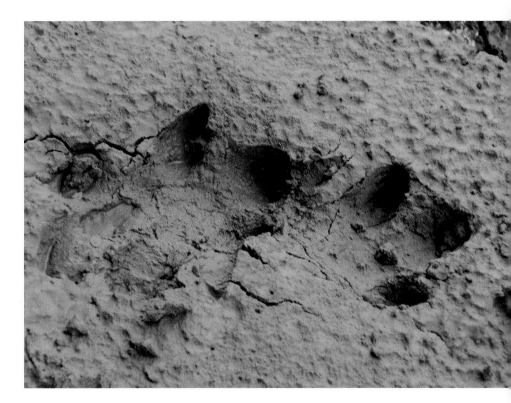

**Footprints in the earth – how much longer can species survive?**

# Introduction
# Oro verde (green gold)

## The true wealth of

Yasuní does not lie below the ground. The area is regarded as being one of the most biodiverse, with one of the largest gene pools in the world. It is thought to be a zone that did not freeze during the last ice-age, which began 2 million years ago and lasted up to 10,000 years ago. As a result, it became an island of vegetation where flora and fauna took refuge, survived and eventually re-populated the Amazon. This explains the extraordinary richness of nature in the zone and the quantity of endemic species found there. Many of these are not found elsewhere; some have hardly been studied and little is known about them.

World Wide Fund for Nature (WWF) has designated the humid forest of the Napo as one of the 200 most important sites in need of protection, and also as one of the 24 priority areas for the world's wildlife.

The unique nature of Yasuní was first officially recognized by the Ecuadorian Government which made it a National Park in 1979. The area covered some 982,000 hectares between today's provinces of Francisco de Orellana and Pastaza.

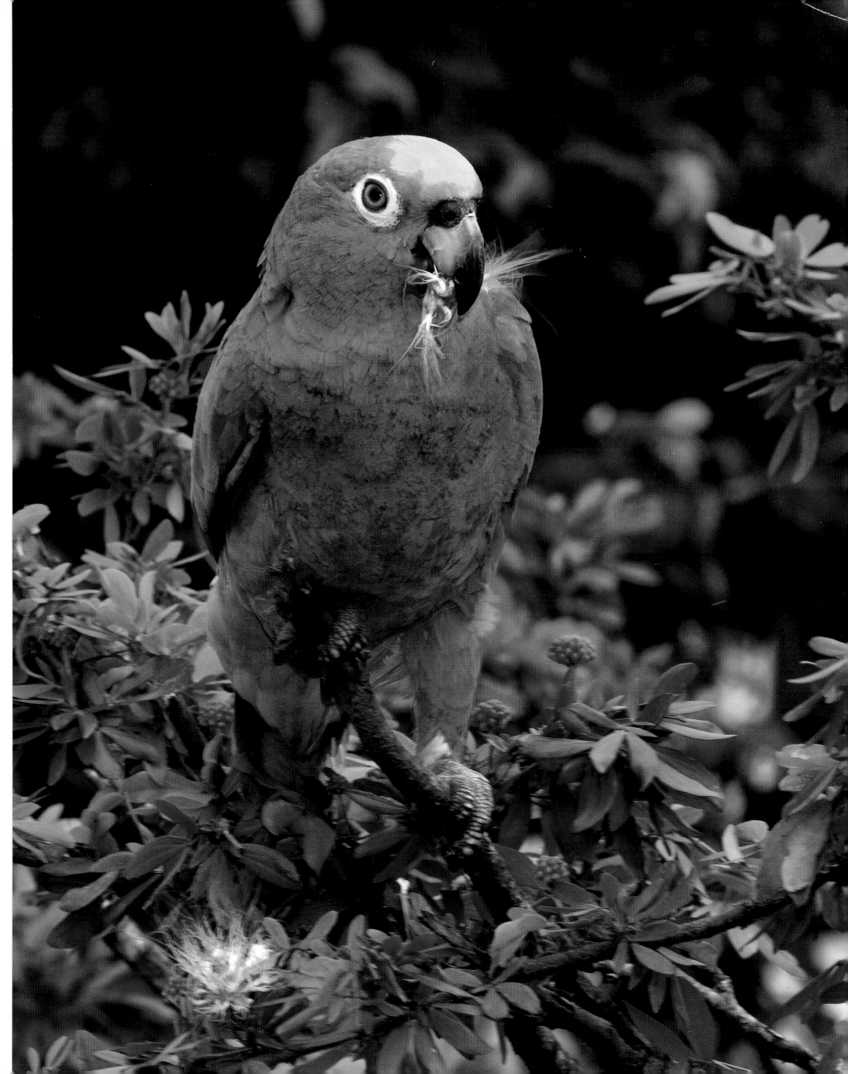

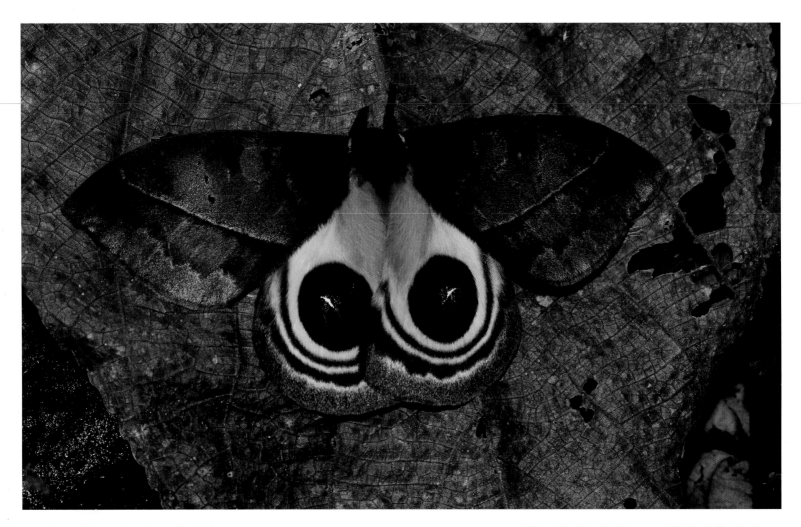

Many butterflies and moths are found along
the rivers that run through Yasuní.

The white-throated toucan, with its distinctive large
bill, mainly eats fruits in the trees. But it also feeds
on insects, birds' eggs and lizards (opposite page).

any mining, oil activity, logging, colonization or anything
that might tamper with the biodiversity and ethno-cultural
nature of the area.

Seven years later, in 2006, the physical demarcation of the
Untouchable Zone laid out an area of 700,000 hectares that
includes the territory of the Tagaeri and Taromenane clans.

However, despite the exceptional biological and cultural
importance, and the many protection orders that have
been bestowed upon the area, Yasuní's conservation
is by no means assured. Precious trees are cut down,

robbing people and animals of their protection. But worst
of all, there is the constant threat of the oil exploration,
now climaxing with the proposal to drill for oil under the
Yasuní Park itself. The plan is to exploit oil deposits that
extend into the Untouchable Zone, so destroying the very
places that are meant to be protected, and taking away
the remaining habitat of the people and species that live
there. The Park boundaries have been redrawn several
times to accommodate oil exploitation (which is normally
forbidden in a national park). In 1999 the Constitutional

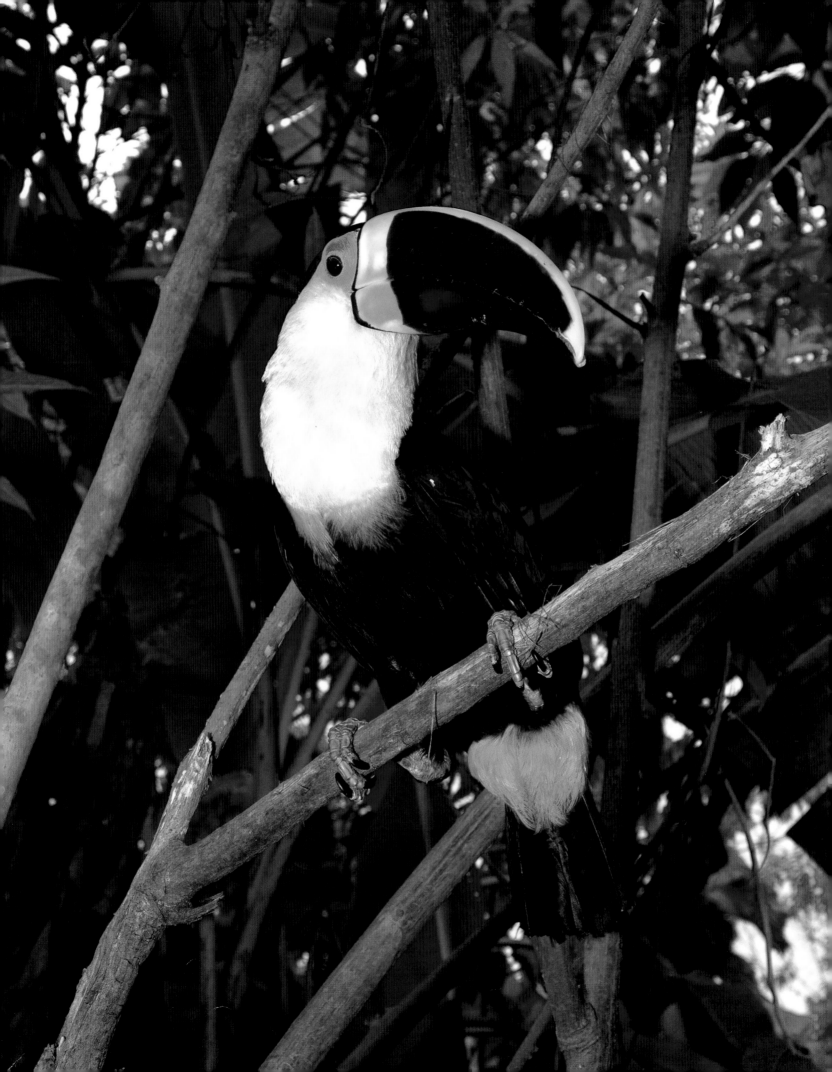

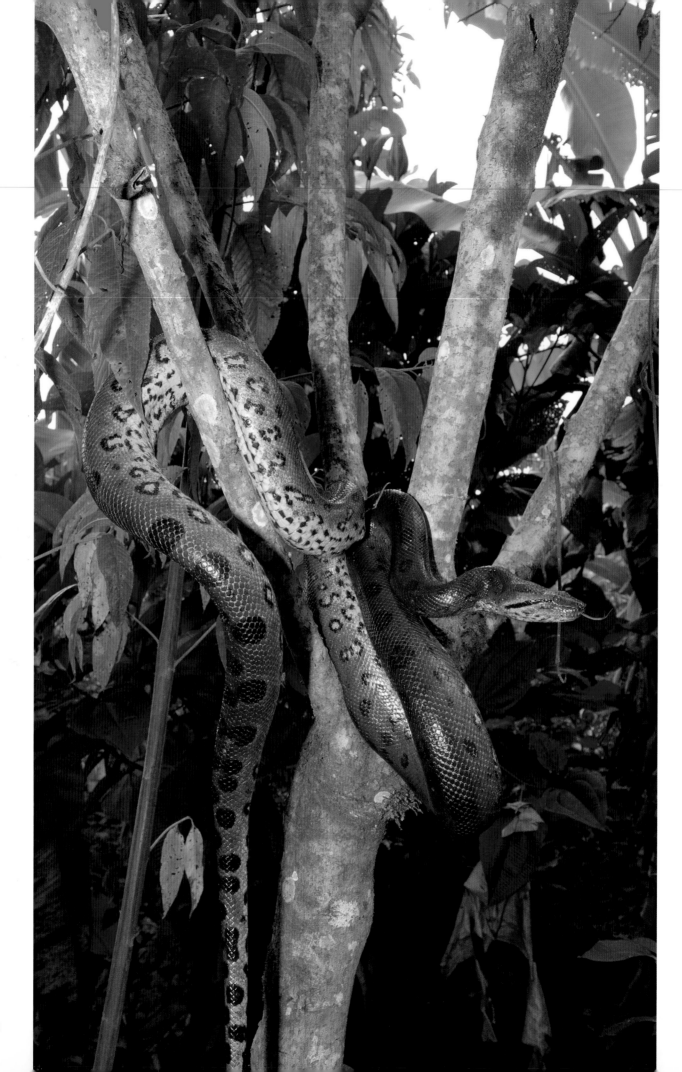

Court approved plans to develop oil in Yasuní National Park – a decree that violates the park's legislation.

The likely impacts of oil exploration in the Park, based on what has happened in the surrounding areas, are all too predictable and well documented. Water sources will become polluted. Yet more trees will be felled. Birds, plants, insects and other animals will have to move or die out, as will the social fabric of ancient human cultures.

In response, the local authorities and some native and social movements in the zone have raised strong opposition. They will continue to defend conservation, and look for alternatives to oil for the sustainable development of the region. They are acutely conscious that sustainable development, making use of the biodiversity and of the traditional knowledge of the native people, is invaluable – it is a wealth for the future: it is oro verde – green gold.

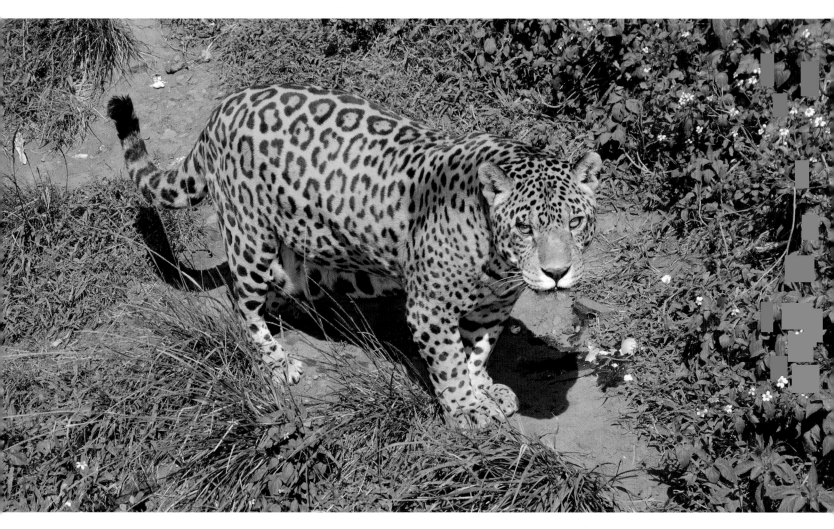

**Green anaconda. This semi-aquatic snake is the largest member of the boa family and one of the largest snakes in the world, reaching lengths up to 8.8 meters (29 feet). Its eyes are set high on the head so it can see above the water without exposing the rest of its body. It can consume prey as large as tapir and deer and sometimes even caimans and jaguars (opposite page).**

**When a shaman dies, the belief is that he is transformed into a jaguar (*panthera onca*, above). Ordinary people must brave the mythical giant anaconda – the River Napo – to reach heaven and for this they must wear slender splinters made of chonta palm wood inserted on the side of their nostrils. If they do not, they fall back to earth and transform into termites.**

The Yasuní area is one of the most biodiverse, with one of the largest gene pools in the world.

There are thought to be over 600 different species of ants. According to some studies, on just one tree there are more ant species than exist in all England (opposite page).

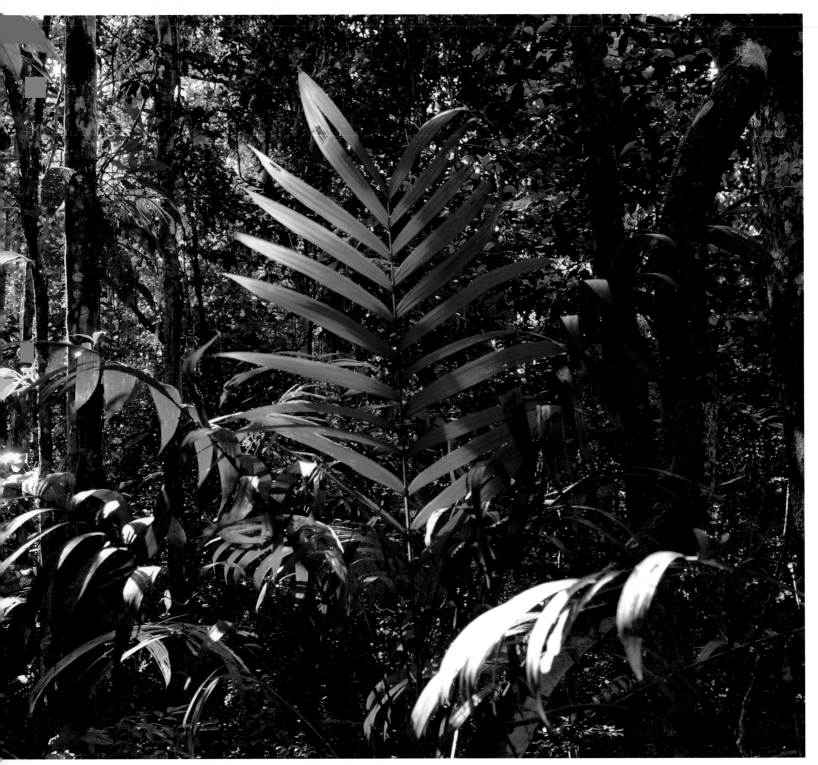

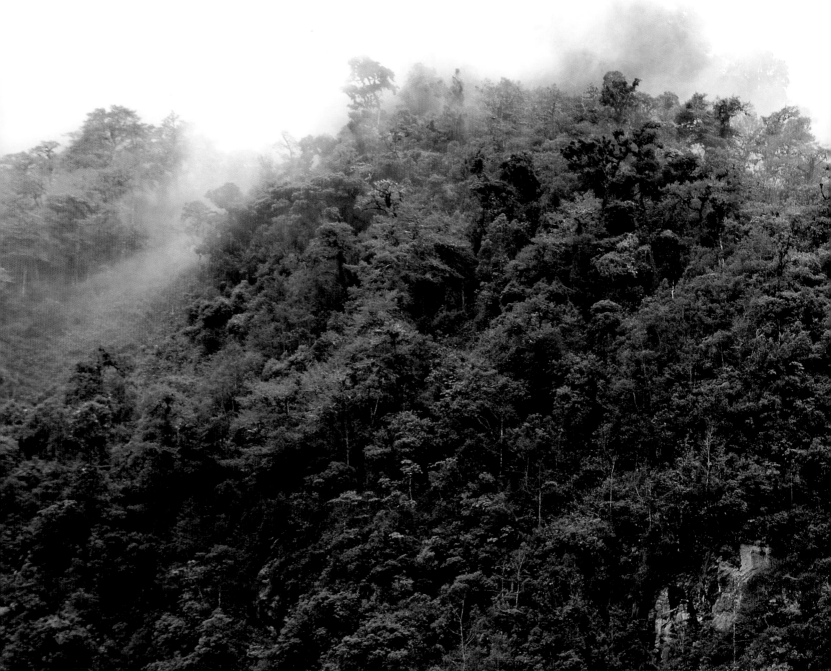

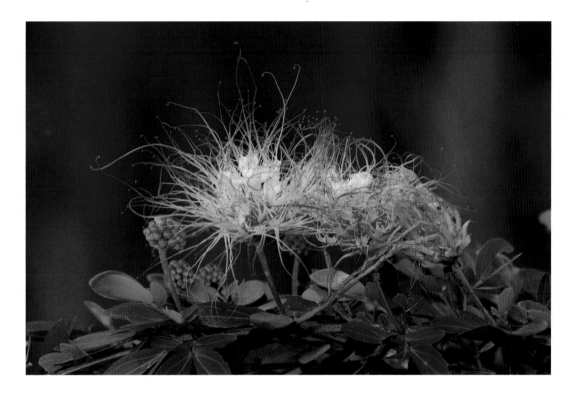

In the rainforest, each animal and plant has its niche, the medium it can thrive in – all in nature's balance. For some it is in the top of the canopy, up in the air. Others flit from flower to flower, or hop from leaf to leaf.

# Chapter 1
# People of the forest

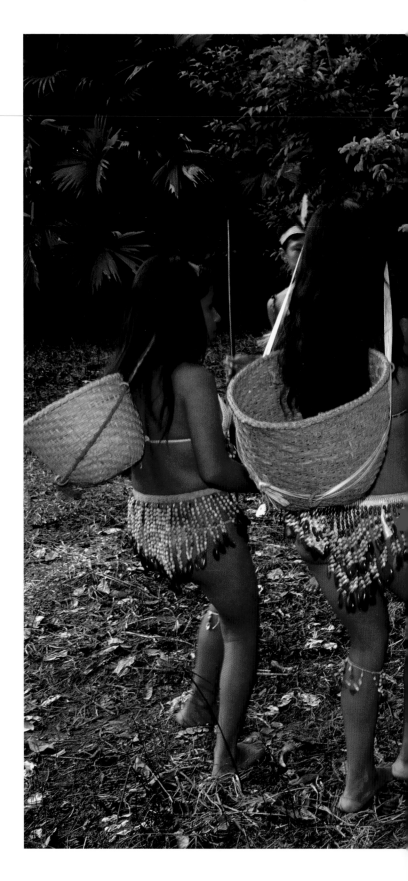

## Inside and around

the Yasuní National Park live three different indigenous groups – Waorani, Kichwa and Shuar. Traditionally, these Amazonian people live from the plants and fruits of the forest as well as by hunting its animals. In the past, they mainly killed small mammals for food, with rules and taboos (particularly for the Waorani people) prohibiting the hunting of some animals. The indigenous people also share a tradition of passing on their knowledge and cultural inheritance primarily by demonstration and word of mouth.

### Naporunas (Amazonian Kichwa)

Today's Amazonian Kichwa are descendants of the former inhabitants of the region: the Quifkos, Záparas, Omaguas, Shuar, Achuar and Siona. Within the Kichwa, there are still various sub-groups. Today there is an expansion of 'Kichwization' in the Amazon because of marriages with other groups and migration.

From colonial times to the present day, there have been almost continuous attempts to assimilate Amazonian people and undermine their culture, yet Kichwa in particular have not only survived but have expanded and grown stronger.

Hunting is regulated by a belief system based on a concept of the relationship between humans

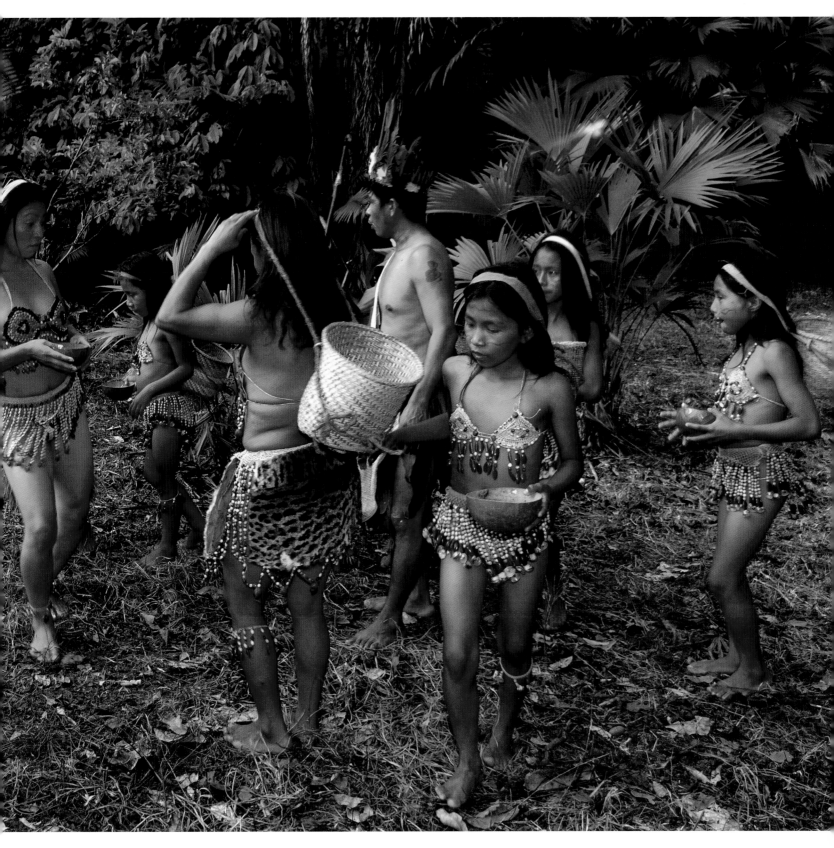

Kichwa are the most populous indigenous group in Orellana.

and the forest. Sacharunas (people of the forest) are subject to a series of rituals whose compliance guarantees the effectiveness of the hunt.

According to Kichwa belief, the father (the Napo River) fertilizes the mother – earth – in order to ensure abundance. The Napo is the cultural and economic cradle for the Naporunas, whose name means 'people of the Napo' in Kichwa.

On the banks of the Napo River's smaller tributaries lie Kichwa houses and communities. The garden or small farm is very important, not only from an economic but also from a cultural and social point of view.

Many parts of Kichwa life, such as tending the crops, are done according to customs which are part of their worldview (opposite page).

Kichwa have expanded and grown stronger, despite attempts to undermine their culture.

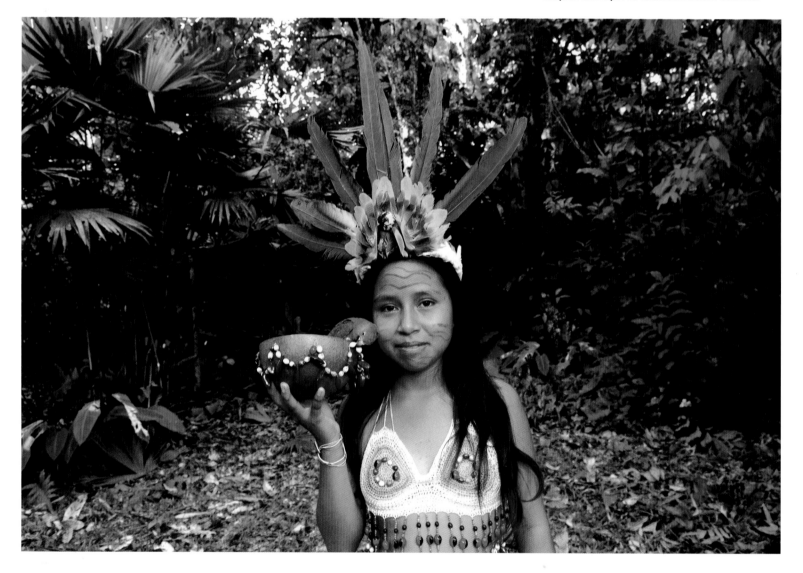

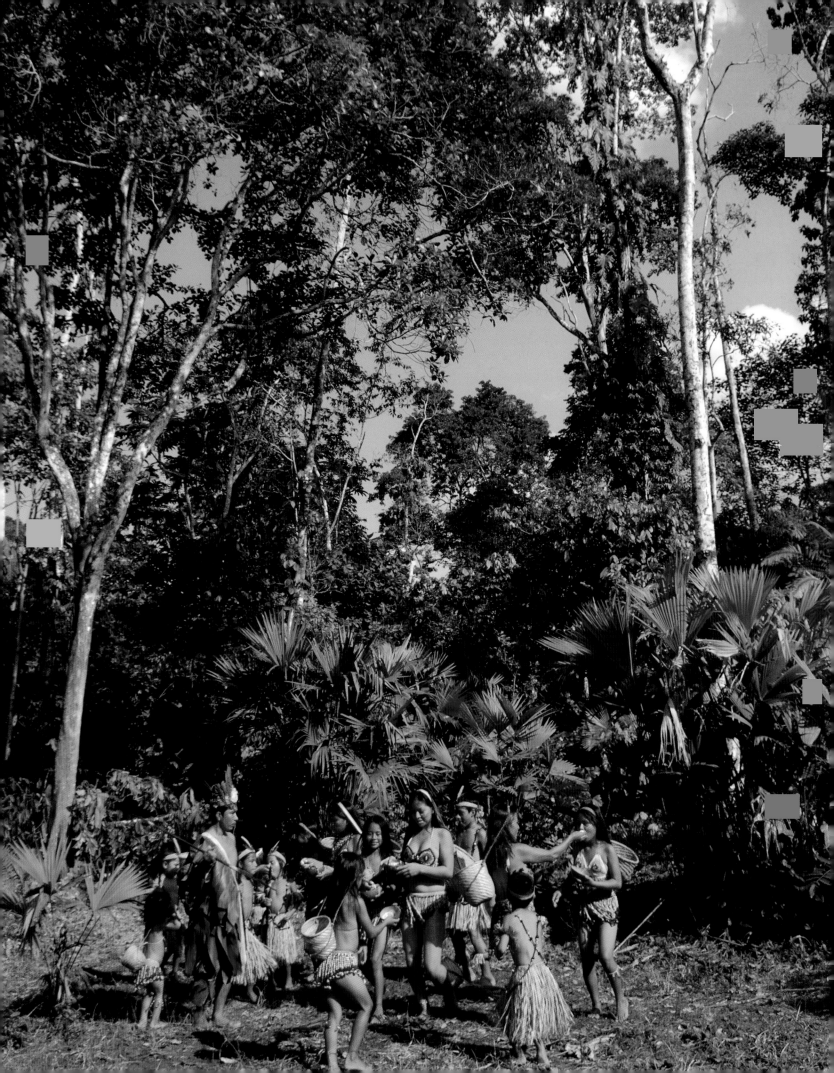

Before constructing a house, the people must prepare the land for cultivation. The first thing to be planted is the yucca/manioc (cassava) plant, providing the carbohydrate which is the staple of their diet. After this come bananas, corn, coffee, naranjila (naranjila de Quito, little oranges), and palm hearts (also called swamp cabbage, a vegetable harvested from the inner core and growing bud of certain palms). Tending the crops is done according to customs which are part of the Kichwa worldview.

**Guatusa, rather like a big rabbit with short ears and no tail. Indigenous people like them as food and they often end up in the pot.**

**Amazonian Kichwa are also known as *Naporunas* which means 'people of the Napo River'. In the rivers is an abundance of fish, including the *paiche*, one of the largest freshwater fish in the world, apparently reaching lengths of 3 meters/9 feet and weights of up to 200 kilograms/440 pounds.**

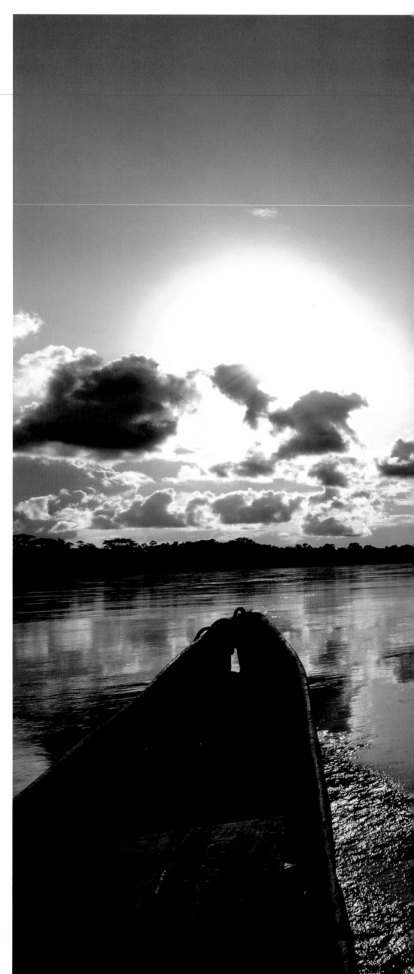

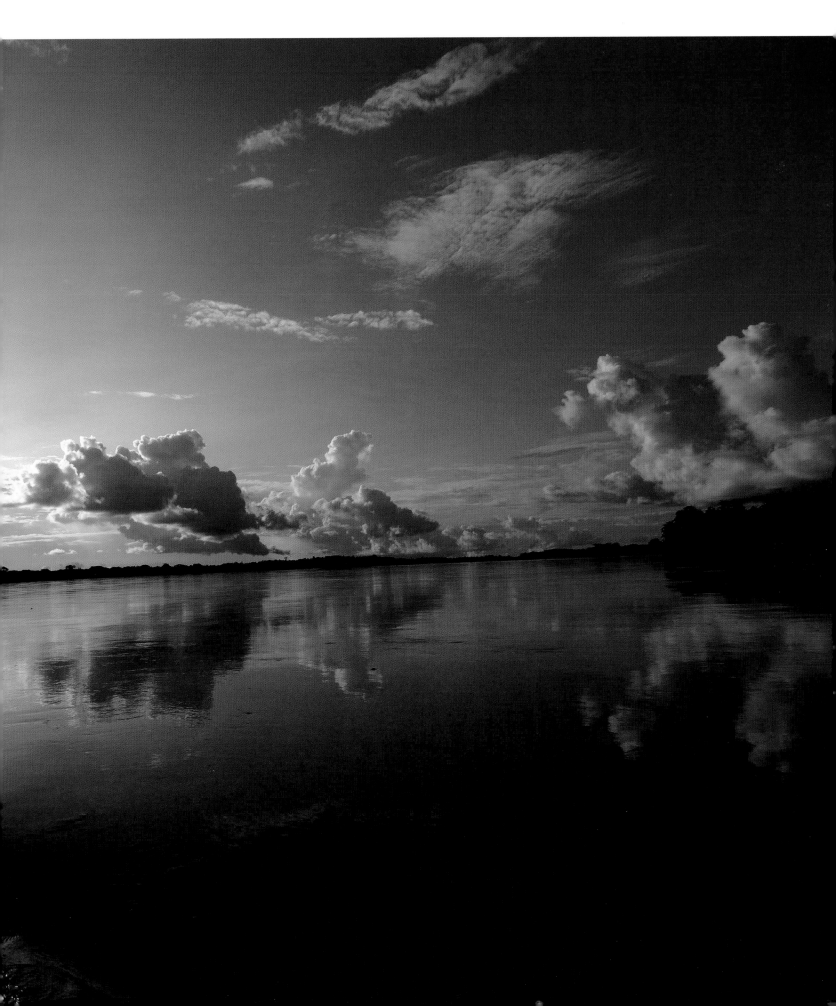

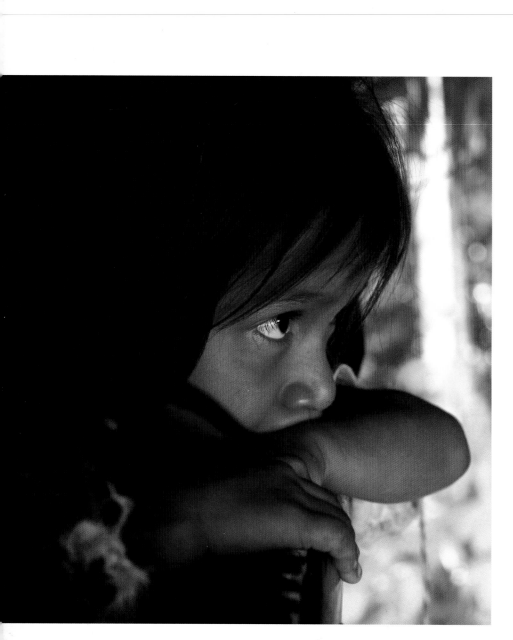

Kichwa girl.

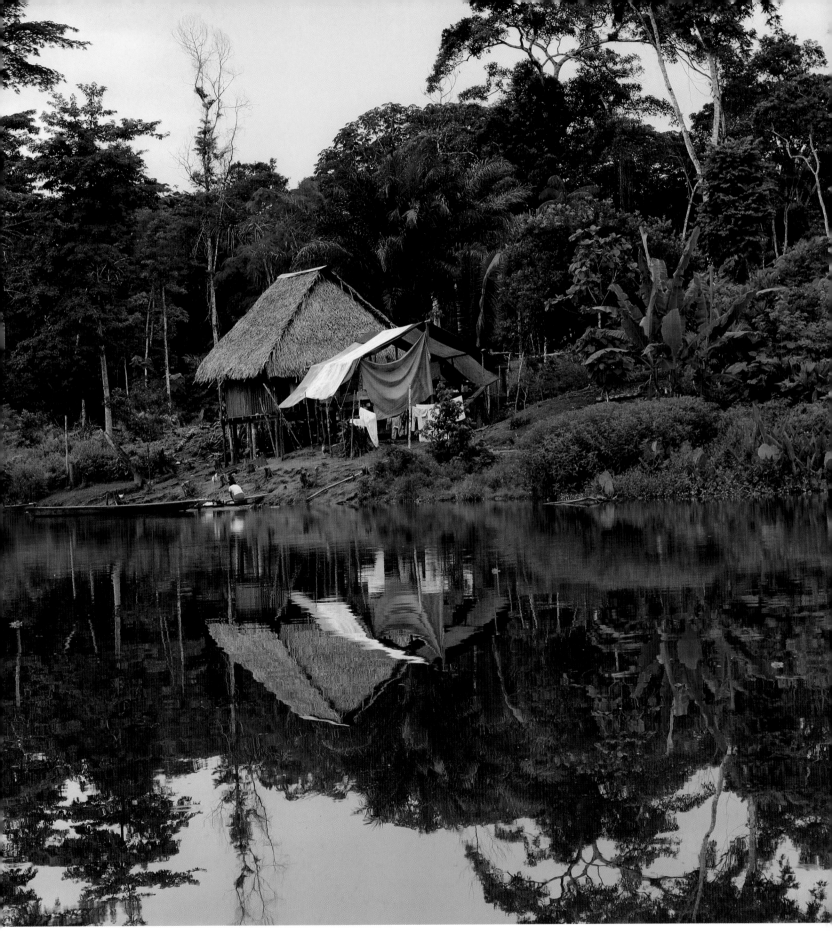

Kichwa settlement on the banks of a tributary of the River Napo.

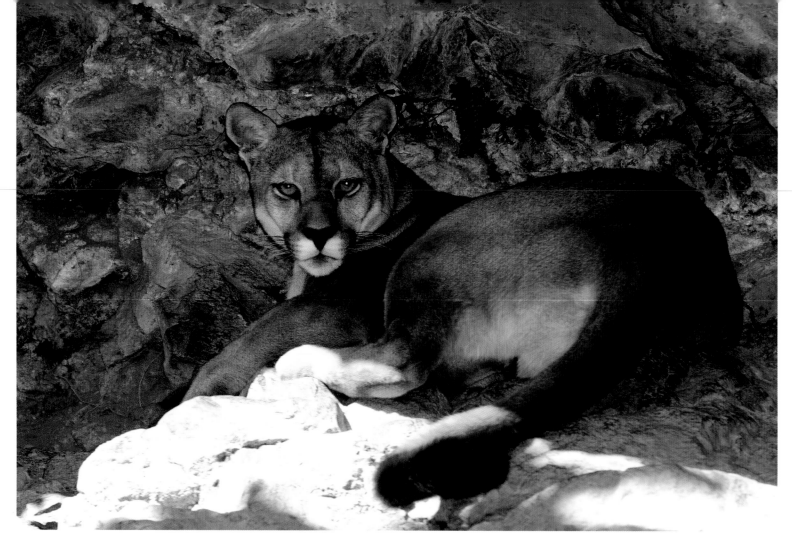

Kichwa clans were believed to be descended from a sacred animal, such as a jaguar or a puma (pictured here). Also known as a cougar or mountain lion, puma used to roam across North America and down to southern Argentina and Chile. They eat a range of animals from opossums to birds, and even snails and fish. To kill larger prey such as deer, they pounce on the animal and break its neck by biting at the base of the skull.

## Shuar

The exact origins of the Shuar culture are lost in time. The Shuar who today live in the Yasuní are not originally from the area and moved there in the late 1980s from the south of Ecuador. They are famous, or infamous, for tzantza, their former practice of shrinking human heads. Today they have abandoned the practice, but use the same technique on monkeys' heads for eager tourists.

In the Shuar tradition it is acceptable for a man to have several wives. Generally a man would marry his wife's sister/s or his brother's widow. The number of wives he could have depended on what his prospective parents-in-law saw as his qualities. They would consider these and make a judgment before allowing any marriage.

In times of conflict, one of the group would be named as leader, a position held only for the duration of the strife.

One of the Nantip Shuar community, part of the larger group trying to keep their customs alive.

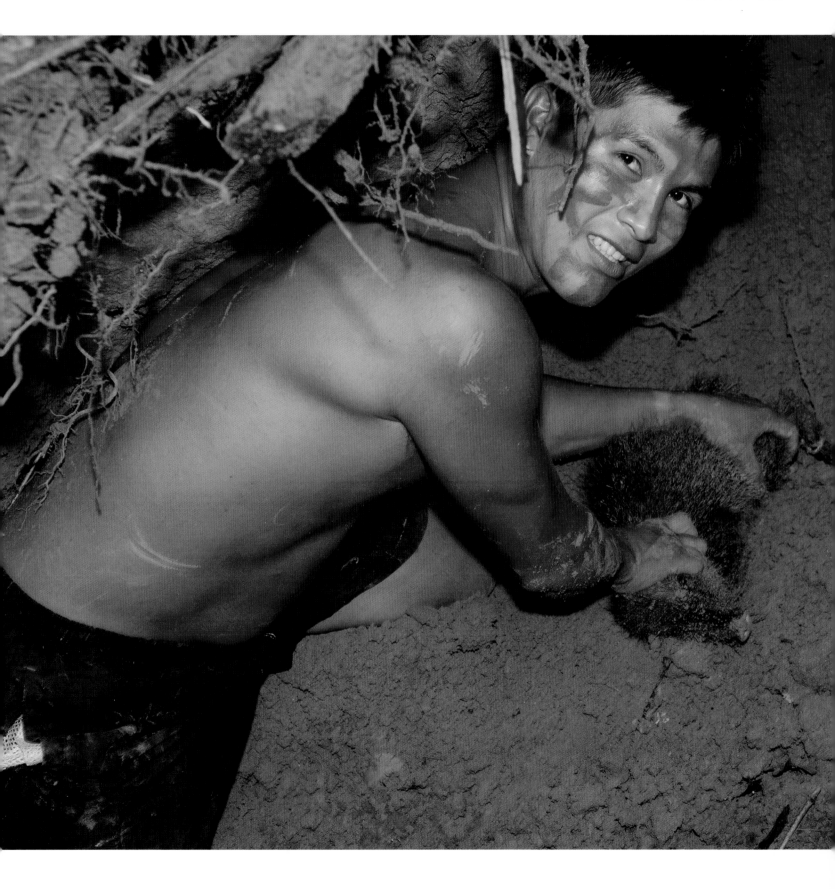

The particular characteristics, both of the impenetrable Amazon forest and the Shuar's warrior spirit, combined to keep outsiders out, and to ensure that the indigenous people were protected from contact with the world beyond. They had resisted domination by the Inca empire in 1490 and had expelled the Spanish from their lands in 1599.

In the last century, colonization of the region was hastened by two factors. First, the 1941 war between Peru and Ecuador led to military activity in that area, which opened it up. And there was also an expansion of rubber and oil production, meaning that more people from outside were coming into the heart of the Yasuní.

Shuar territory in Morona Santiago had been invaded by mestizo colonists in search of farming land and grazing for their cattle. This pushed the Shuar out, and they searched for new territories. By the end of the 1950s they found themselves being integrated into non-indigenous society and expected to abide by its norms and customs.

Traditionally the men had earned their status through their hunting abilities, warrior bravery and valor. Such

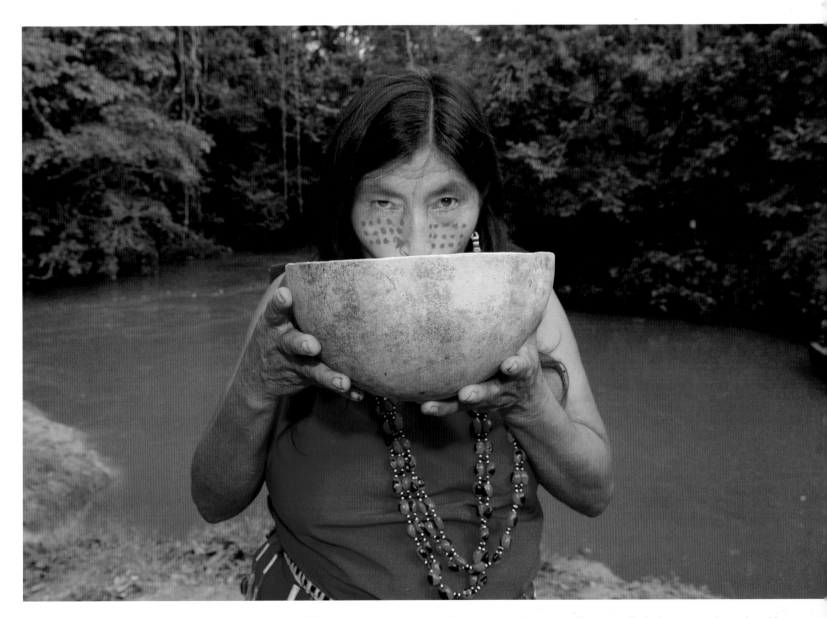

People from the Nantip Shuar community. Their warrior spirit contrived to keep outsiders away and preserve their way of life (opposite page).

Shuar men may take more than one wife, but a man must convince his potential parents-in-law that he is worthy of their daughter.

men would be known as kakáram meaning 'powerful'. Increasing prestige and political influence within the group elevates a man's status to uunt meaning 'great elder', and establishes around him a zone of influence based on parentage and affiliation groups. The wea are the elders, masters of ceremonies, considered knowledgeable and respected as the living guardians of the culture.

Nantip is a Shuar community established 15 years ago in Orellana province. It maintains certain traditions such as how the group is structured, the way they build their houses, what they eat and their medicines and treatments. They also maintain musical, dance and religious customs. This community, along with several others, is part of the River Tiputini Shuar Association which is attempting to keep alive and promote cultural patterns and crafts to strengthen the identity of the group.

**Nantip is a Shuar community which maintains cultural and social traditions (above and opposite page).**

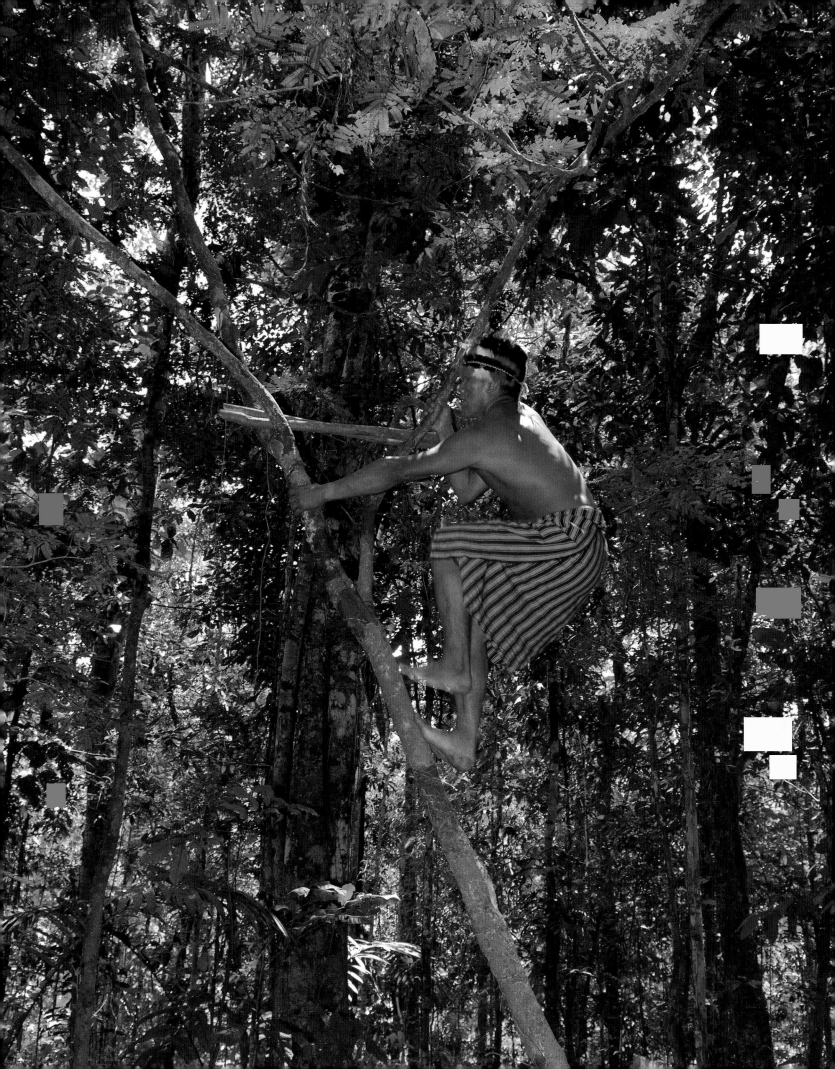

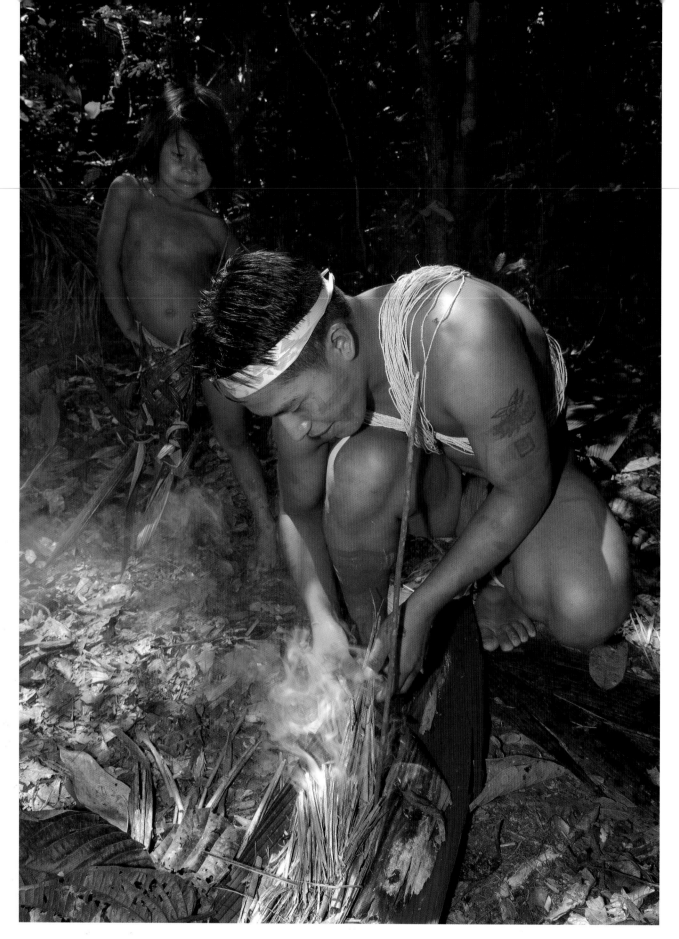

Fire is central to all indigenous peoples' lives. It provides light and heat both to keep humans warm and to cook food with, and it also deters insects and animals from the house.

From a young age Waorani children learn how to survive in the forest. By the age of 11, a child can manage on its own (opposite page).

## Waorani

Waorani have lived in the Yasuní for centuries. They were the most recent group in the region to have been peacefully contacted. This happened in 1958 between an indigenous woman called Dayuma and Rachel Saint, an American missionary. Dayuma's family were rivals of the warrior Moipa, the leader of a Waorani community and in one fight, Dayuma's father was killed. She decided to flee from her community believing she would have more opportunities in life if she left. She met the missionary, and Saint took advantage of their relationship to understand more about her culture, learn her language and (of course) to convert her to Christianity.

Later, in 1958, two women from Dayuma's clan came to tell her that her mother was still alive. Dayuma left with the women, but soon returned to the village where Saint was living and invited Rachel, her colleague Elisabeth Elliot and her three-year-old daughter, Valerie, to come and live with them. In this way, the first peaceful contact with the Waorani people began. Dayuma still lives in Toñampari.

Today, it is thought there are around 2,300 Waorani, living mainly on their ancestral lands located between the Curaray and Napo rivers. There are three known, and possibly as many as five communities who are 'unknown', that is, they have rejected contact with the outside world. There are the Tagaeri and two groups

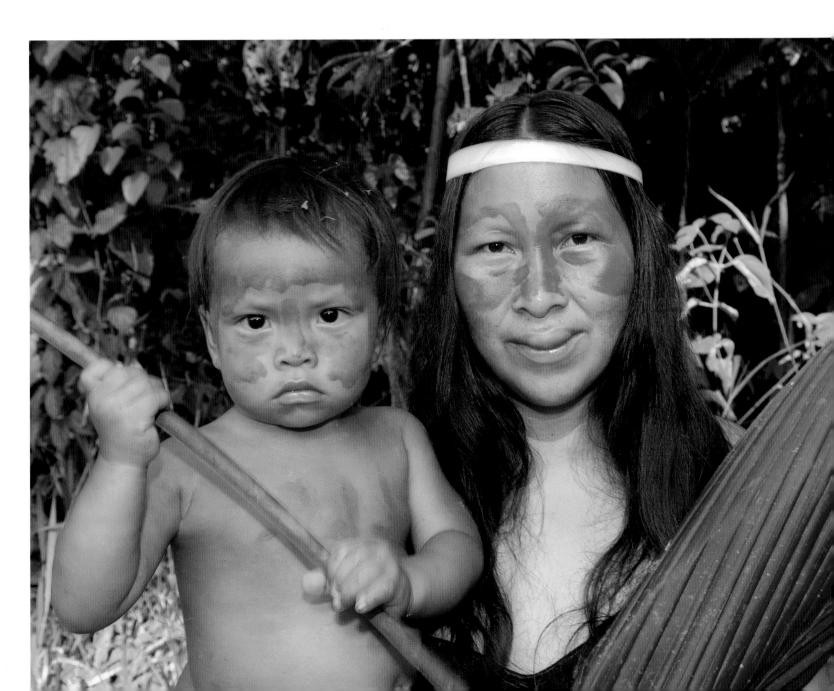

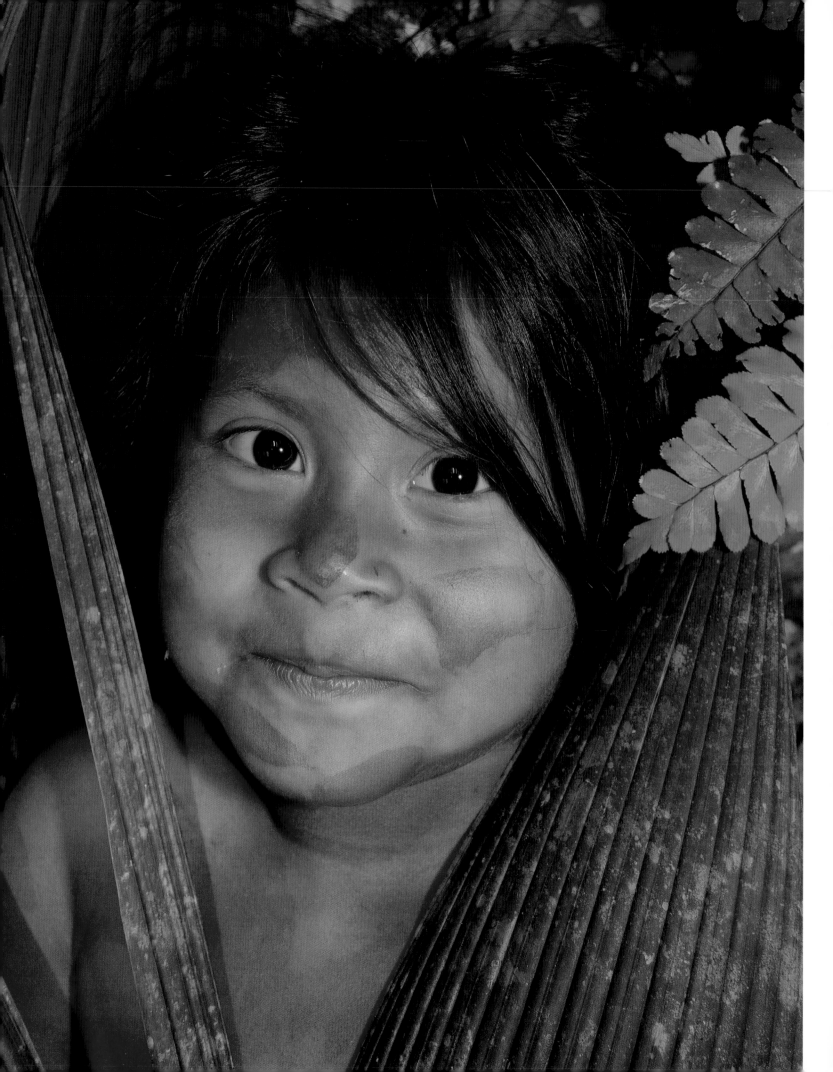

of Taromenane; also the Huinatare and Oñanenane communities, all living in the heart of the Yasuní Park.

Waorani, semi-nomadic hunters and foragers, need a large territory in order to maintain their traditional way of life. Their lands used to extend over about 2,000,000 hectares, but nowadays they have only 612,560 hectares, and even then these boundaries are not respected.

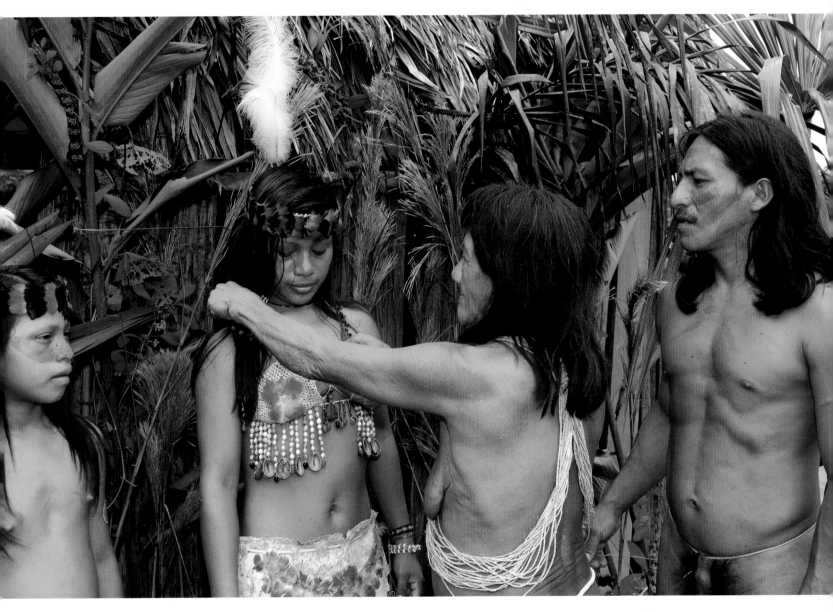

**Kananka, aged 5, may not yet be fully aware of the threats to the forest (opposite page).**

**The new beauty queen of the Waorani people is crowned in a festival in Orellana province. This new festivity has arisen out of the mestizo oil frontier culture.**

Waorani culture, as others, is largely oral: music and stories are most important. The stories are handed down by the older members of the group (opposite).

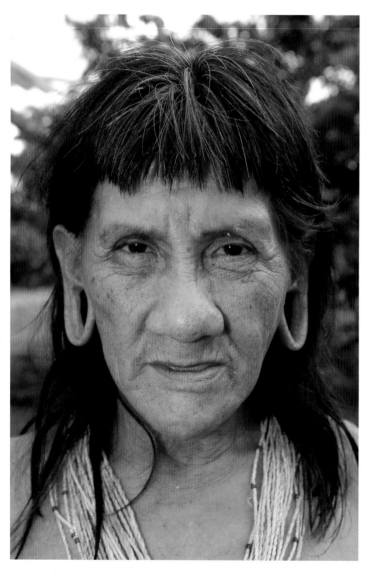

Tepaa, from the Bameno community, is 65 years old, with 12 children and 50 grandchildren.

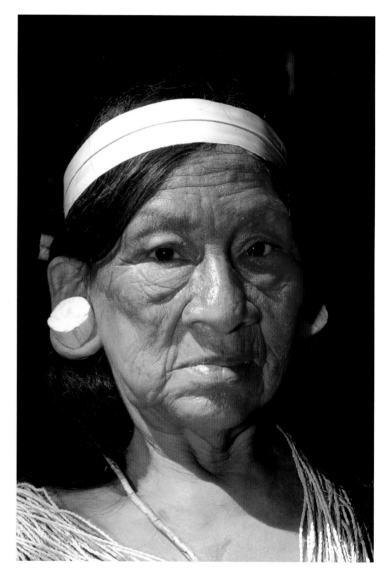

Waorani pierce their ear lobes when young and stretch them by inserting rolled leaves and pieces of wood, before using ornamental ear plugs, *ontaka* (above).

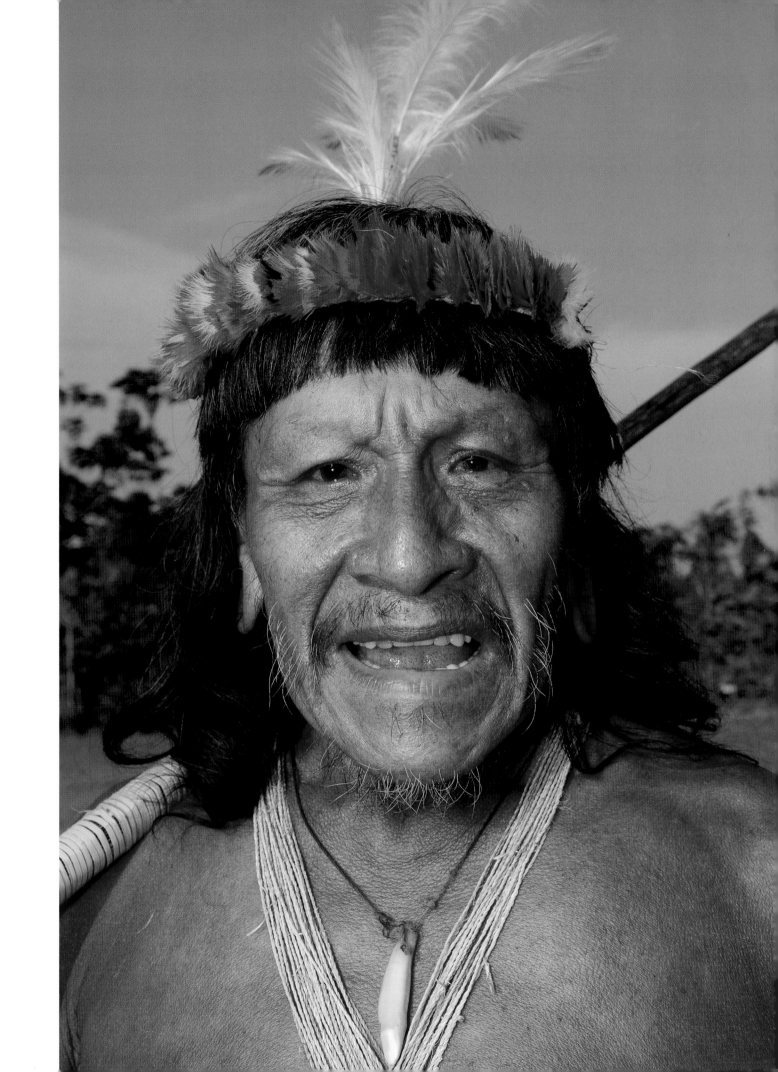

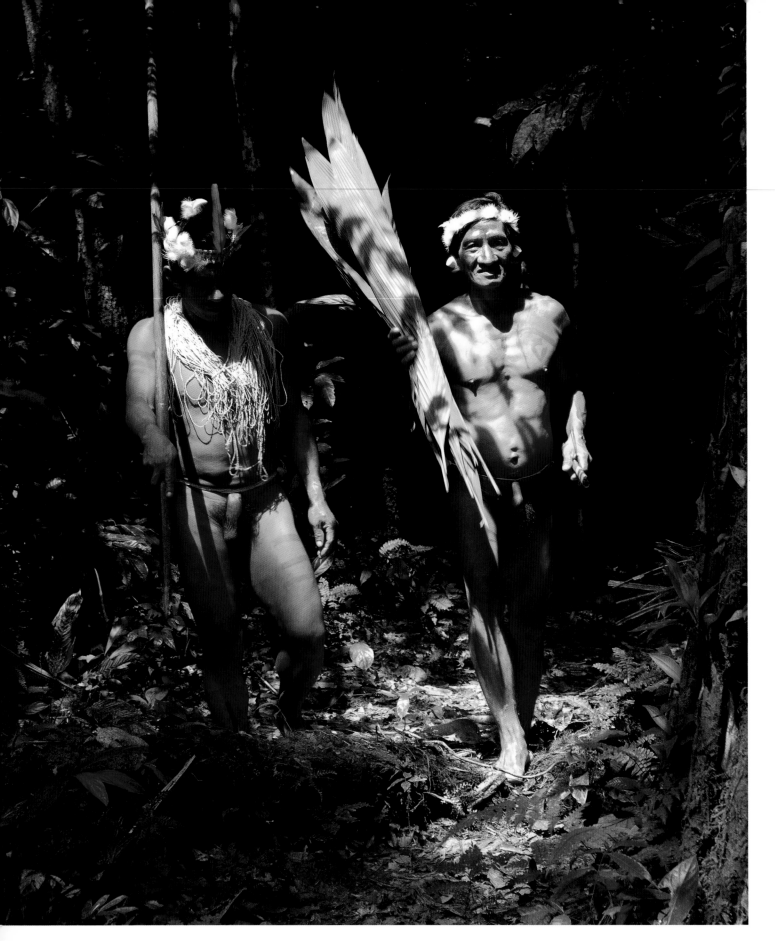

Plants, especially trees, are important for indigenous people. Botanical knowledge is deep: of useful materials to poisons, and medicines. Waorani do not use hallucinogens, unlike Shuar and Kichwa.

The rivers are a fundamental part of indigenous life in the region. To cross the smaller ones people fashion bridges often made of tree trunks; for longer crossings more building is required. Sometimes nowadays people use canoes to get across the larger rivers.

Hunting supplies a major part of Waorani diet and also has cultural significance. To prepare monkeys for eating, they scorch the skin to remove it and then boil the meat for hours in a pot with nothing else, not even salt. They eat while sharing stories of the day's hunt.

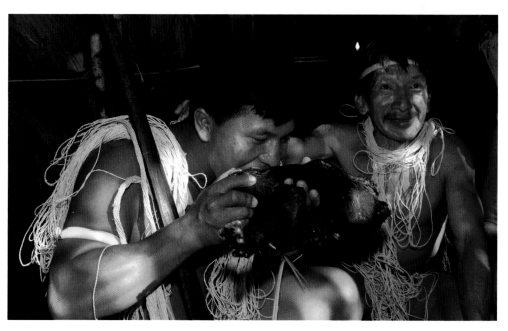

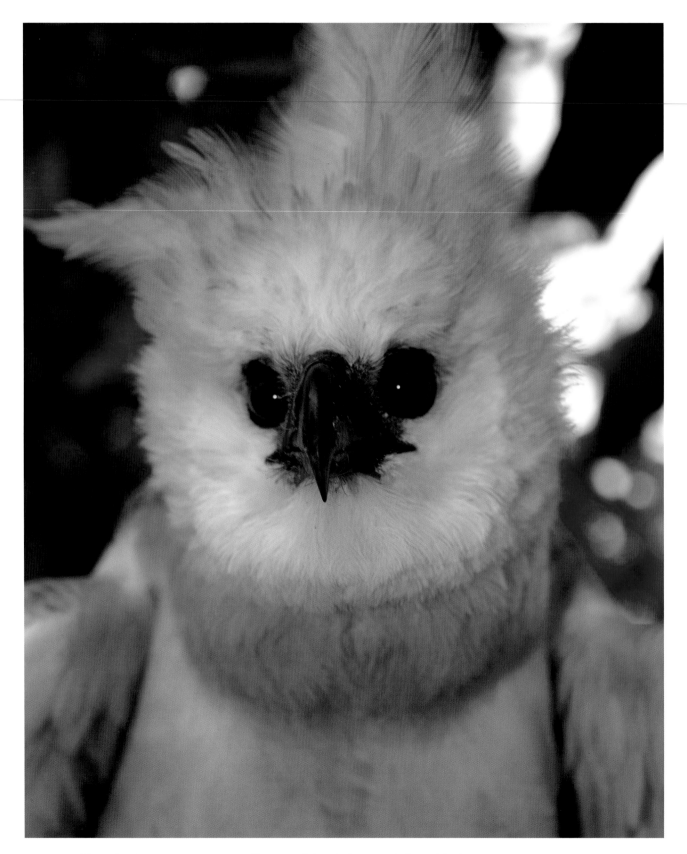

Waorani and the harpy eagle: according to tradition the harpy eagle is a spirit that brings protection to the family and strength to the warrior. The crowns and bracelets of war are generally adorned with an eagle feather.

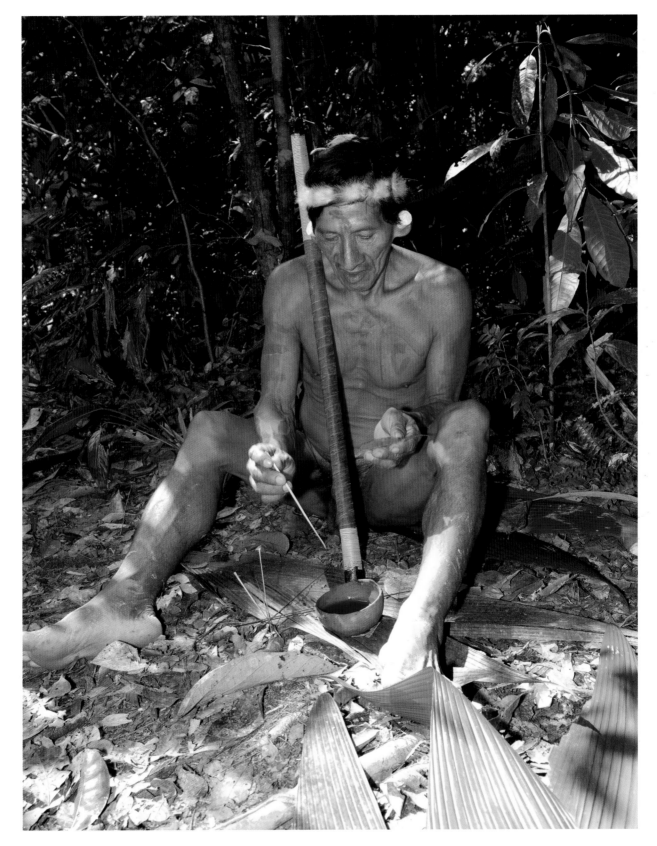

Although hunting is an important activity, killing animals has a spiritual dimension for all Amazonian indigenous people.
The dead animals' spirits live on and must be placated or else they might do harm in retribution. To mitigate the offense
of hunting, a Waorani shaman shows respect through a ritual preparation of the poison, curare, used on darts.

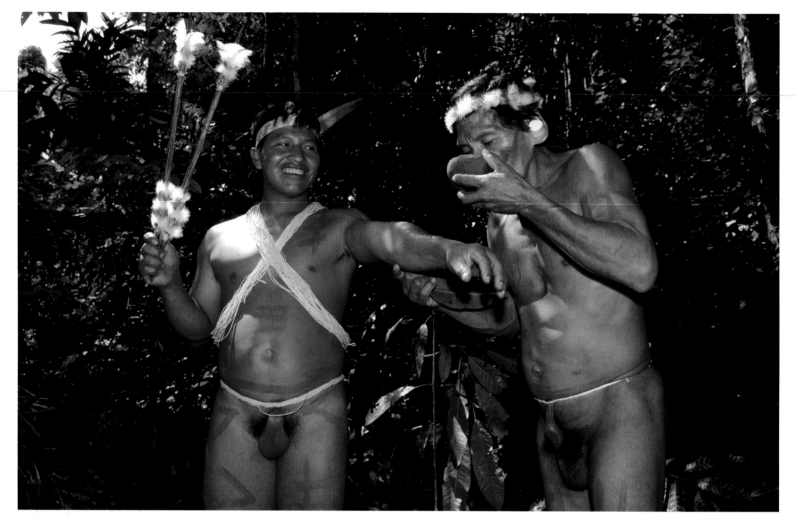

When catching prey a hunter acknowledges
his debt to nature.

Red Brocket Deer. These are not eaten by Waorani,
as they consider the deer's eyes to be too similar to
those of humans. In the past Waorani traditionally
killed only birds and monkeys, and occasionally,
peccaries.

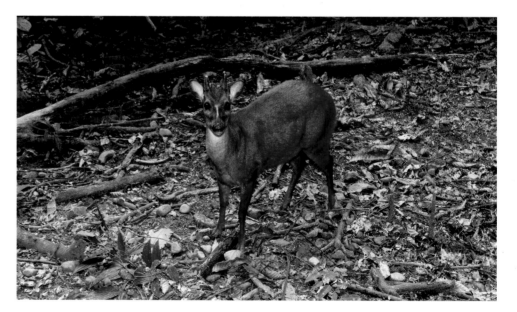

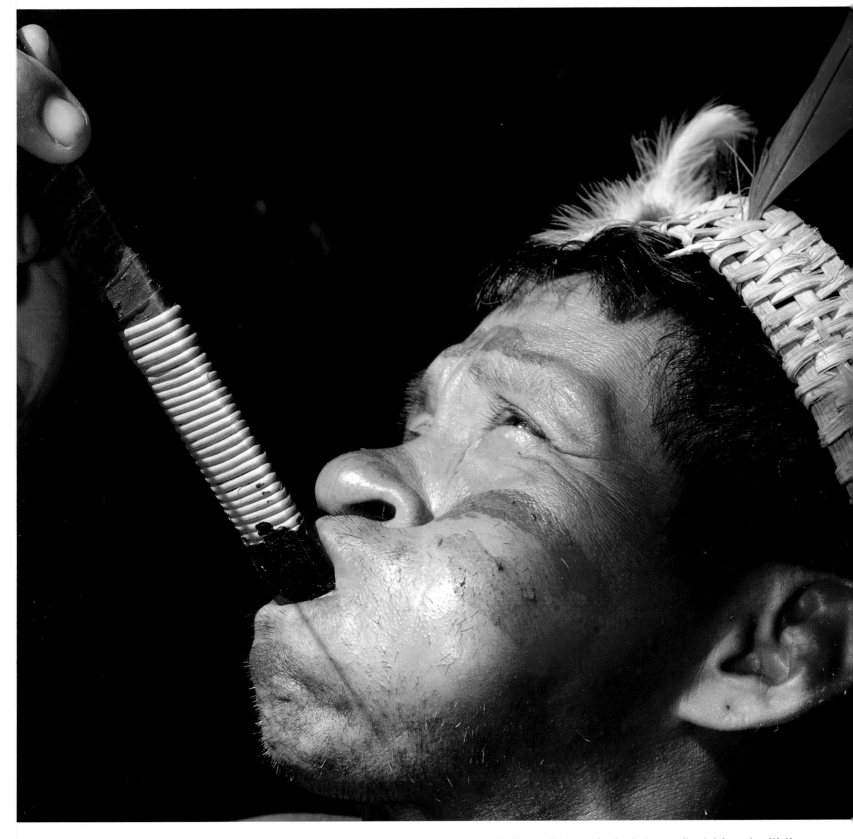

When the blowpipe is shot by the hunter, he and it are hidden in the trees. On the dart, a small notch is made with the tooth of a piranha fish so that when the dart hits its target, the poisoned part breaks off and stays inside the animal.

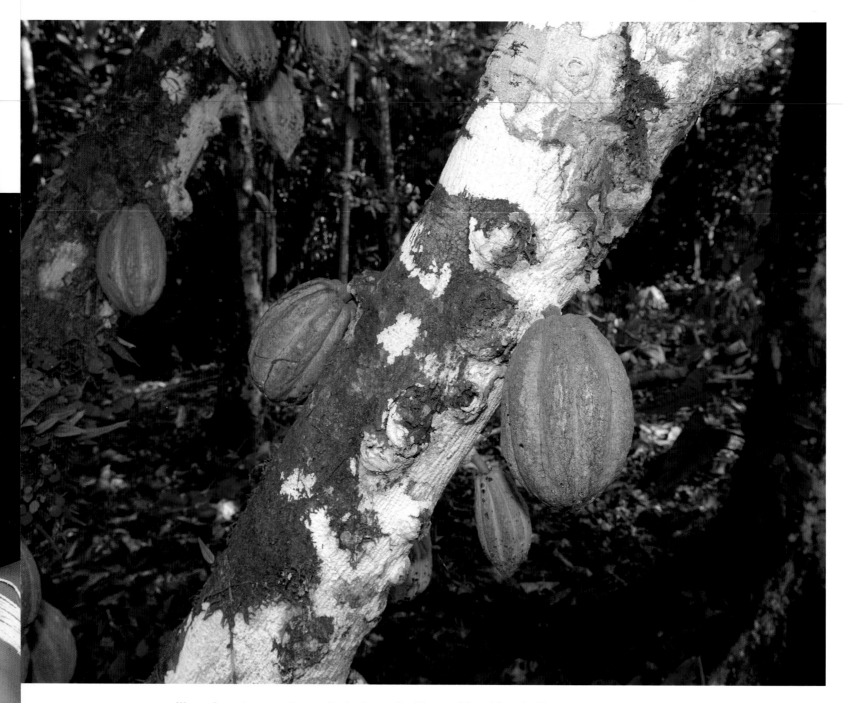

Waorani people are semi-nomadic, hunters and gatherers of forest bounty. From
January to March the forest is full of fruit and edible plants, for humans and animals.

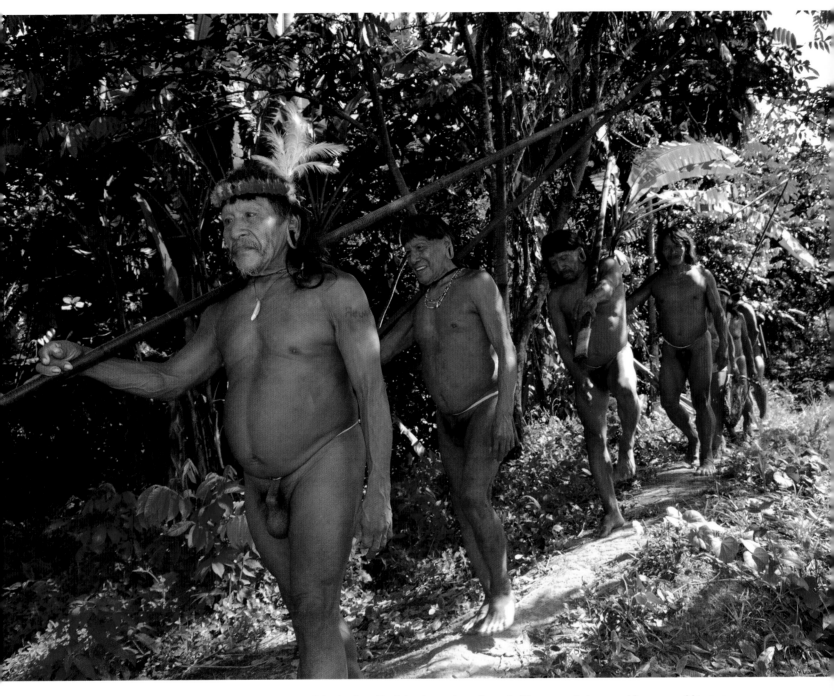

Hunting begins early, before dawn has fully broken. Each hunter and warrior puts his personal stamp on his spear or blowgun.

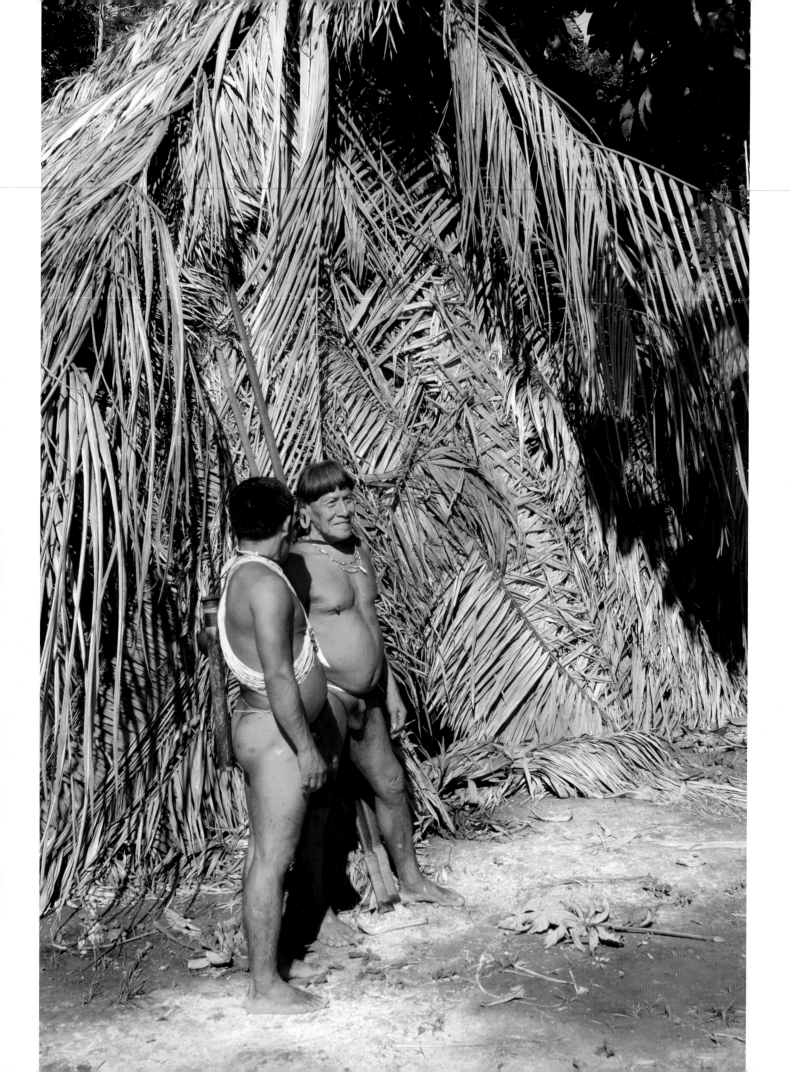

The *onco* is the traditional home of the Waorani. It houses between 30-40 people, members of the same extended family, and is constructed with palm leaves and other materials gathered nearby (opposite page).

The blowpipe or *umena*, made from chonta palm wood, is used only to hunt monkeys or birds; darts are dipped in curare poison. These weapons are typically from 9 to 12 feet long, and the poison quickly paralyzes the darted animal. Hunting in this way is not really seen as killing but more as another kind of harvesting from the trees.

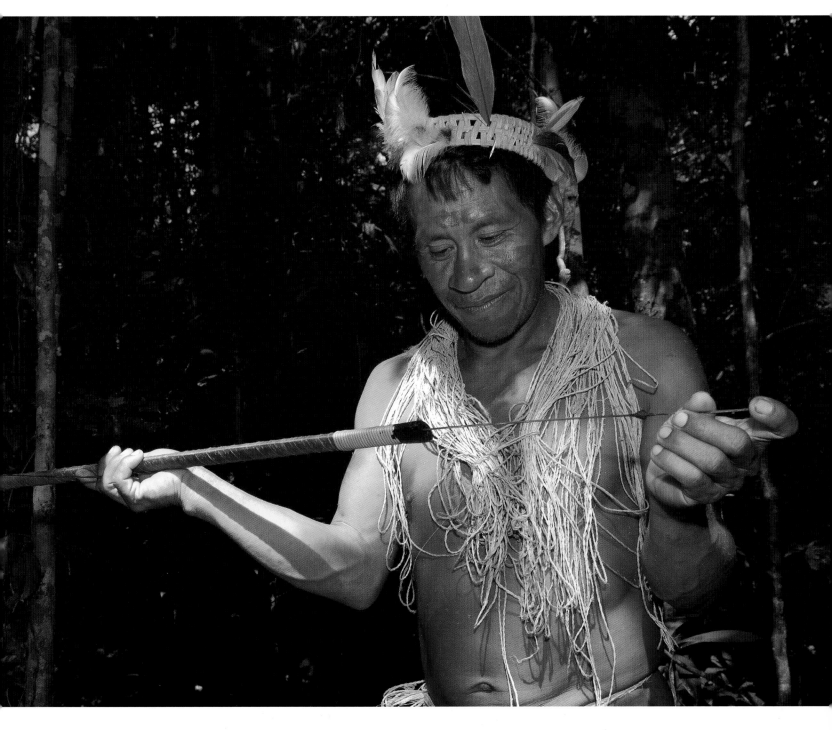

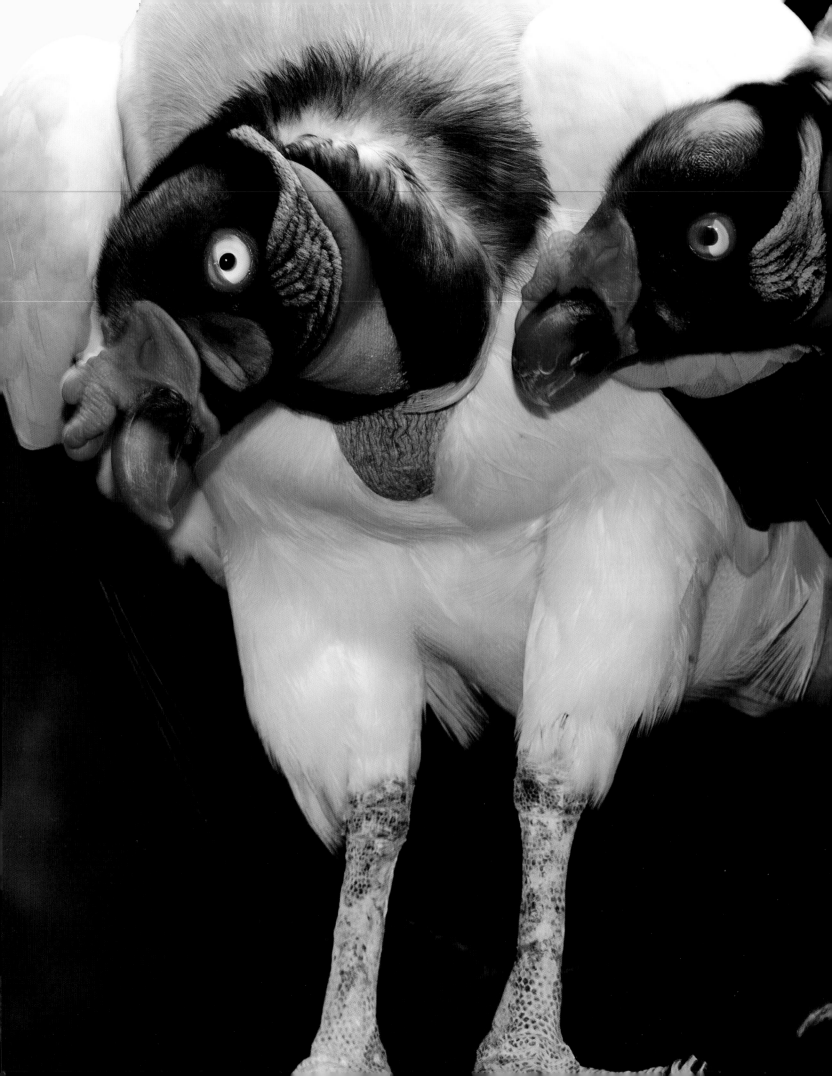

# Chapter 2
# Forest bounty

## The Yasuní National

Park is famous for its extraordinary and unique biodiversity. The World Wildlife Fund for Nature (WWF) has called it one of the world's most important protection areas. UNESCO has named it a human and bio-reserve while an international group of scientists has written a report which calls for its preservation. The Park contains a high number of the world's tree species and is home to 44 per cent of the Amazon Basin's birds, making it among the world's most rich avian sites. The statistics are similarly plentiful for the variety of bats, amphibians, reptiles, bees and other creatures.

The king vulture is the only surviving member of the genus sarcoramphus. Usually just one chick is hatched and it remains black for about three years before its plumage becomes white. In order to conserve energy whilst searching the forests for dead animals, these large birds glide on air currents. In its role of 'cleaning-up' animal carcasses, they fill a particular ecological niche and may help to prevent the spread of disease.

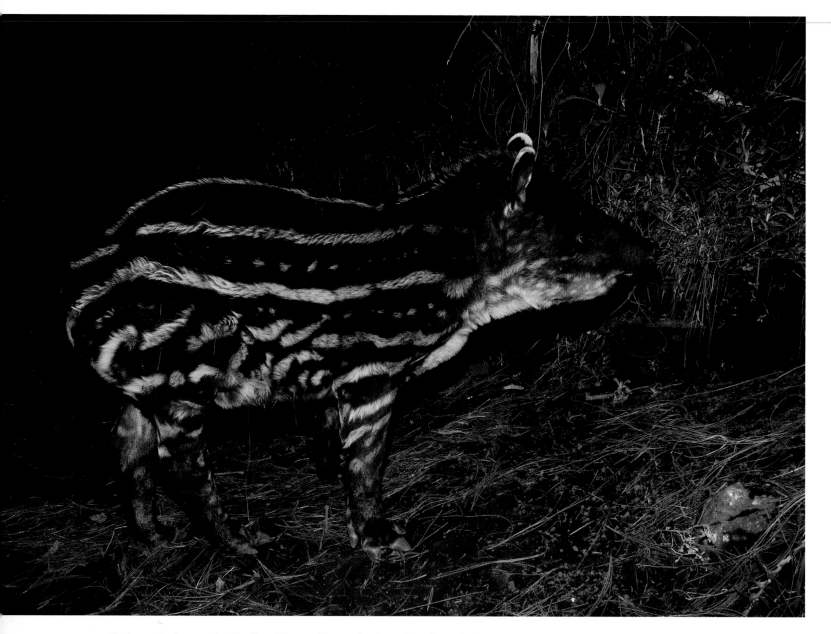

Tapirs are in danger of extinction. These solitary animals are from the only living strand of the *tapiridae* family; their closest living relatives are horses and rhinoceroses. Baby tapirs have striped and spotted coats for camouflage. They are water-loving and like to swim before sinking to the river bed where they feed on the soft vegetation. They can remain submerged for up to three minutes.

Colorful macaws are a highlight of the Park – flashes of bright color amid the greenery (opposite page).

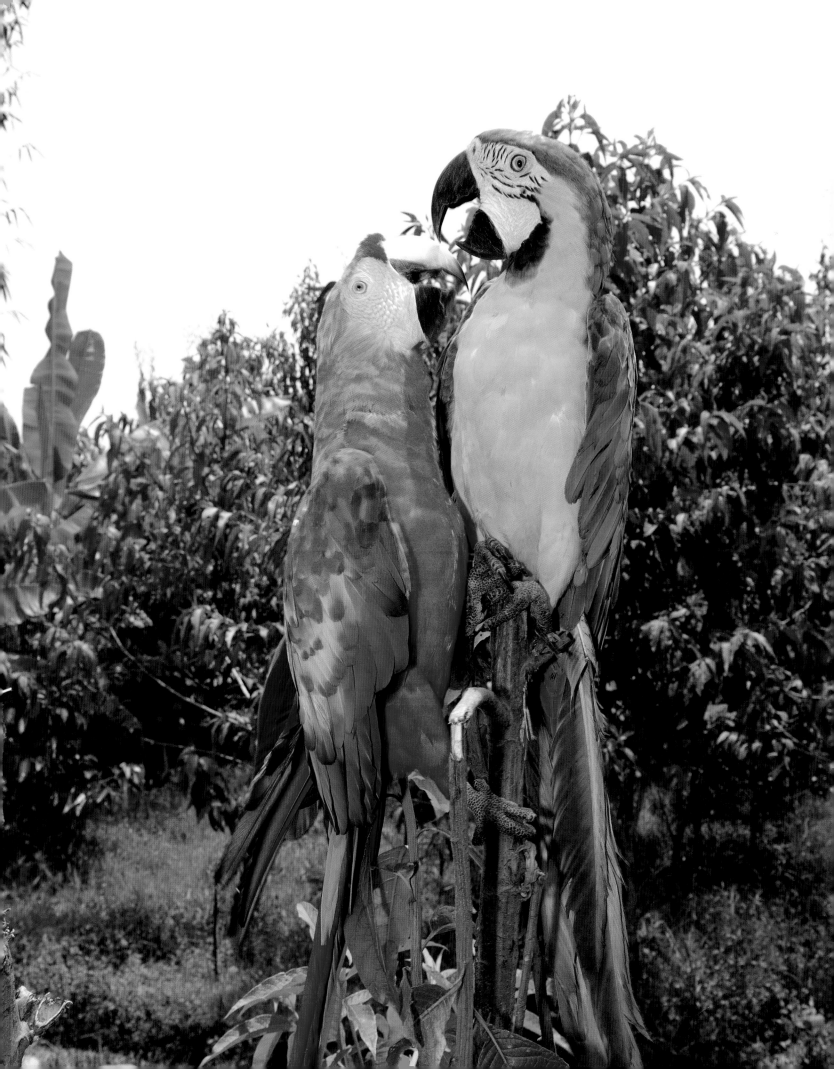

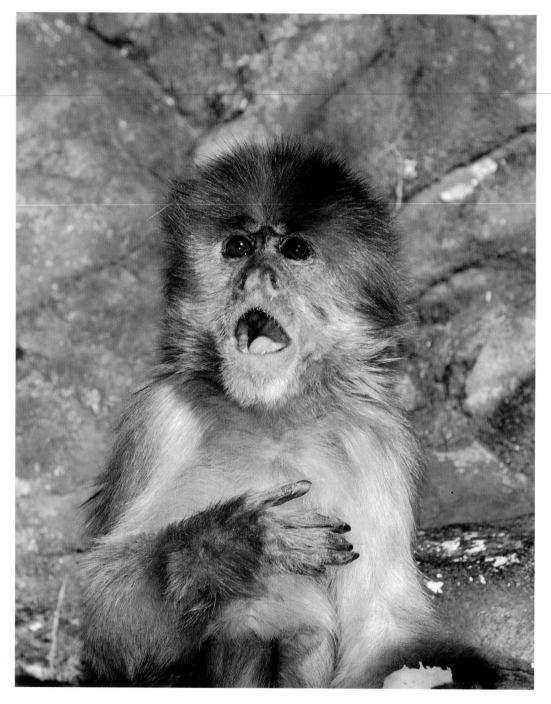

White capuchin monkey. These are the most common monkeys because they are adaptable. They are popular pets. Despite being trafficked for the pet trade, they are still widespread. However like most of the animals described here they are vulnerable as their habitat is destroyed by deforestation.

Green parrot snake, a non-venomous python often found on the ground and in small trees or shrubs, usually near water. It mostly eats amphibians, reptiles, and birds.

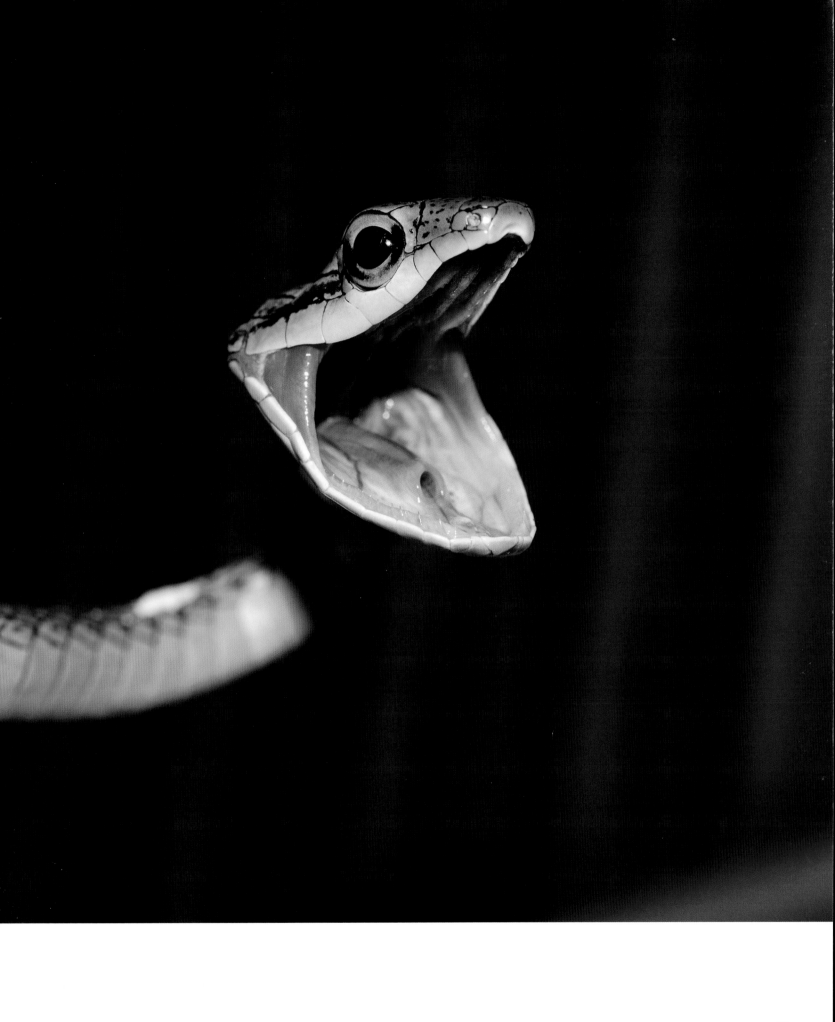

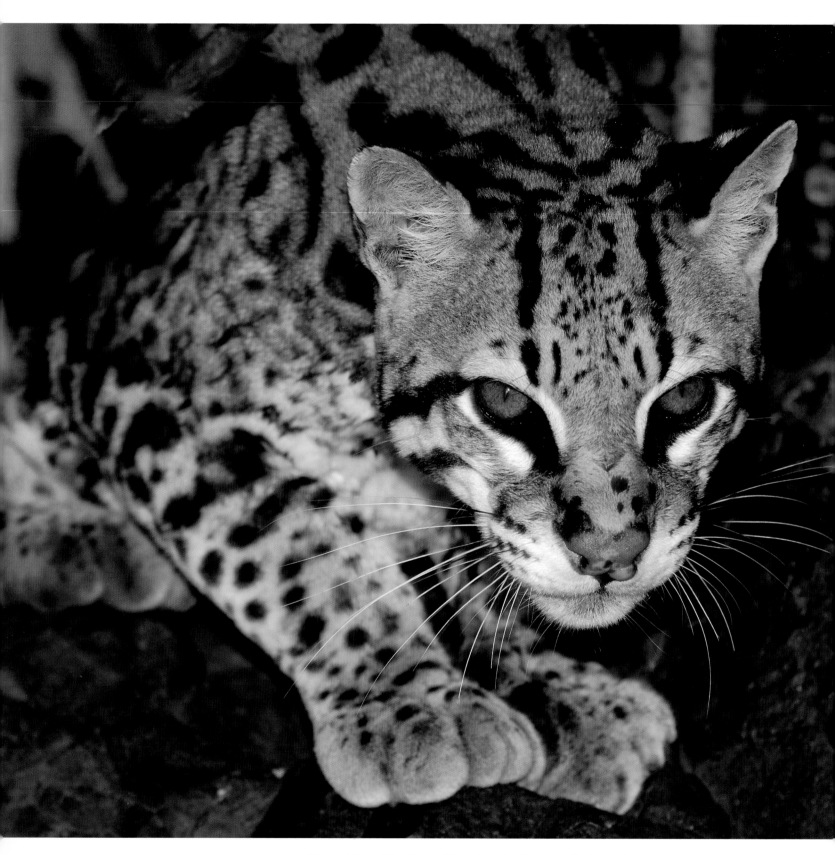

The ocelot or wild cat is mostly nocturnal and very territorial, eating small animals such as monkeys or birds. Because of its beautiful fur, it was widely hunted.

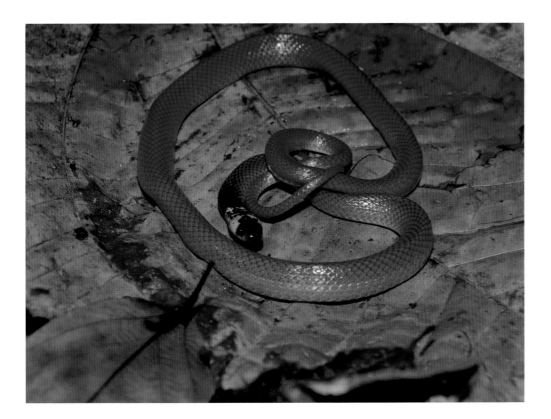

Mussurana snake: red when young, it becomes a grey-blue color when adult. It attacks and eats other snakes, being immune to their venom. One of its common prey is the smaller Central and South American pit-viper like the one below.

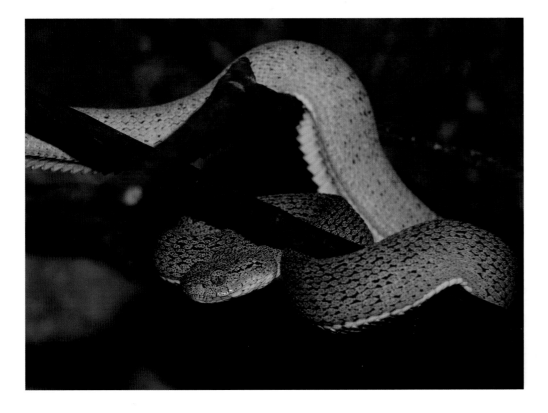

Two-striped forest pit-viper. This is a thick-bodied lowland rainforest snake often found near water, and it is very common in agricultural and urban areas. Because it lives in places that humans inhabit, their paths frequently cross and people get bitten.

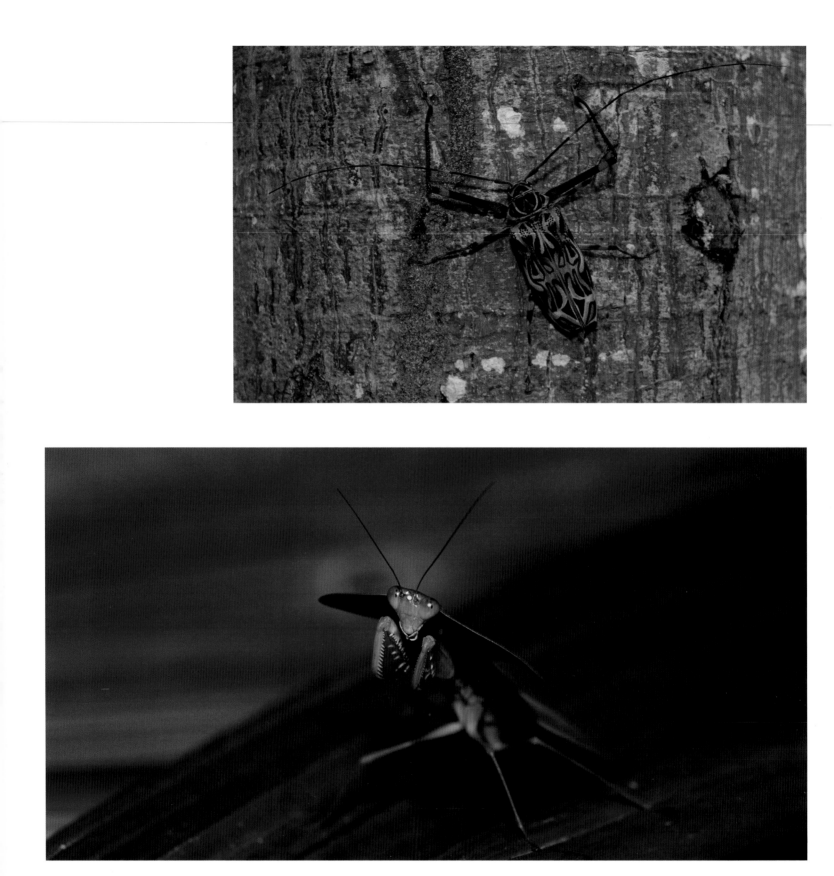

Mantis. The word mantis comes from the Greek for prophet or fortune-teller. They are known for their predatory hunting skills, eating mainly insects. However larger species can also hunt small lizards, frogs, birds, snakes and even rodents. The head is very flexible and in some species can turn through almost 280 degrees. Often called 'praying mantis' because of a common stance, as if they were praying.

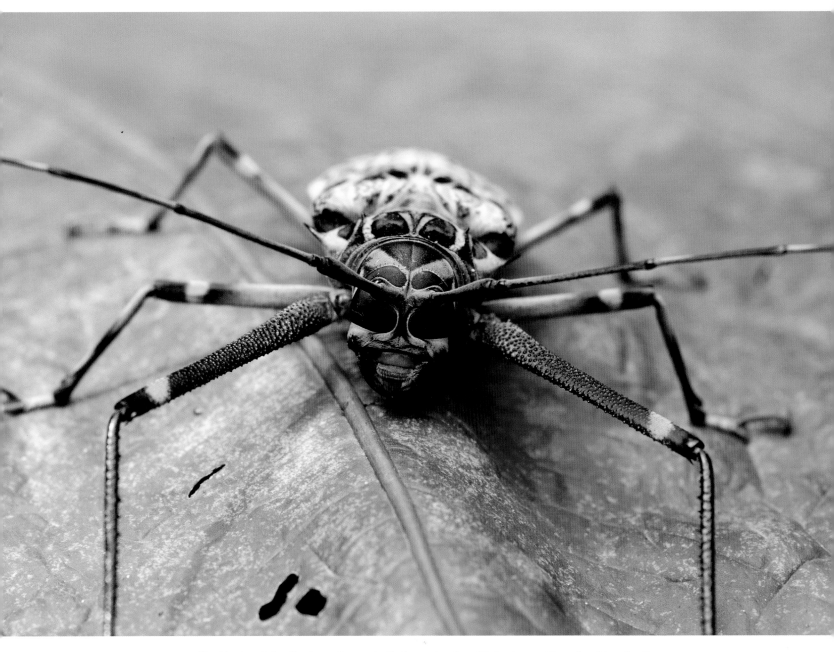

Giant harlequin beetle. Conspicuous by its large size, beautiful colors and long front legs (on the male), this is a longhorn beetle. The elongated limbs are used when mating and they also assist in climbing the tree trunks on which the beetles live (above and opposite, top left).

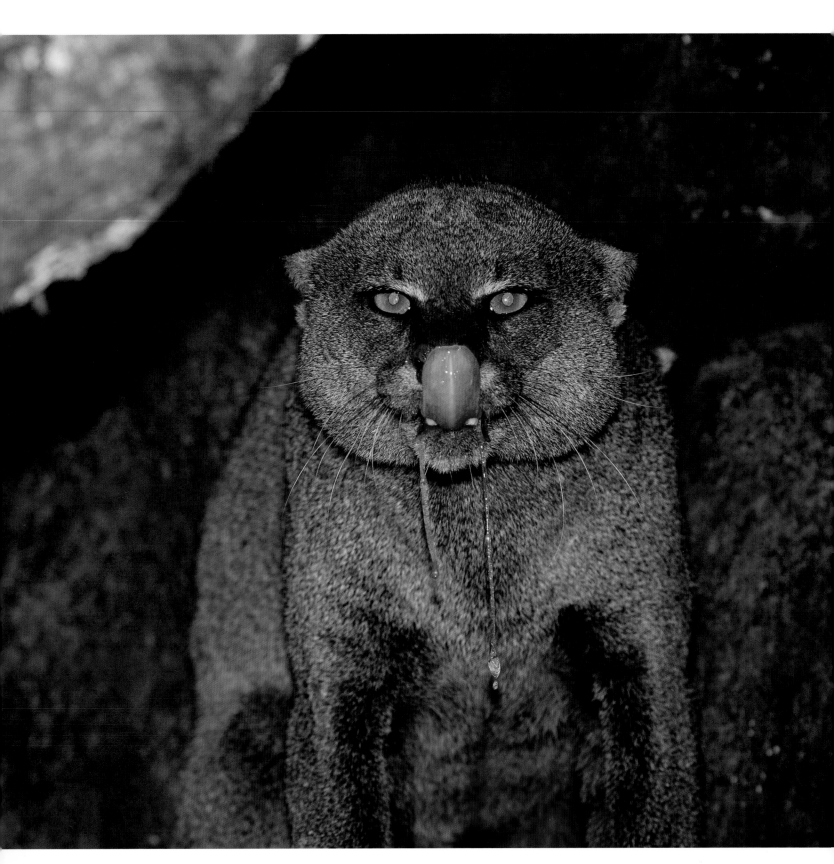

Weasel-cat/Jaguarondi. Like a small cat with a long tail, this animal is also known as an 'otter-cat'. It is one of the Park's animals whose numbers are in decline through loss of habitat. Their coats are plain, and may be black, grey, brown or reddish like a fox. Although they mostly hunt on the ground, catching mice and rats, they can climb trees easily and pounce on their prey.

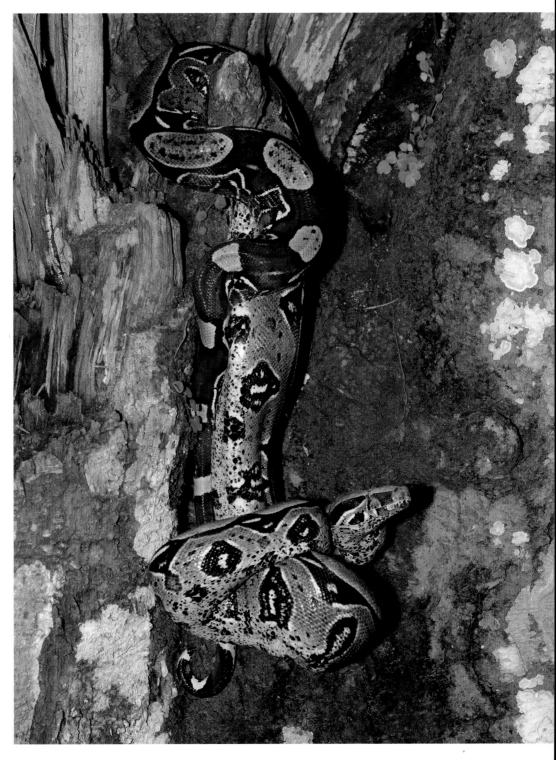

**Red-tailed boa constrictor. They suffocate prey by the pressure of their encircling coils. Once the prey is dead the snake can dislocate its jaws to accommodate the prey.**

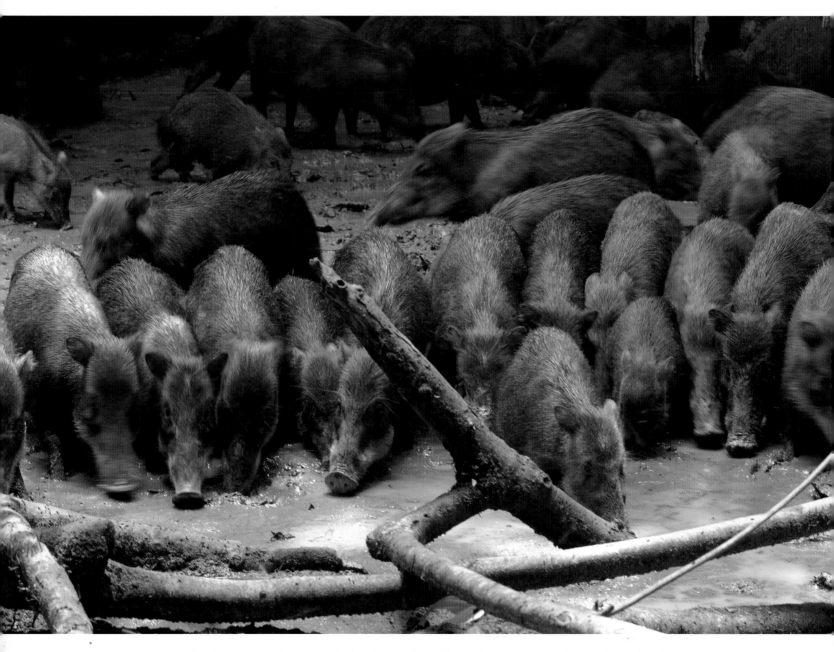

Peccaries: there are two types – white-lipped and collared. Collared peccaries have close social relationships;
they live in herds of about 10 animals and eat, sleep, and forage together. Territories are demarcated by
scent-marking on rocks, tree trunks, and stumps. Generally, peccaries are a fairly resilient and adaptable
species, but some subspecies are threatened by rainforest destruction.

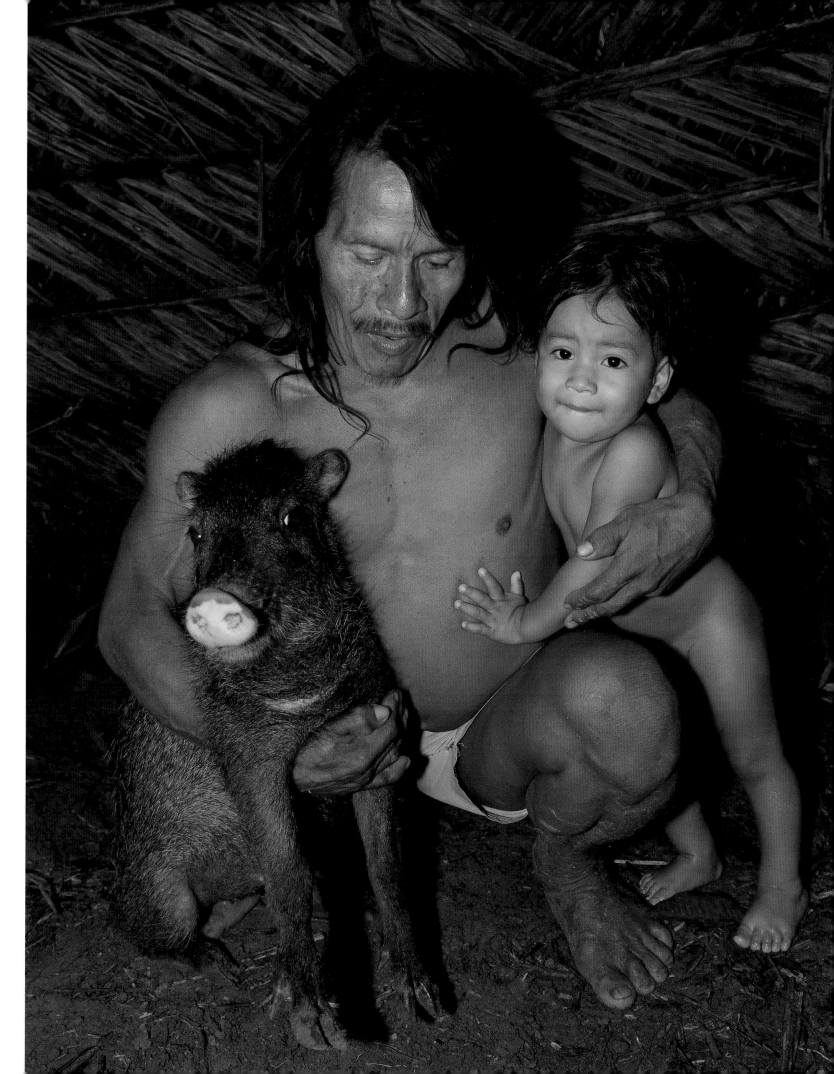

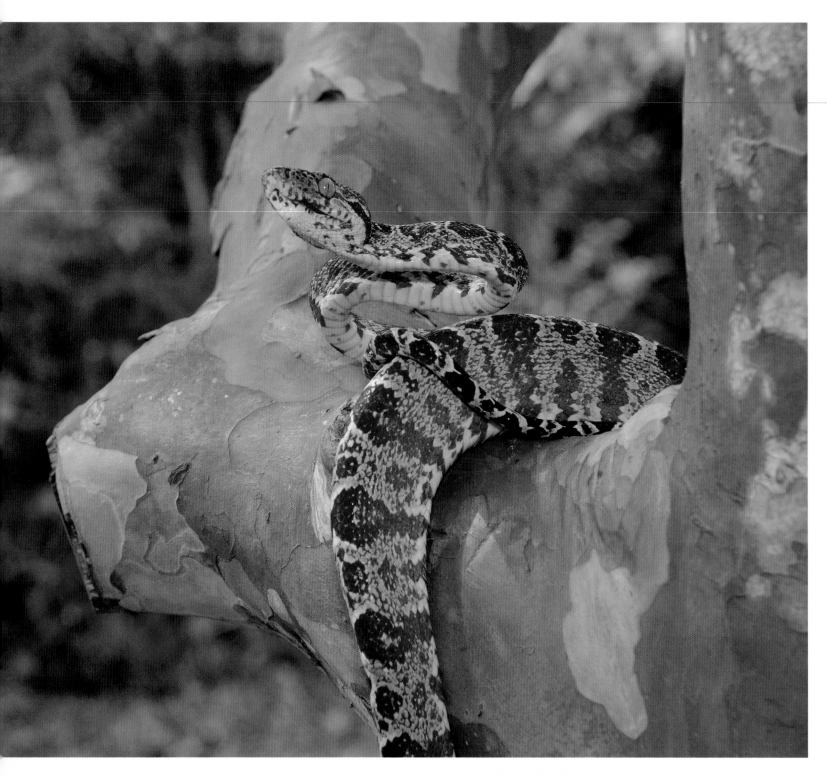

Amazon tree boa. Named as such because they dwell in the trees: eating, mating, giving birth. They drink the raindrops, dew and mist that gather on the leaves.

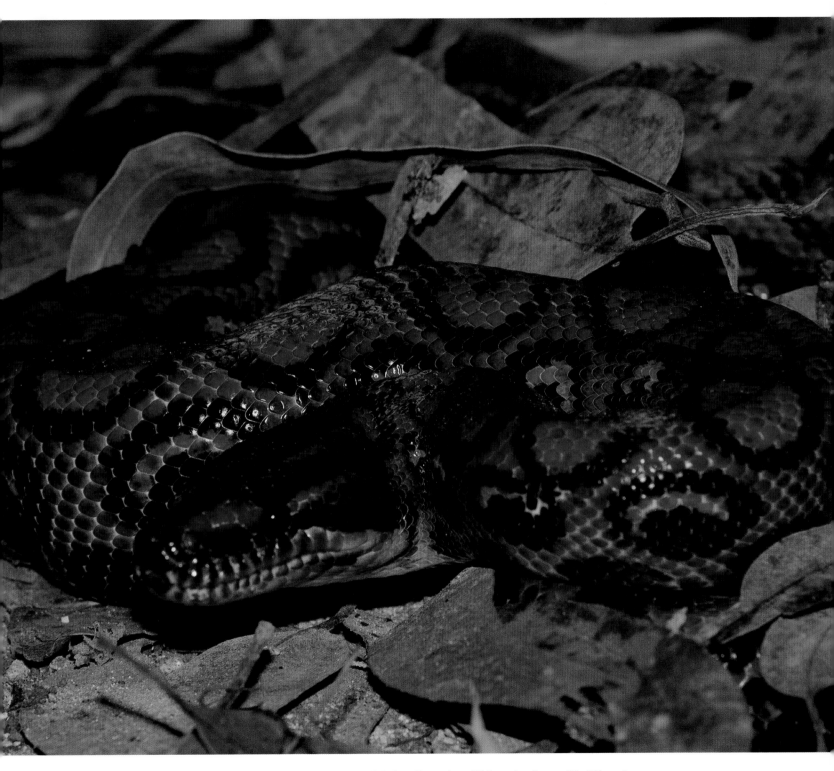

**Rainbow boa.** Under particular lighting, the scales of this snake gleam with different shades of blue, purple and green. Most boas eat rodents, lizards, iguanas and birds but sometimes also marmosets (monkeys) and coatis, a raccoon-like animal.

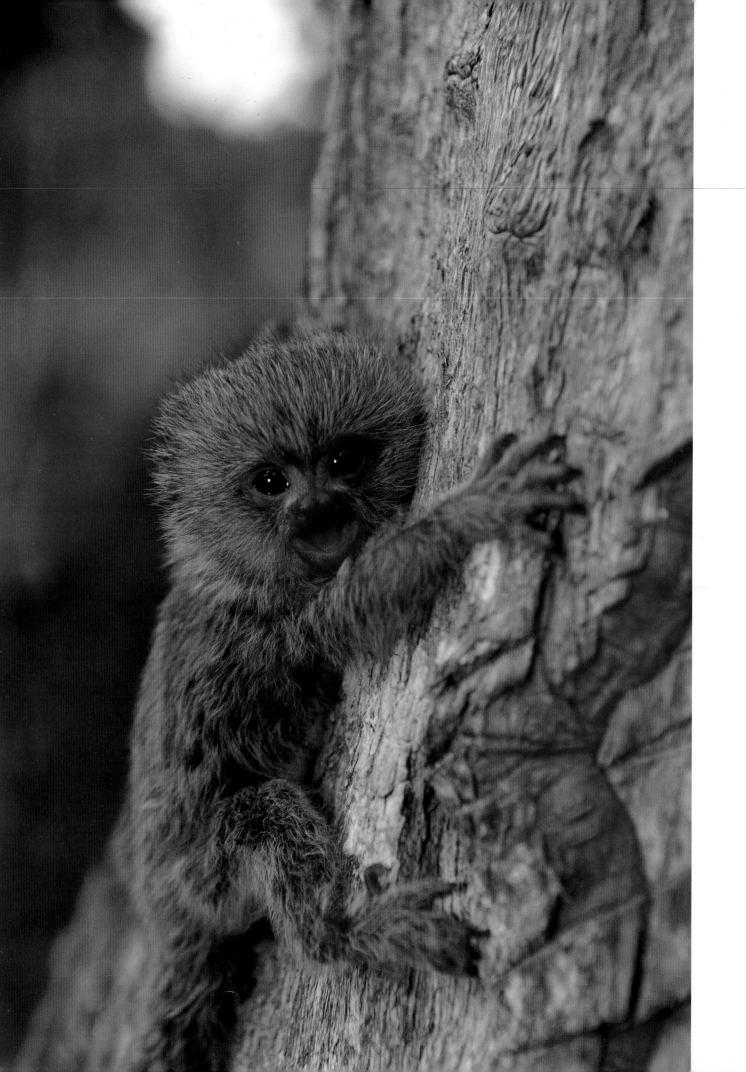

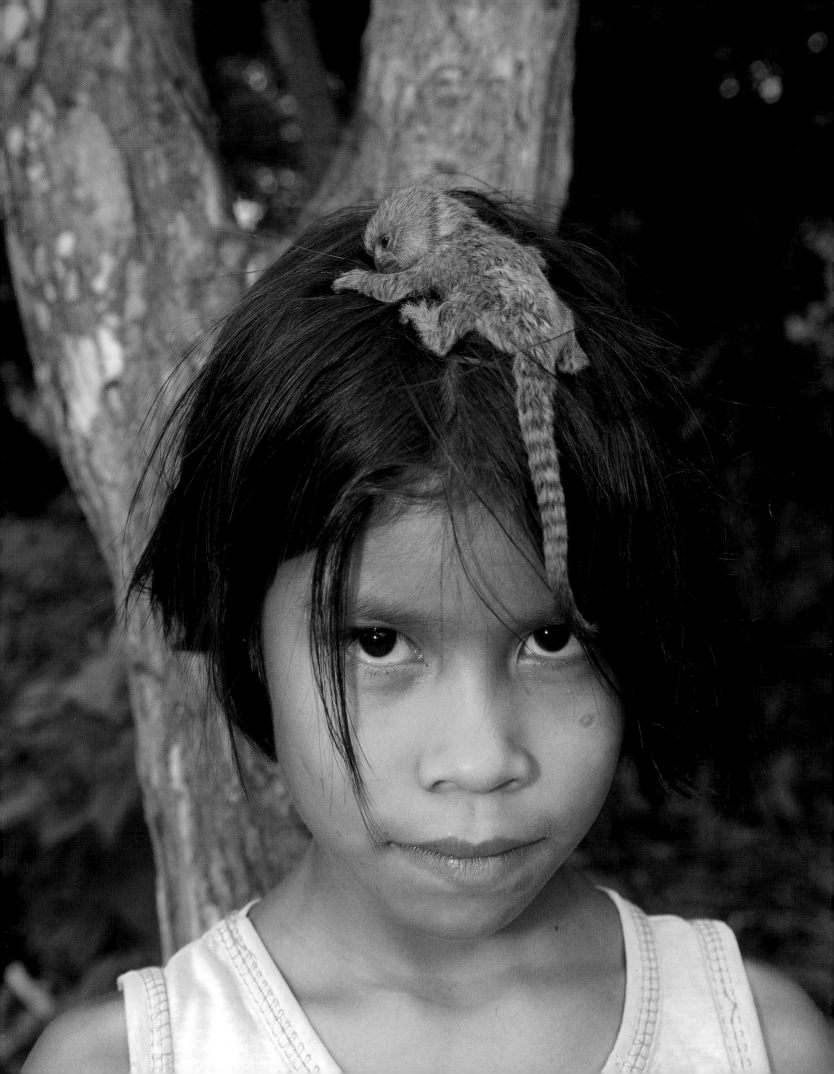

Kichwa girl and pygmy marmoset. This is the world's smallest monkey, with a body length of just 14-16 cm. Their claws are specially adapted for climbing trees and they tap trees for sap as food. Pygmy marmosets are quite rare. They feed on only one type of tree and so if these trees are felled they lose their food source (previous pages).

Caimans eat fish, mammals, birds and other animals. They spend most of their time partially submerged in the water, waiting for the right moment to hunt down their prey. They are excellent swimmers, using their tails to give them a burst of speed (right).

Capybara – the world's largest rodent stands about 2 feet/60 cm tall. It is a good swimmer and can stay under water for up to 5 minutes. When a capybara detects danger it emits a whistle, alerting other capybaras who make for the water.

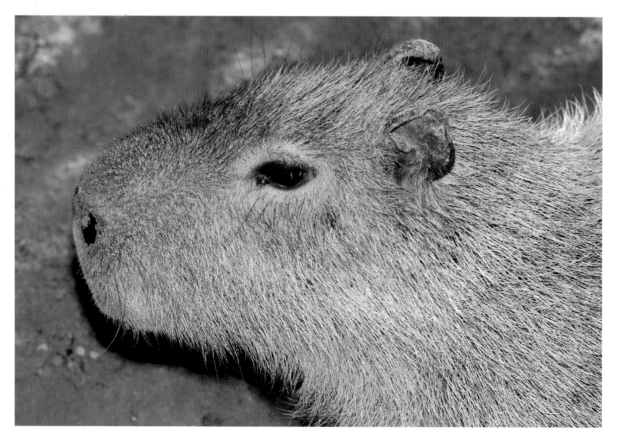

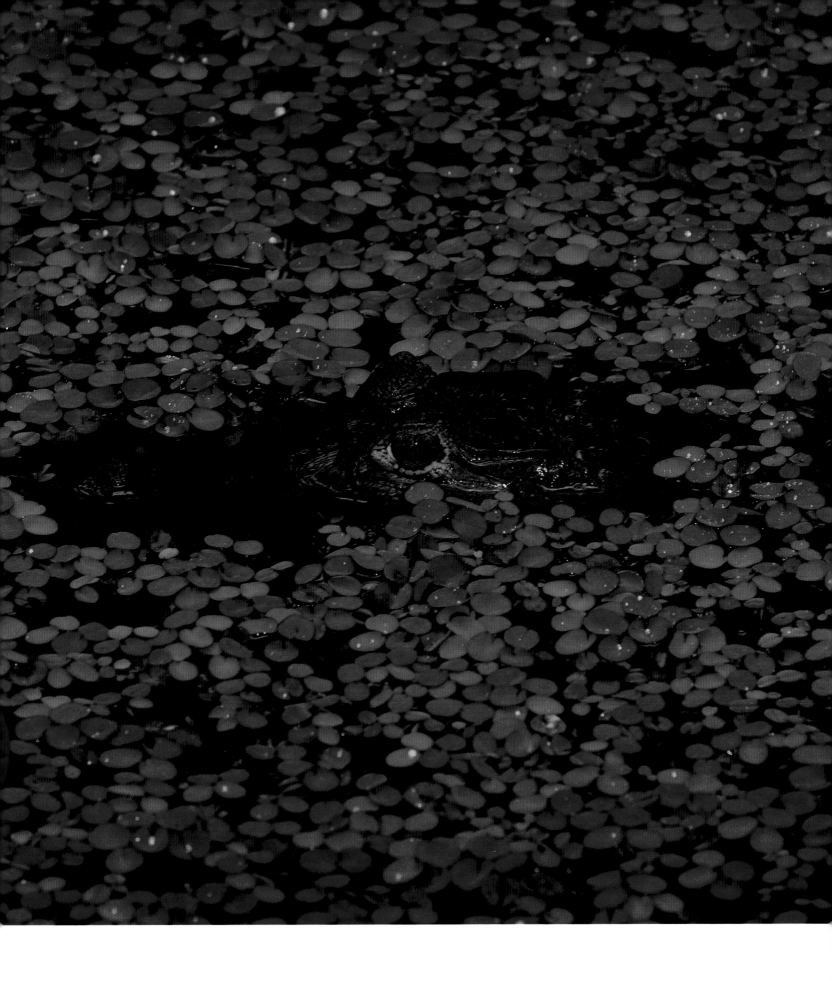

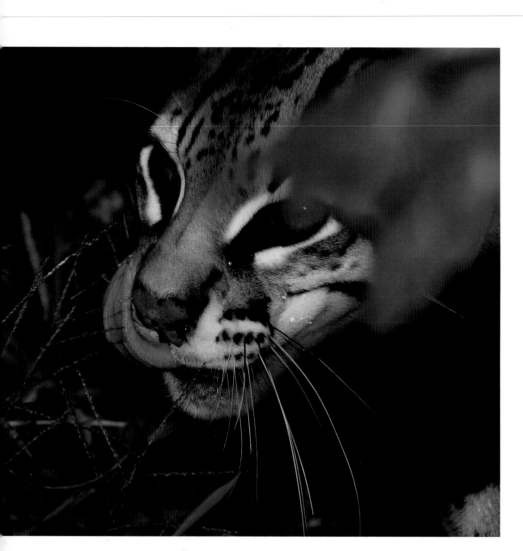

The little *tigrillo* or ocelot relies on stealth to survive. It was killed in its hundreds of thousands for its pretty 'painted leopard' fur. But thankfully today its numbers are recovering.

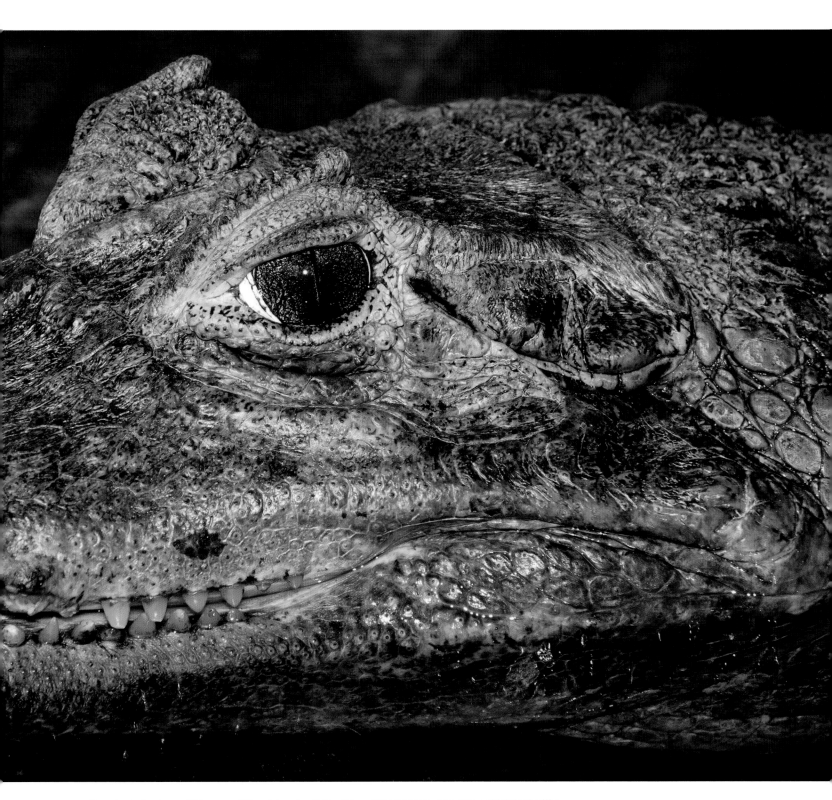

Spectacled caiman. It is named thus because of the bony ridge between the eyes, which looks like a pair of spectacles. Caimans have strongly protective maternal behavior, raising their young in crèches, with one female taking care of her own as well as several others' offspring.

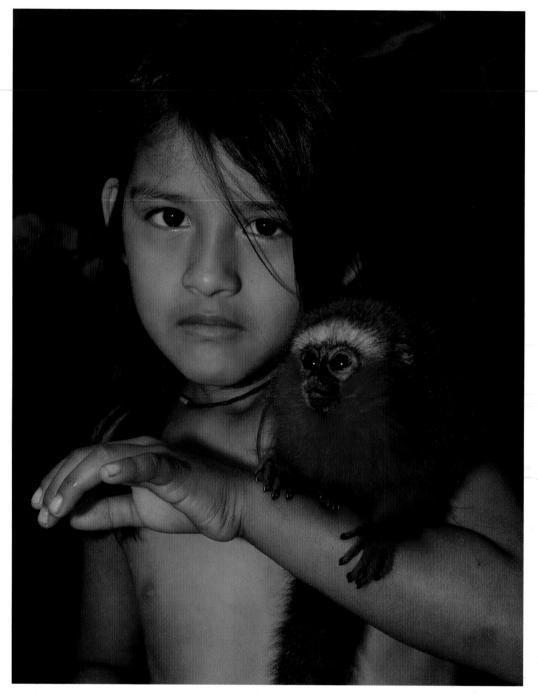

Waorani girl with a red titi monkey.

The indigenous children love to have pets. Sometimes their parents catch young monkeys, birds or rodents in the forest and bring them as presents for their children. These monkeys forage in the canopy's lower levels, mainly eating fruit. They have an elaborate system of communication that includes sound, sight, smell and touch. They use these to signal to family members and also to indicate aggression towards other groups that are potential competitors (right).

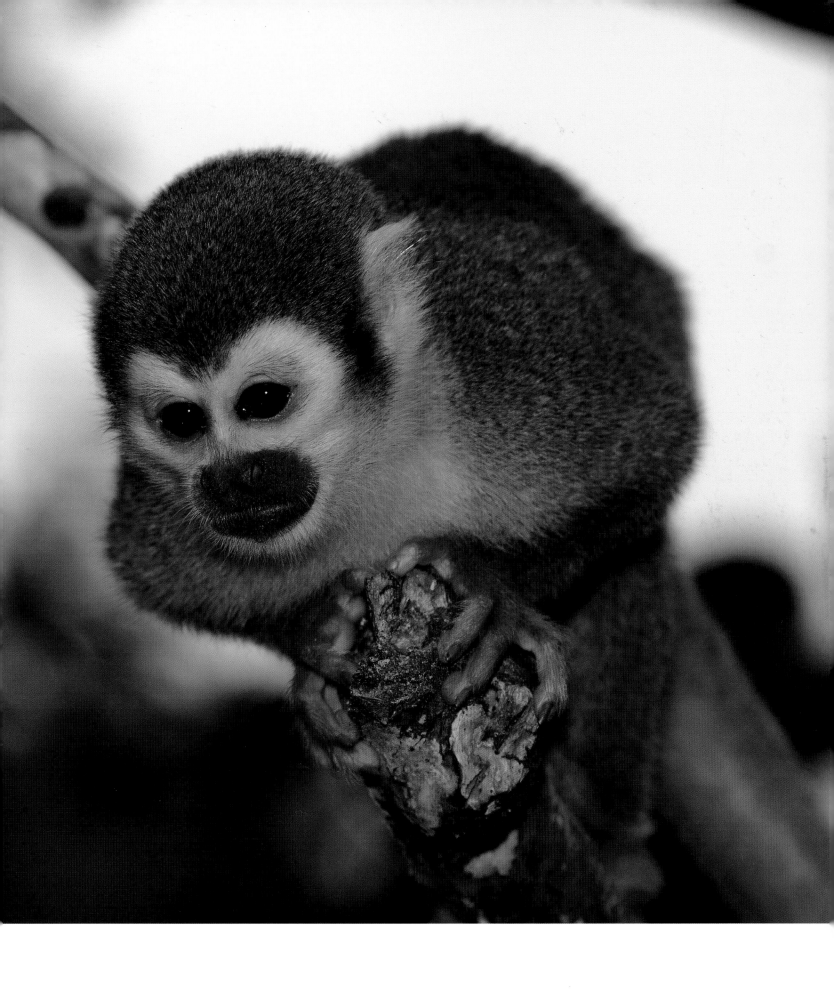

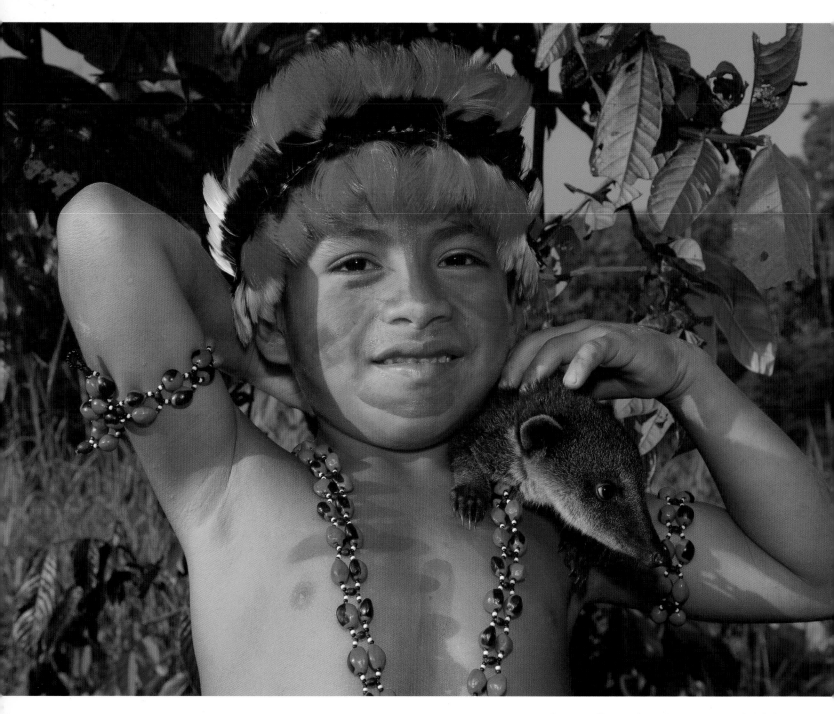

Here a Shuar boy is playing with a baby coati. The coati lives peacefully alongside the Amazonian people, in the forest. They like to rest up in the canopy in their rough-looking nests.

Raccoon-like coatis walk on the soles of their feet like grizzly bears, but – contrary to their much larger relatives – coatis are able to descend trees head first, thanks to a double-jointed, flexible ankle. They face unregulated hunting and the serious threat of environmental destruction in Central and South America (opposite page).

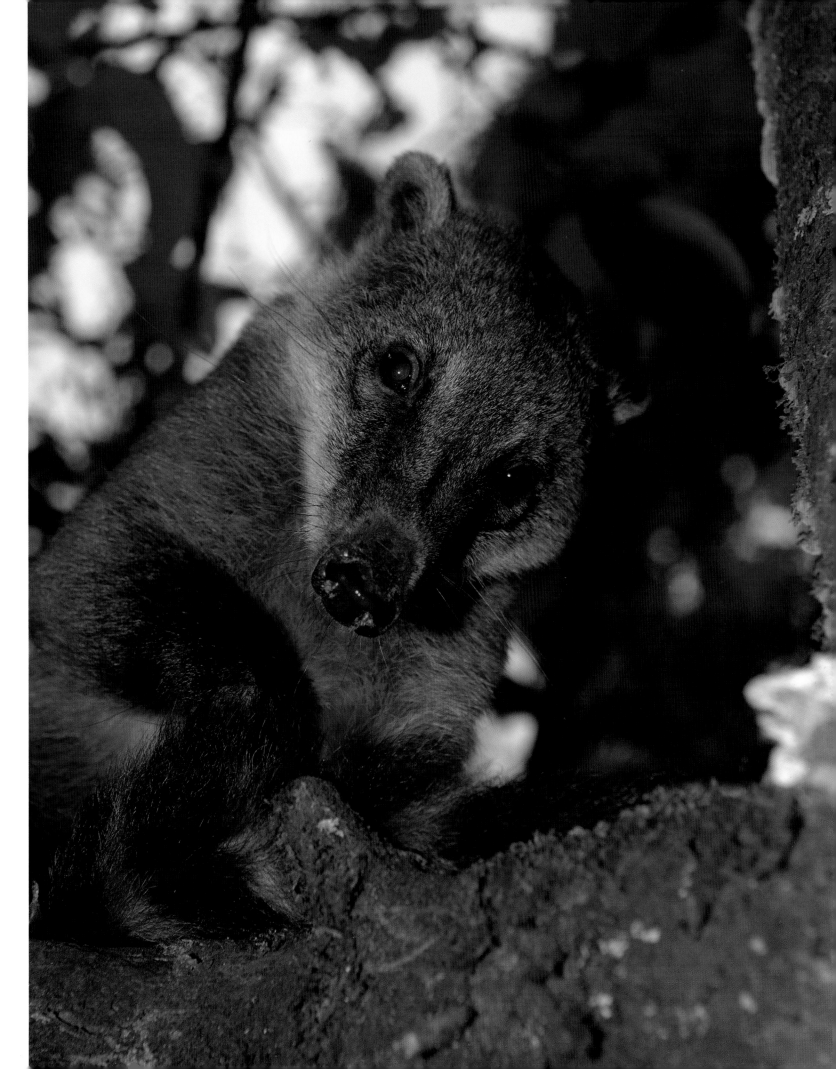

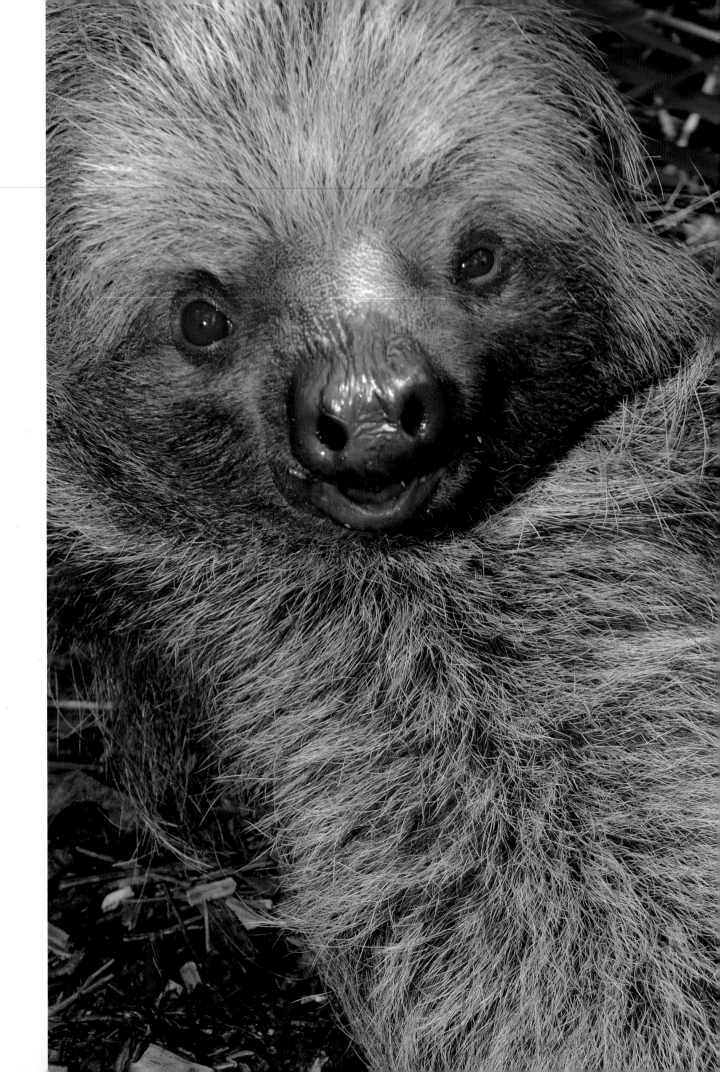

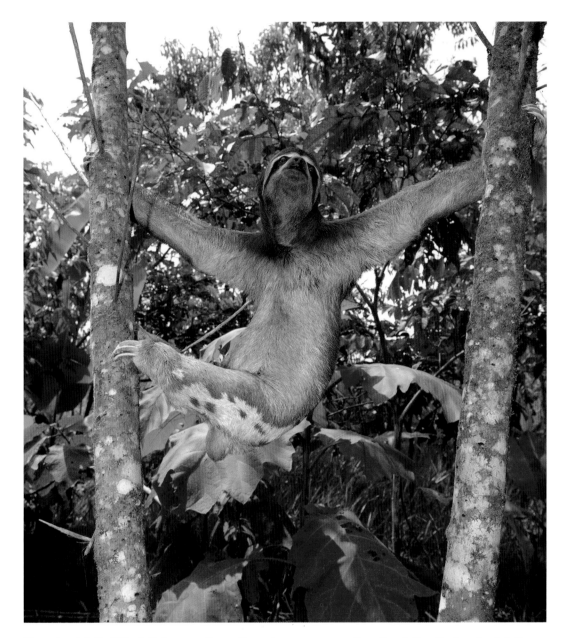

Three-toed sloth. This sloth is generally smaller and more numerous than its relative, the two-toed sloth (see opposite). It is more active moving through the forest during the day. In order to protect the animal from the rain when it is hanging upside down, a sloth's hair, unusually, points outwards from its stomach towards its back. Because they live in the trees, sloths are relatively free from attack by predators which include harpy eagles, anacondas and jaguars. The three-toed sloth is rarely seen on the ground because it cannot stand on level surfaces. It usually descends to the ground once a week to defecate, and then is just able to pull itself along using its claws by holding onto objects.

Two-toed sloth. The hind feet have three digits which have long, hook-like claws used for hanging from branches. Eating, sleeping, mating and giving birth all take place as the animal is upside down in the trees. Sloths move slowly, both in trees and on the ground (left).

Hoatzin – a pheasant-like bird that lives near swampy ground. One of its many peculiarities is a
unique digestive system. Somewhat similar to cattle digestion, bacterial fermentation in the gut
breaks down the vegetable material. The resulting odorous emissions have earned the hoatzin its
other name, 'stinkbird', but the smell also deters predators. The chick has another unusual feature;
it has two claws on each wing. When threatened by a predator the chick drops down from its nest
and then grasps its way back to safety using its clawed wings.

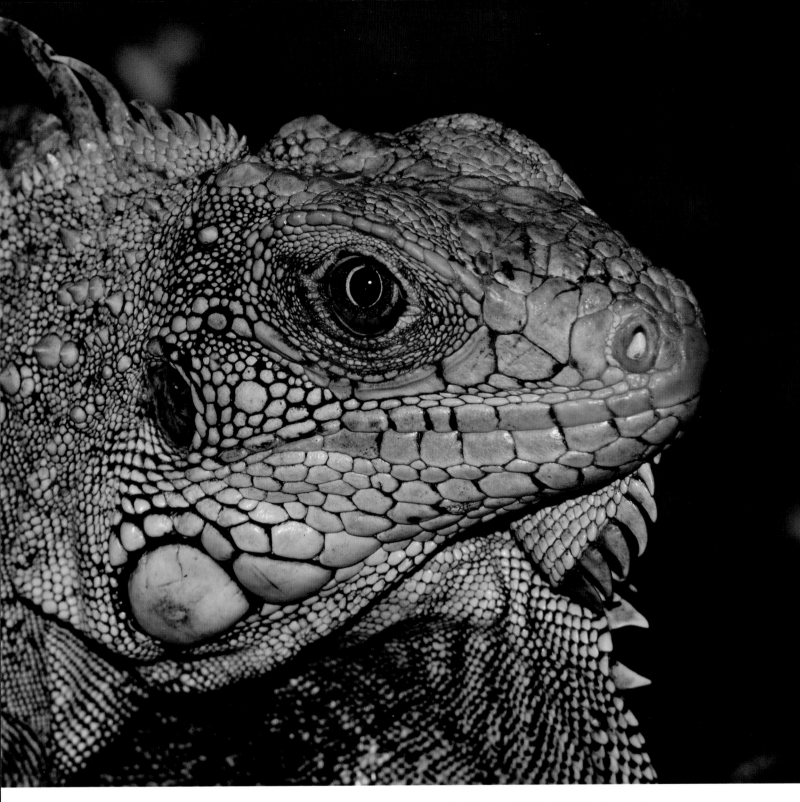

Green iguana. These iguanas have a row of spines along their backs and tails which help to protect them from predators. Their whip-like tails can be used to deliver painful strikes. If the tail is trapped, it breaks off to allow the iguana to escape – in time, the tail re-grows. The green iguana is popular in the pet trade as well as for its meat, so that although it is currently not endangered, warnings have been issued that the trade has to be controlled so as not to harm the species in the future.

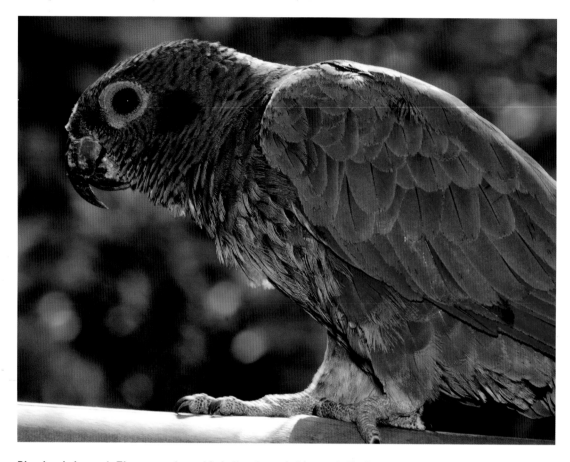

Blue-headed parrot. These parrots nest in hollow trees and forage in the lower canopy. The name comes from the blue heads they acquire with their adult plumage at about one year old. They are very social birds, gathering together frequently. Feeding on nuts and fruits, they are important dispersers of seeds in the forest. The parrots usually live about 25 years, but can live to be as old as 40.

Blue and yellow macaws are relatively large birds, with a body length of 36 inches/ 92 cm, a wingspan of almost four feet/115 cm, and weighing up to 2.5 pounds (over one kilo). They usually congregate in large flocks of around 100 and move in leaderless groups. Within the flock, pairs tend to fly close together with their wings almost touching. Their attractive appearance, trainability and intelligence make them desirable pets. But this, together with loss of habitat, has led to a decrease in their numbers in the wild (right).

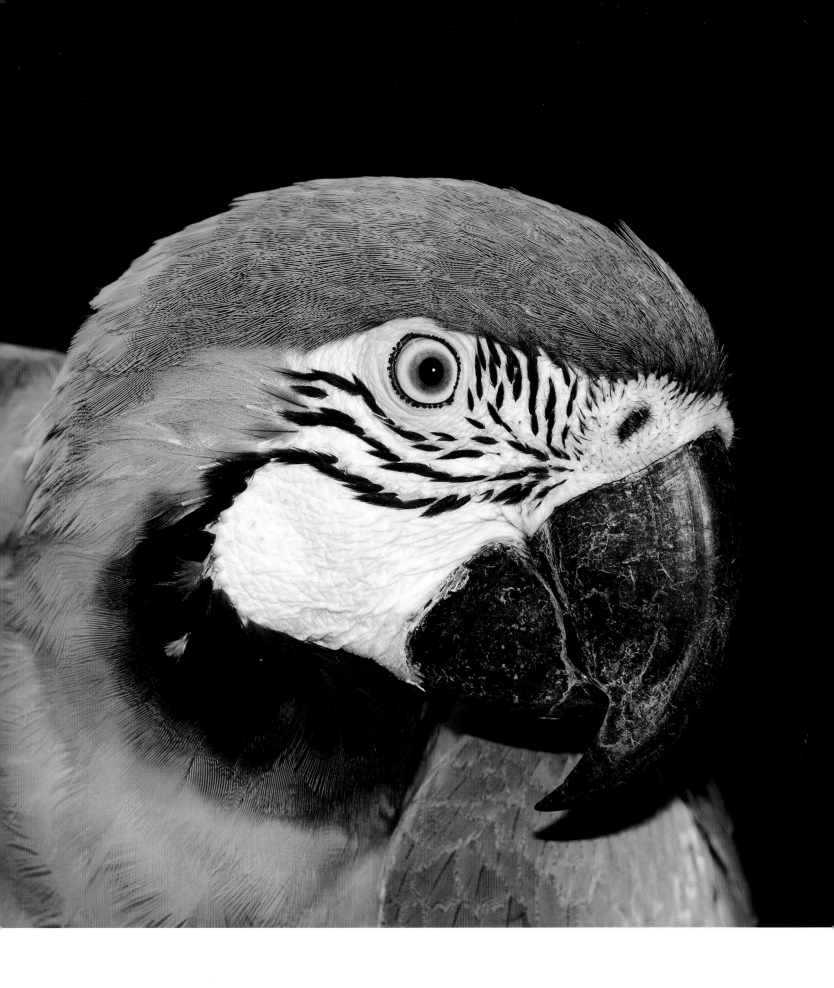

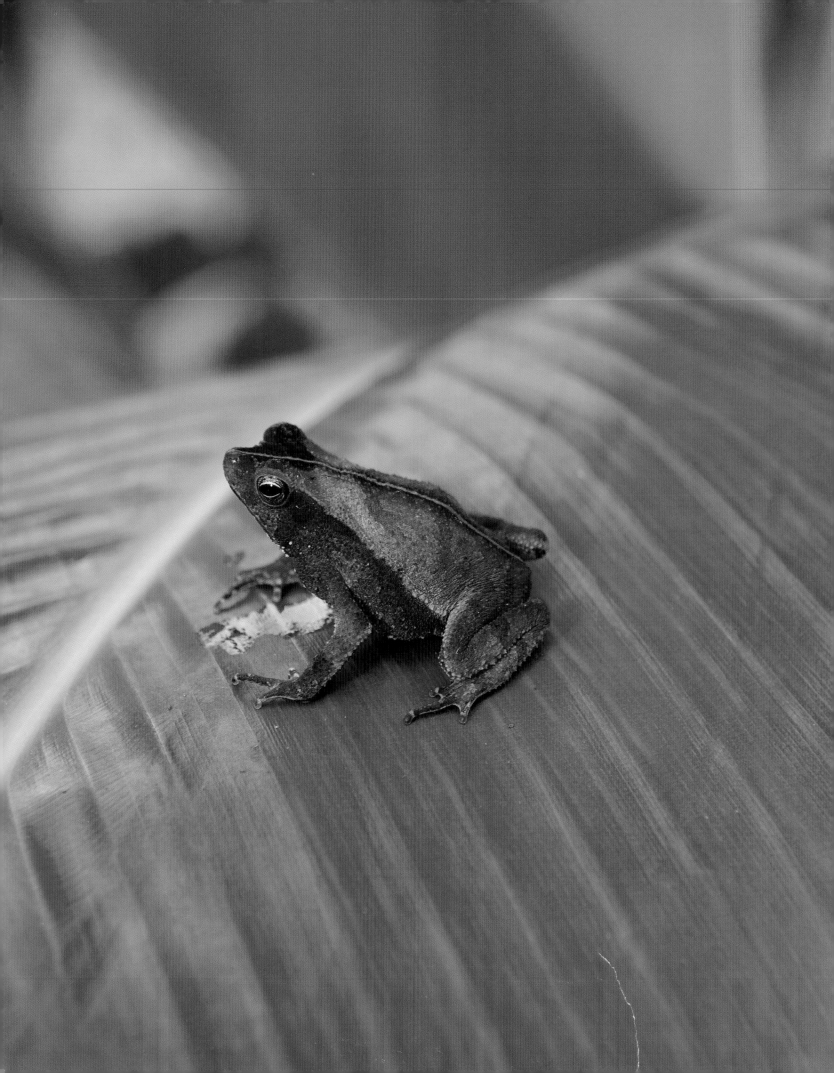

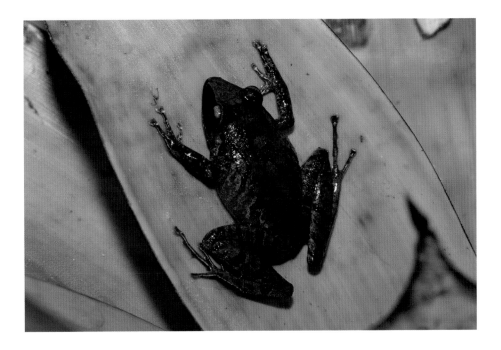

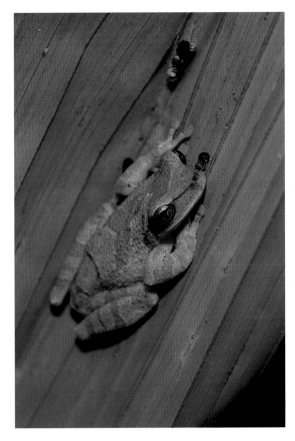

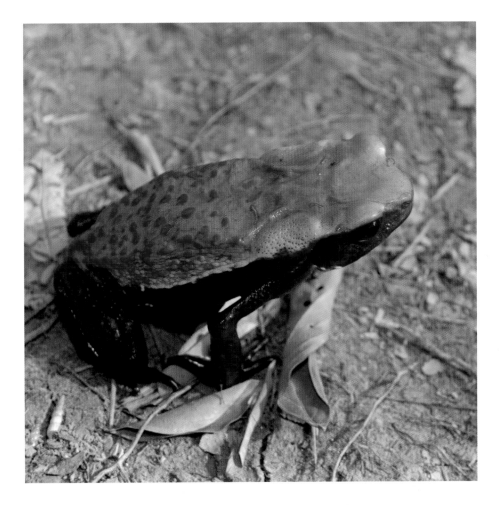

Tree frogs, as their name implies, live mainly in trees and in bushes, and are rarely found on the ground. They have distinctive slender bodies and long fingers which have sticky pads at the end allowing them to climb easily and leap through the tree tops.

They are quite small, around 1-3 inches long. Mostly green or brown, they use camouflage to blend in with their background. Male tree frogs do the croaking: their throat swells up to look like a giant bubble.

*Bufo typhonius* – a toad that is active during the day moving on the ground under the trees. Its body color and spines make it look like dead leaves (left).

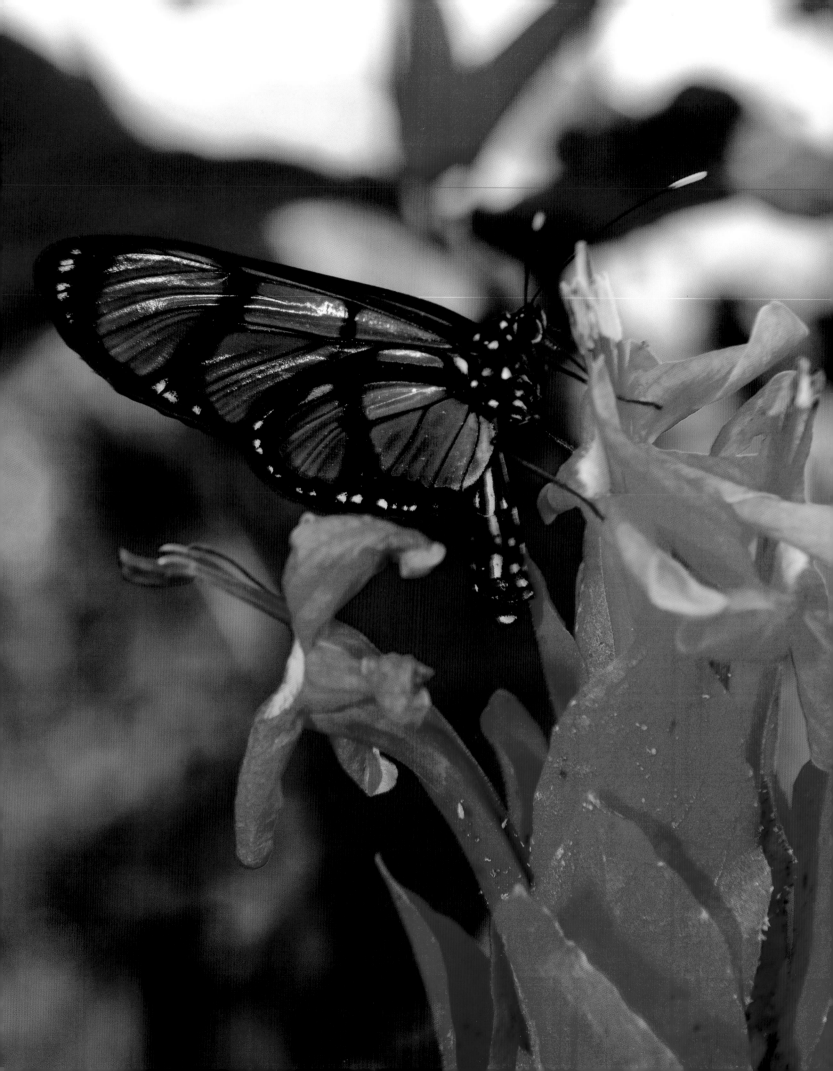

Transparent giant glasswing butterfly, one of the many hundreds of different colored butterflies that float from flower to flower in Yasuní (opposite page).

Dragonfly: these eat mosquitoes, midges and other small insects and are valuable for keeping down the biting insect population.

The forest provides a wide range of ecological niches for insects and other animals.

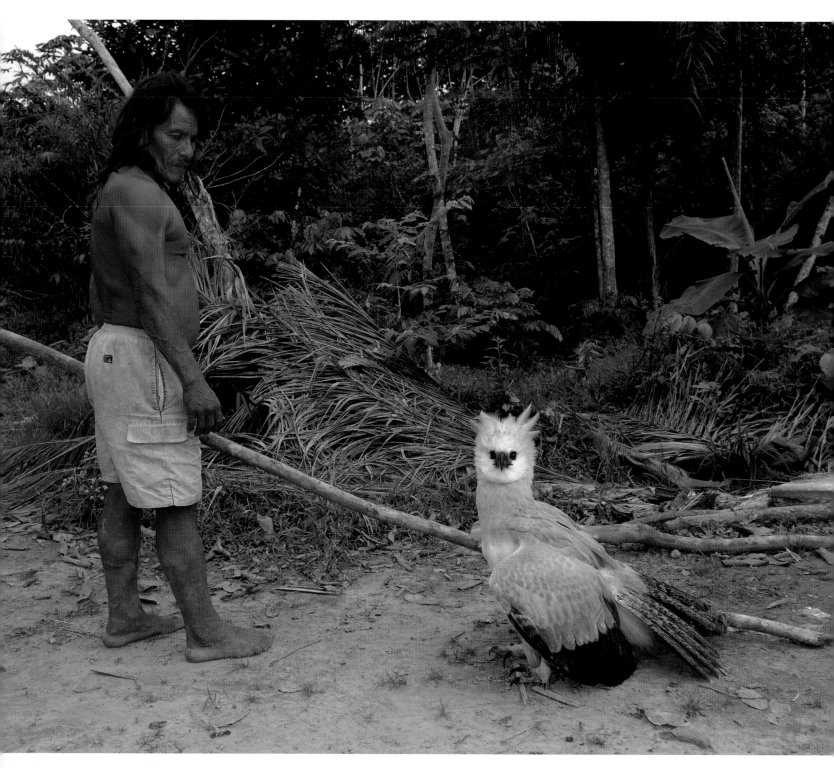

Harpy eagle. This impressive bird has a wingspan of over 6 feet, and weighs 10-20 pounds, with females up to twice the size of their mates. They are one of the world's largest and most powerful eagles. Although their hind talons are about the same size as a grizzly bear's claws, the eagle can only fly carrying prey half their body weight. Tree-dwelling animals like sloths, monkeys, opossums, birds and some reptiles are the main food.

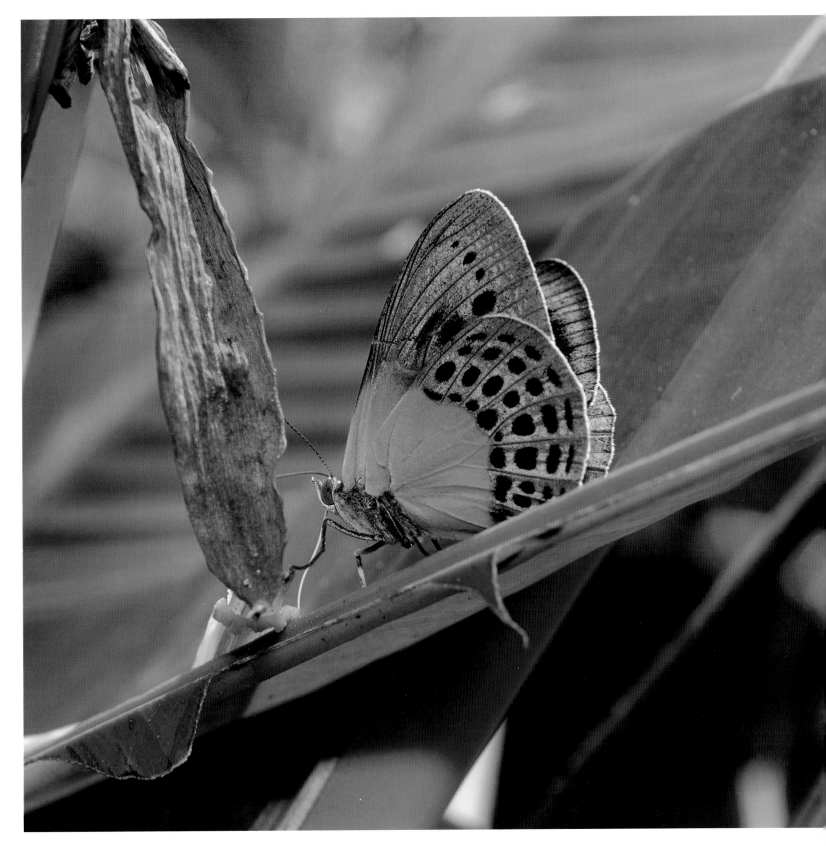

One of the many beautiful butterflies of the Yasuní.

There are so many insects and amphibians that every time you move a leaf or twig, you will find another one.

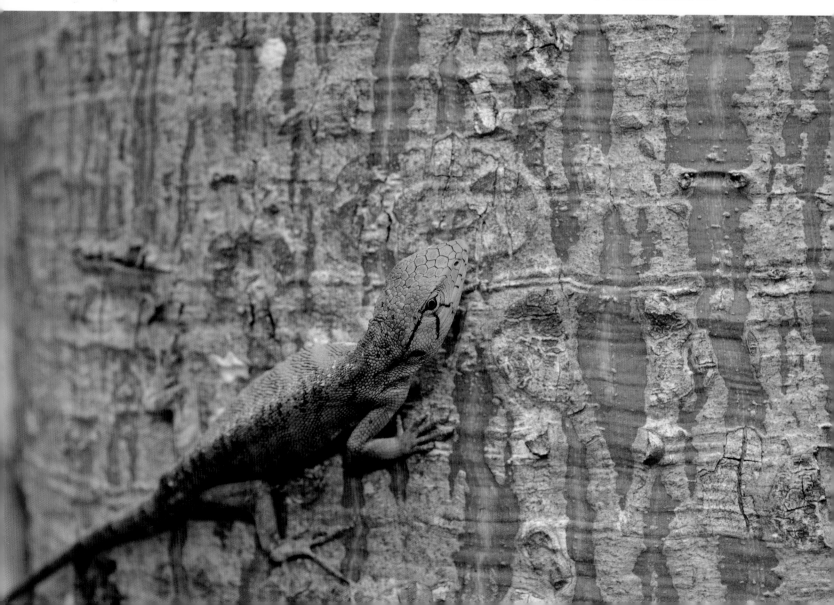

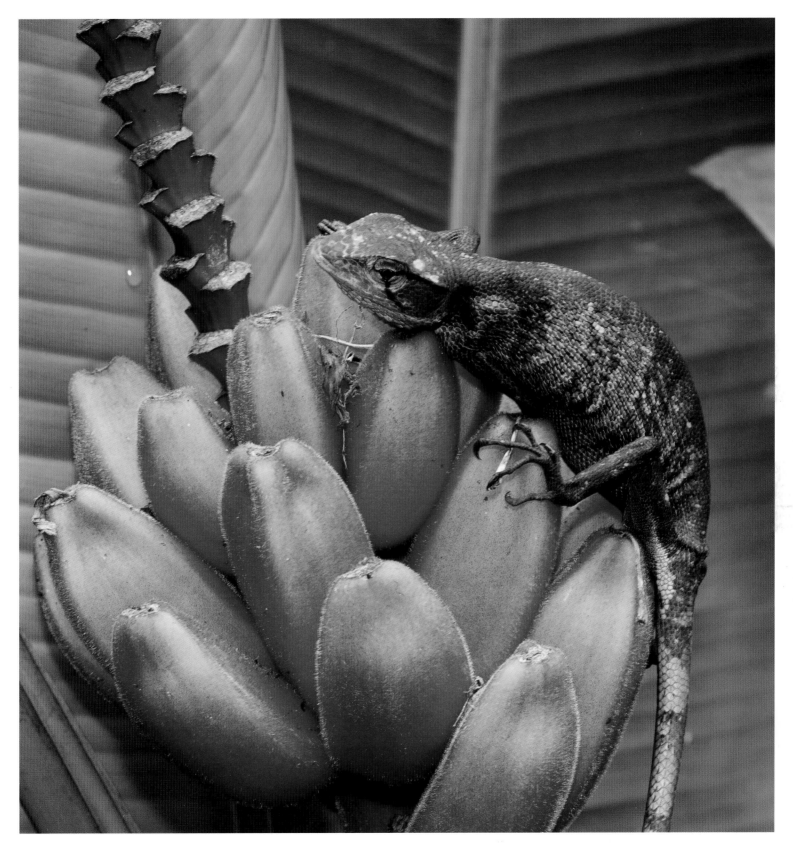

**About 105 amphibian and 72 reptile species have been documented in Yasuní, making it a rich resource of their biodiversity.**

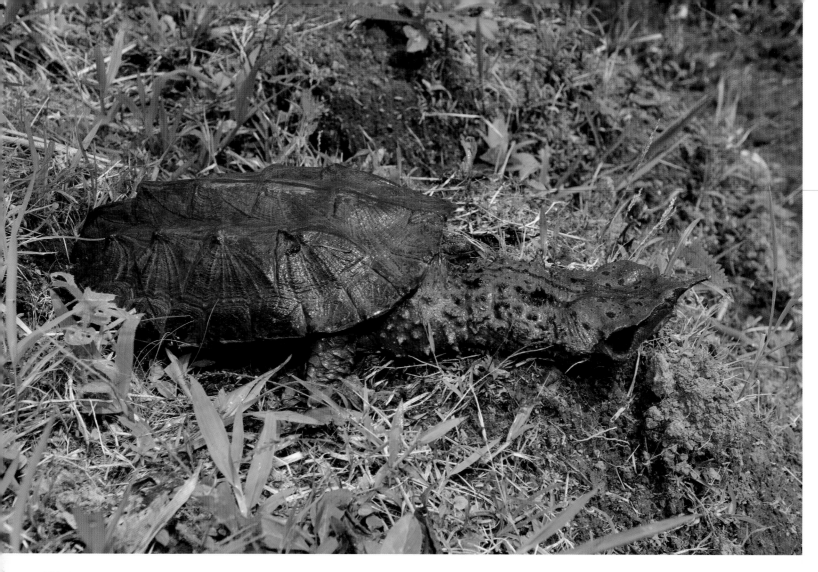

This is a mata mata, a freshwater turtle. It lies in the shallows, with its snout just breaking the surface so it can breathe. It remains motionless, blending into the background until a fish passes close by; then it opens its mouth to create a vacuum which sucks the fish inside.

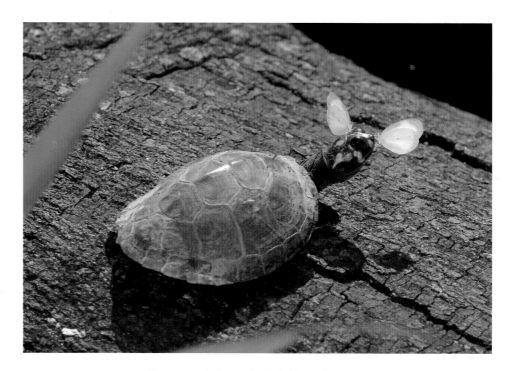

Charapa tortoise, endemic to the region.

**This species of tortoise (tortuga charapa) can measure over a meter long. It is endangered because its eggs are taken for food. The young have yellow or orange markings on their heads.**

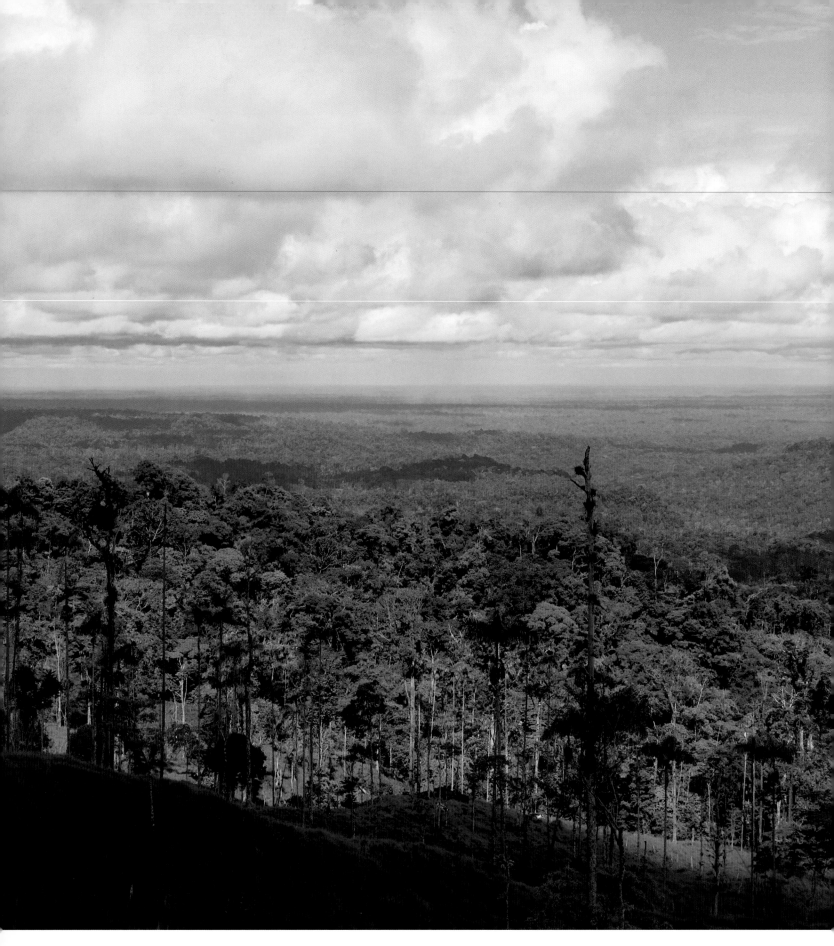

There are more than 1,130 types of tree in the Yasuní and 280 liana species.

Insects go in for fancy dress with sometimes amazing costumes. The strange appearance of these flatid leaf bug or planthopper nymphs attracts curiosity.

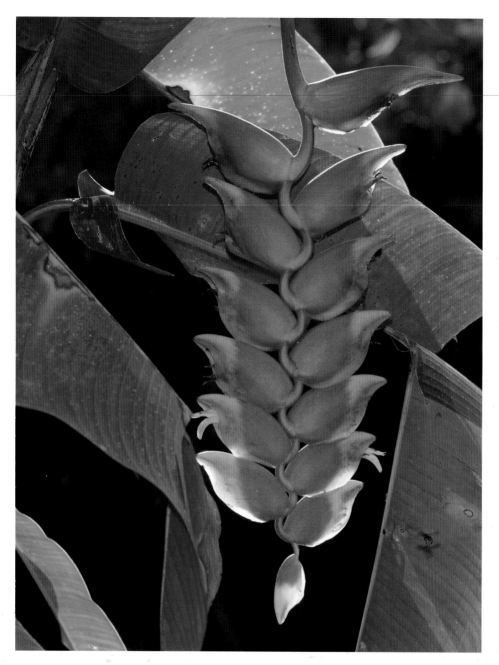

Heliconia is a red, hanging flower with large, elongated paddle-shaped leaves. Its fruits are eaten by many types of birds, however it can only be pollinated by tropical hummingbirds. They are often found in small sunlit areas or on the edge of the forest and the heliconia needs a lot of sunlight.

Waorani say that there was once an enormous ceibo tree which fell and created the Amazon, and this is a common myth across the Amazon Basin (right).

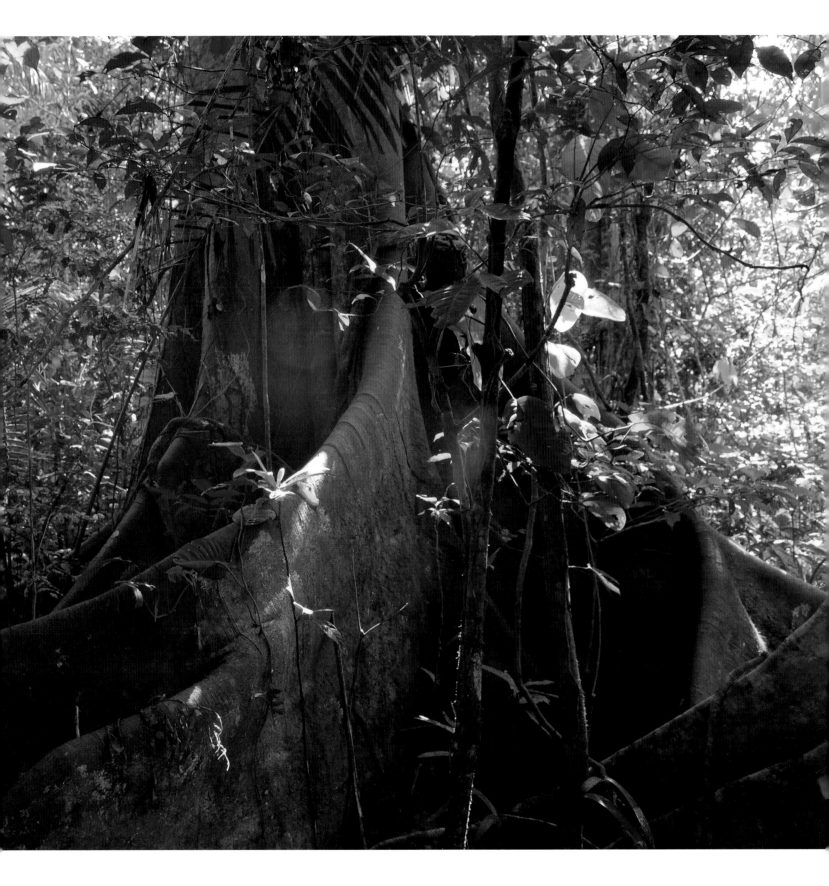

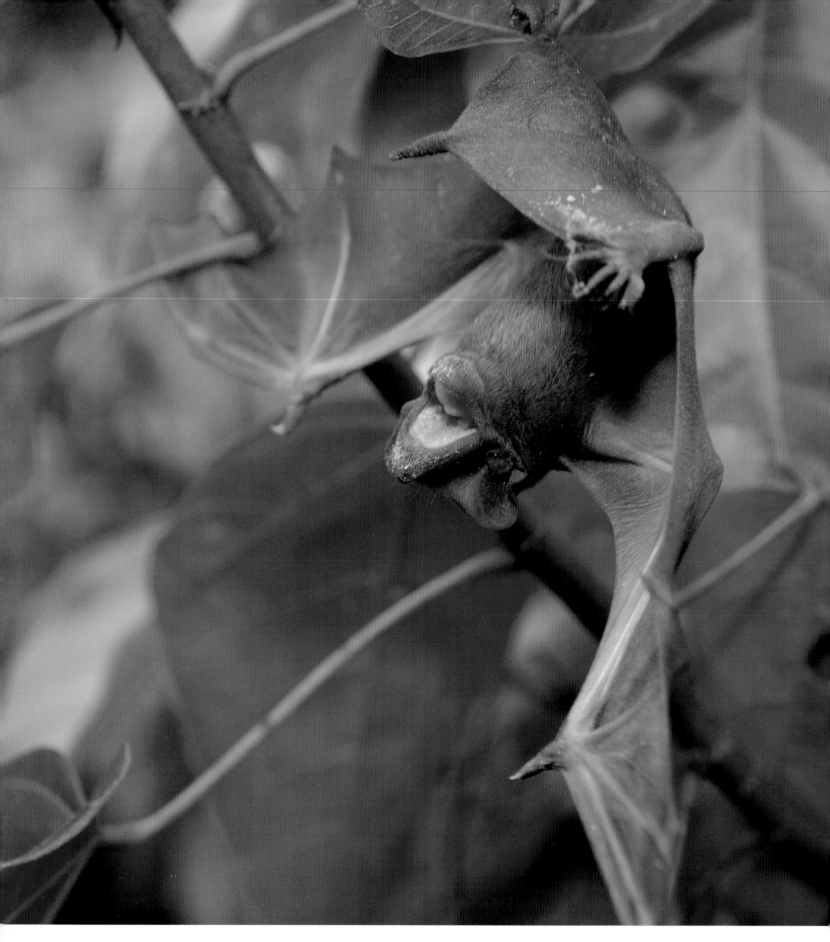

There are 165 species of mammals, including 90 species of bat in the Yasuní. Bats emit sounds which allow them to find their way around and locate prey, rather like a sonar system.

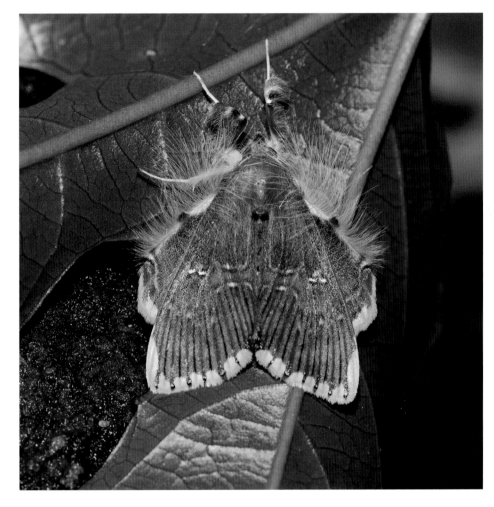

Male moths and butterflies find their mates by following the special scent trails that rise up into the jungle air at certain times of the year. Males track these from hundreds of meters away.

The forest flowers are full of nectar, which is rich in energy. Many animals are attracted to the juice and spend much of their time roaming around from flower to flower in search of it. Just one rainforest tree can produce 600,000 flowers with over 200 liters of nectar, but this abundance can only be sustained for a few weeks a year. So the animals plan their route through the canopy via the flowering trees, pollinating them in return .

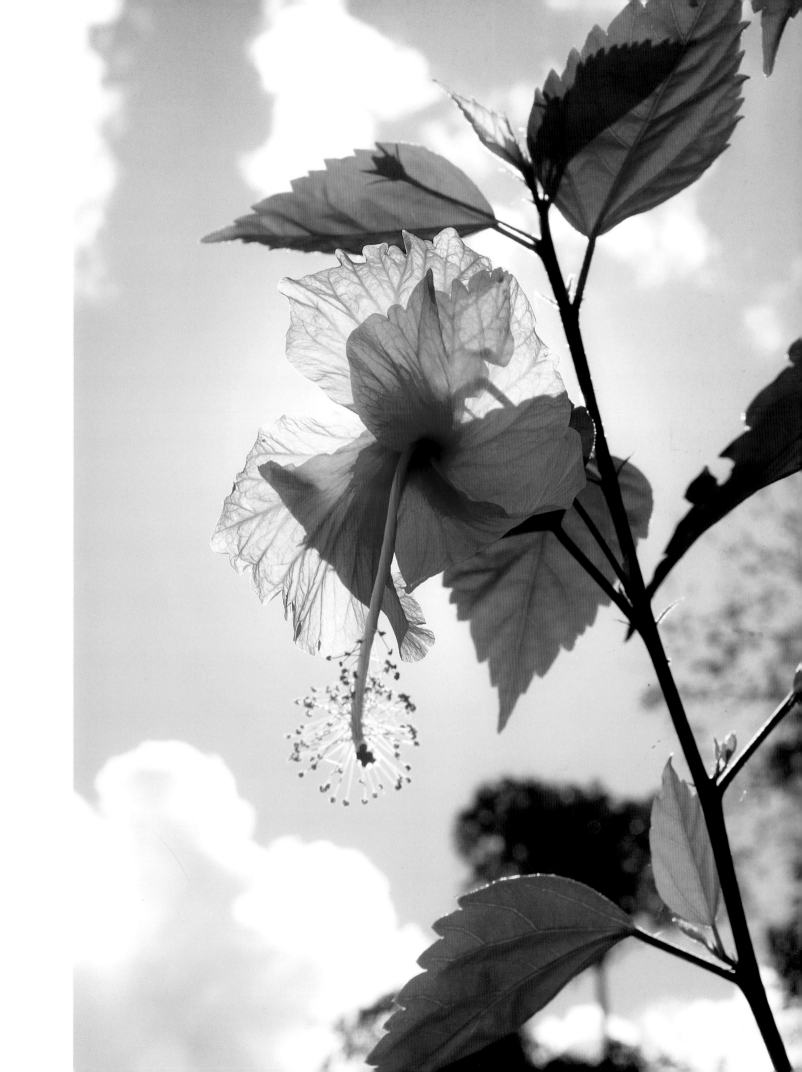

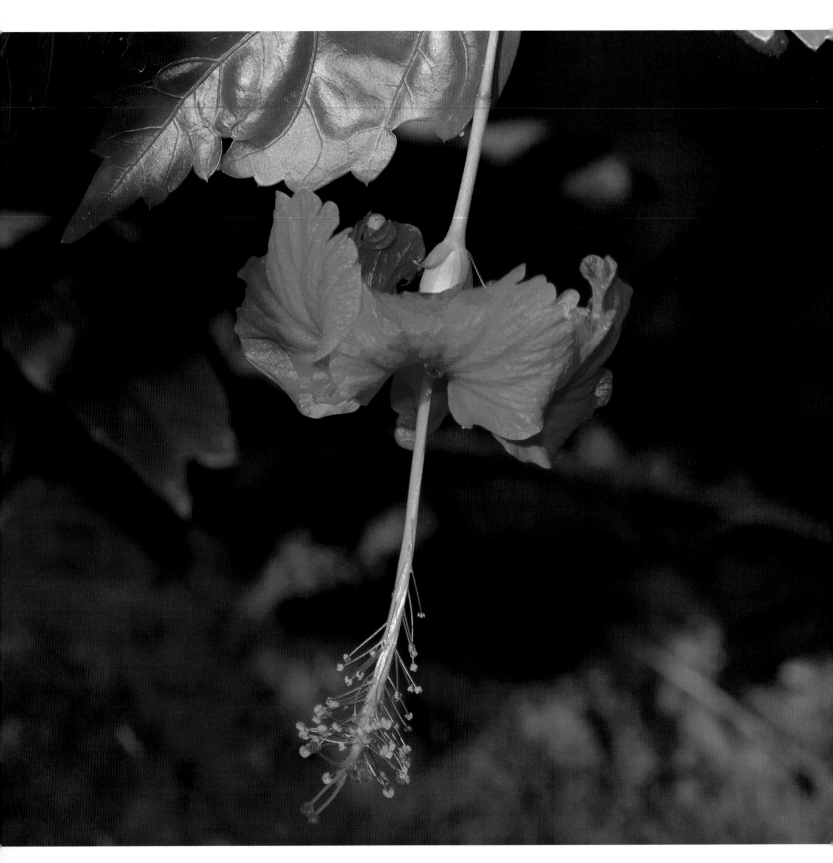

Different types of flowers attract different animals. Flowers for butterflies and moths have long slender trumpet shapes while those for birds are strong, brightly colored and shaped like bird-feeders.

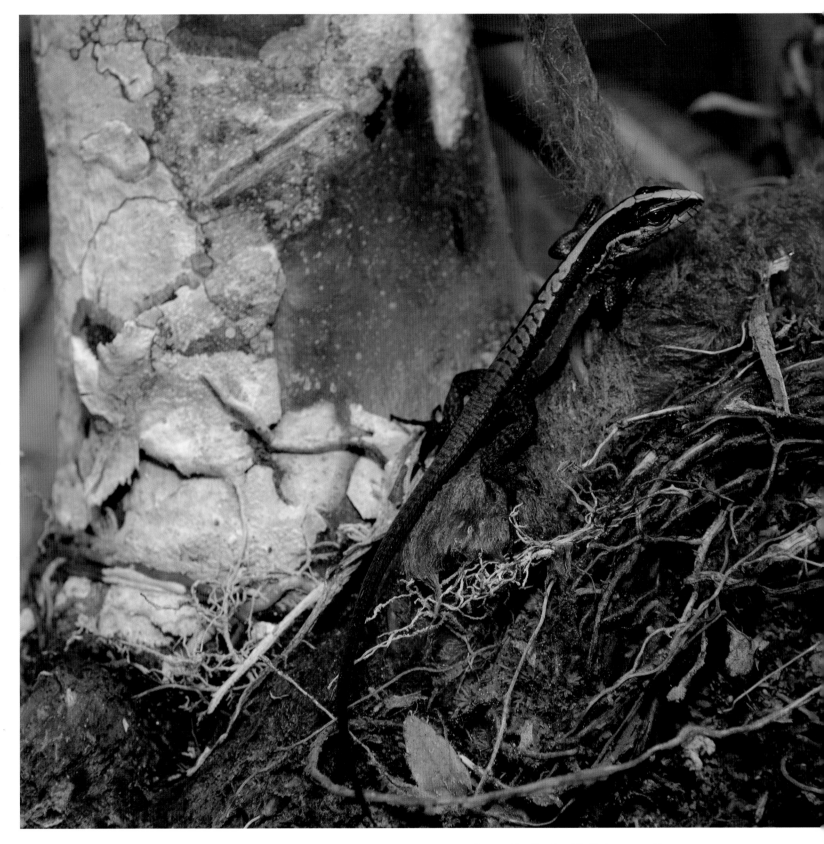

Forest Whiptail. Some animals camouflage themselves from predators, blending in with their surroundings.

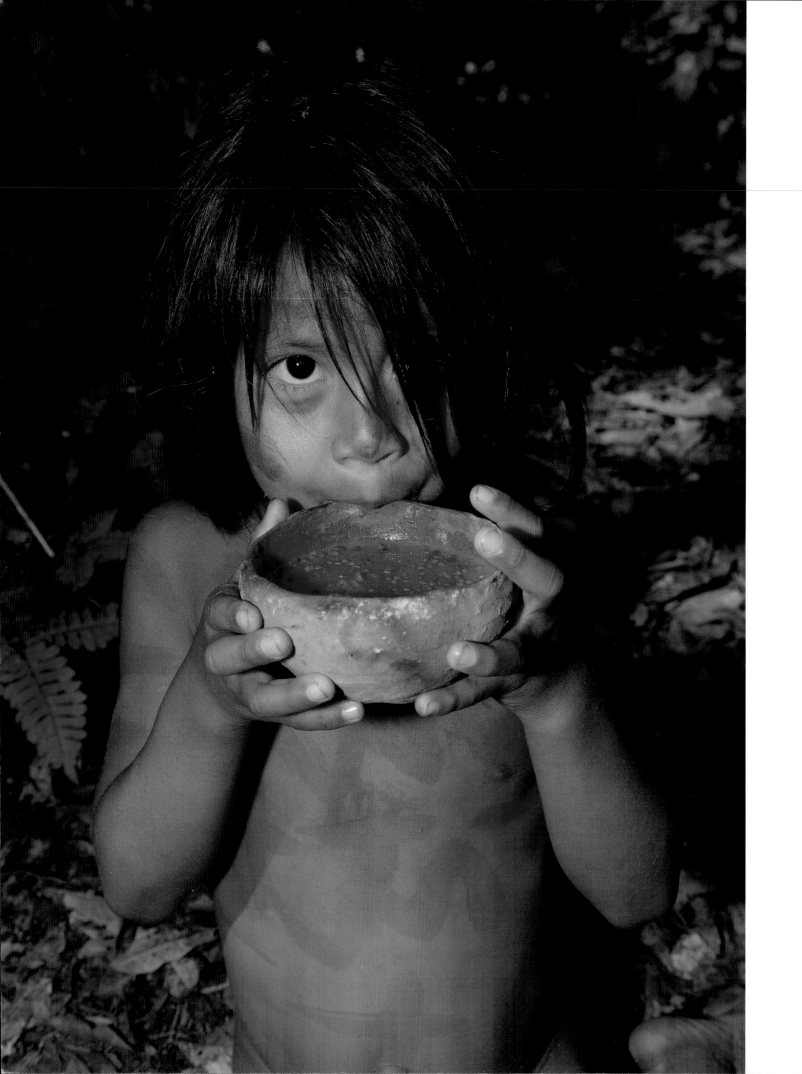

This is an achiote plant (right), also called the lipstick tree. The outer covering of the seeds contains bixa, a bright red pigment that is used to paint faces and bodies (see left).

Achiote has medicinal properties and is used for treating skin problems, fevers and hepatitis; it is also thought to aid digestion (opposite page).

Delicate flower that bears some resemblance to the South African strelitzia.

**Harlequin beetle.**

The Yasuní rivers contain more than 540 species of fish.

The great biodiversity of the Yasuní exists to a large extent because of the variety of its waters. There is 'white water', rich in Andean sediment from the rivers' sources. 'Clear water' originates in the Amazon itself and is colored by the quantities of decomposing leaves that fall into it. Then there is 'black water', flowing through swamps and wetlands, which is the color of tea (opposite page).

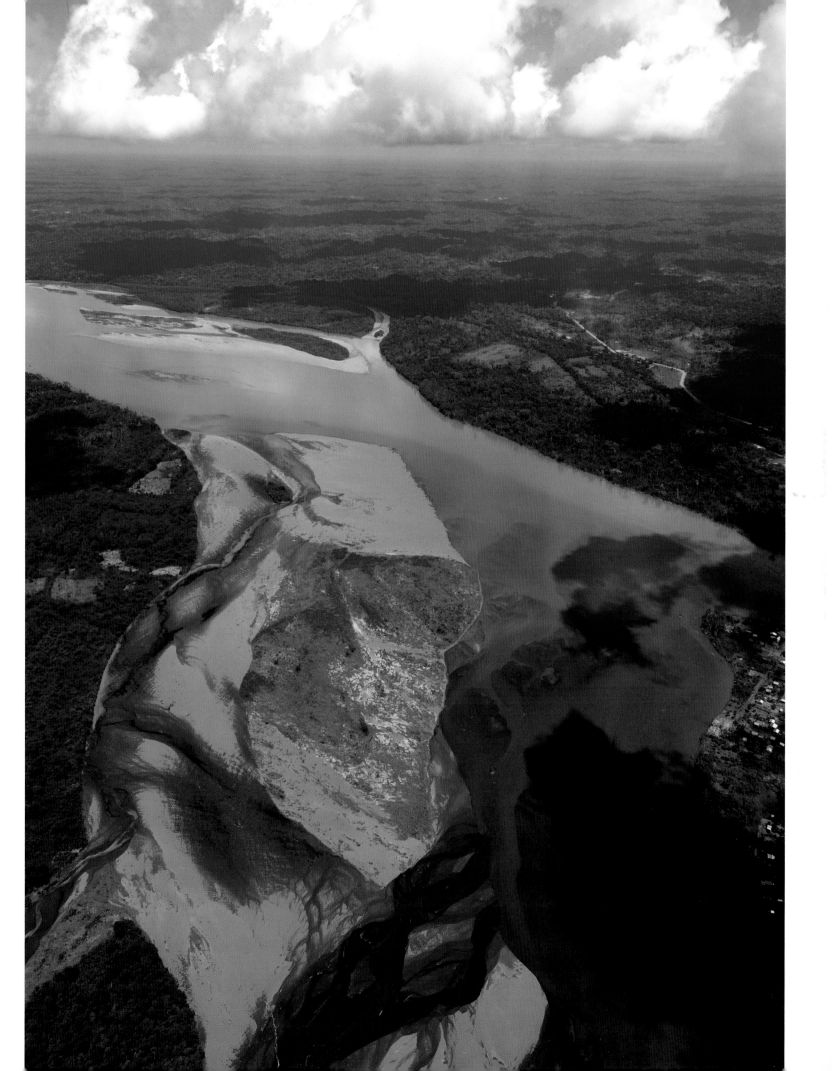

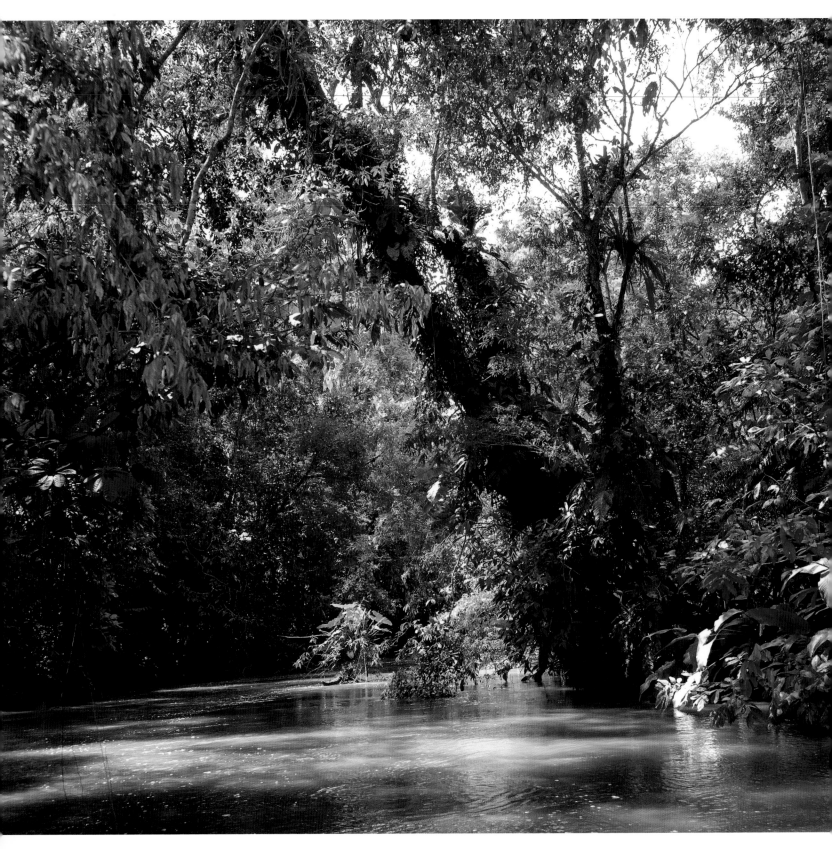

The Tiguano River. The rivers of the Amazon Basin are estimated to hold around 2,000 species of fish.

**Mimicry is a technique which insects use to conceal themselves in the forest. Here, the insect's body resembles a leaf.**

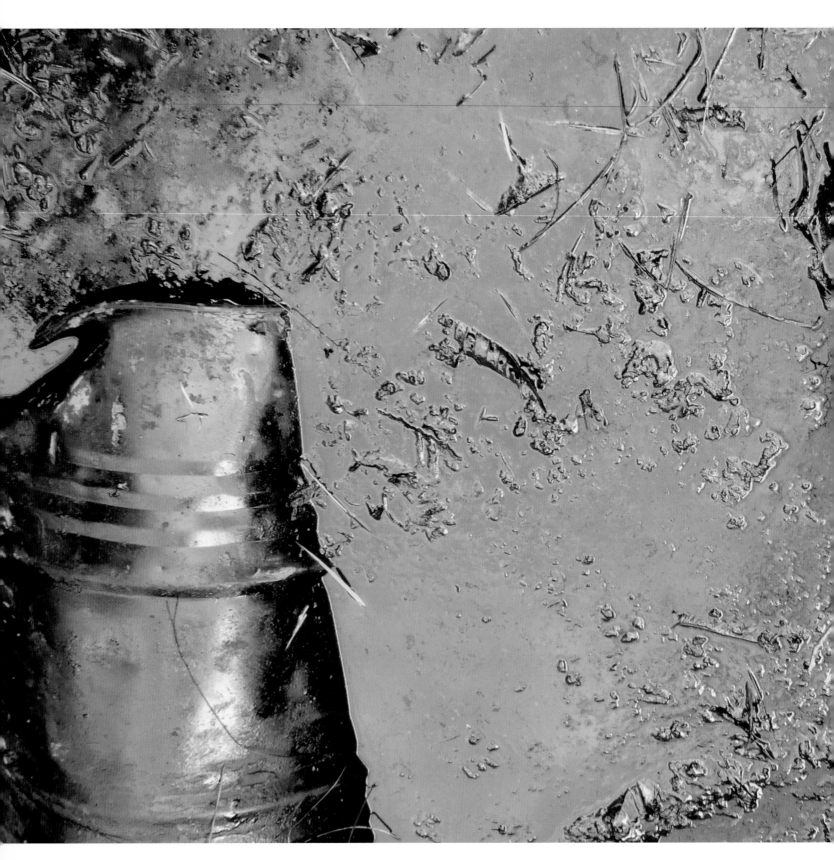

About three-quarters of the population is believed to use polluted water. It is used for cooking, bathing and drinking. Attempts are made to decontaminate the water supplies, but generally this is not successful and toxic substances remain in the rivers. Often these are bio-accumulative – building up in the bodies of animals, fish and people that consume them – resulting in various illnesses.

OSCAR FRANCINO / ALI SUPAY

## Chapter 3
# The stain of oil

## Since oil was

discovered in the region, the industry has extended its sticky tentacles into all aspects of life, with the promise of progress and the reduction of poverty. The indigenous people's ways have been undermined and destroyed causing many people now to be completely dependent on oil.

Colonization of the forest lands has so many different consequences. Roads, for example, cut a scar through the trees, stripping the vegetation. Estimates suggest that for every new kilometer of road built in the region, an average of 120 hectares of forest are lost to agriculture. Although the Yasuní is supposed to be a 'strictly protected area', the building of the Maxus Road into the Park has provided an entry point for migration, colonization, and deforestation. Many farms and even towns have been constructed along the road. Additionally, road construction just to the north and west of Yasuní has led to widespread deforestation and increasing resource extraction in those areas, encroachment nipping away at the edges of the Park.

Logging has risen in Ecuador by nearly 20 per cent in the last 15 years. In the same period, the country has lost almost a quarter of its forest cover.

The economic impacts of the oil industry have included loss of local people's farm animals and crops because of water contamination. Hunting has become more difficult as wild animals cannot tolerate the polluted water and the noise of chain saws as they strike down the forest.

The oil companies appear to have little respect for local cultures, ignoring people's traditions and myths and not respecting sacred sites. Deception and broken promises are part of the picture, along with threats and bribes to leaders of native organizations. Impacts on indigenous people's health have been particularly woeful. This is most clearly seen in the high percentage of people with cancer and the number of children born with deformities. In addition, close proximity with the oil frontier brings alcoholism, prostitution and sexually transmitted diseases, and the all too common oil spills.

Oil spills are frequent and few precautions are taken to prevent them. Some see them as a good way for the pipe companies to earn more money – the pipes are

**How the forest vegetation should look...**

maintained not by the oil companies but by separate contractors. The effects of such spills are far-reaching. For example, a recent incident affecting the town of Orellana meant that 30,000 people had no safe drinking water for more than two weeks until emergency supplies could be brought in from another river.

Oil seeps its polluting way into the ground, tainting the water, poisoning or killing any living thing around it. The most shocking case involved oil giant Texaco which spilled 17 million gallons of crude oil into local river systems and dumped more than 20 billion gallons of toxic drilling by-products. The company also ripped out forest for access roads, exploration, and production activities.

One incident in 1992 led to a 275,000-gallon spill, causing the Rio Napo to run black for days. Peru and Brazil, lying downstream, declared national states of emergency for their affected regions. These instances are not rare – they happen virtually all the time. In fact they are so common that one can see leaked oil from the pipelines that run parallel with the roads of the region.

For local people, the effects are disastrous as toxins are released into the rivers, the only source of water.

OSCAR FRANCINO / ALI SUPAY

**...and what an oil spill can do to primary tropical forest.**

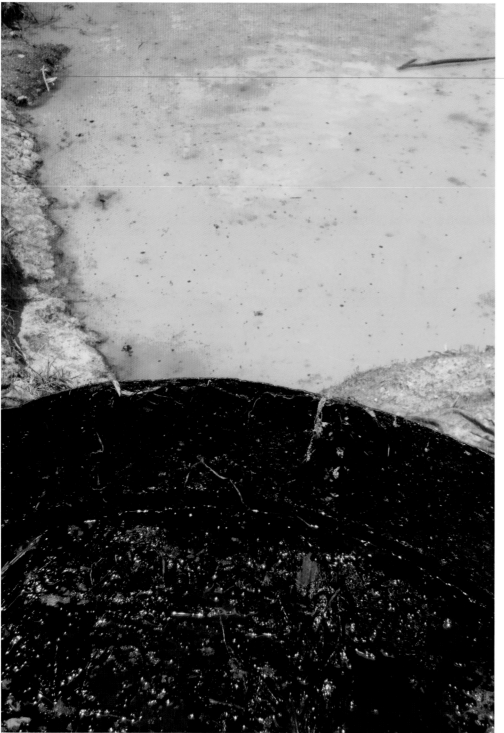

Cleaning up after oil spills affects people's health. Those who regularly do such work can suffer neurological problems from ingesting toxins, as well as digestive problems and general bad health. Cases of cancer are much more frequent in the areas close to oil activity than in the rest of Ecuador.

OSCAR FRANCINO / ALI SUPAY

OSCAR FRANCINO / ALI SUPAY

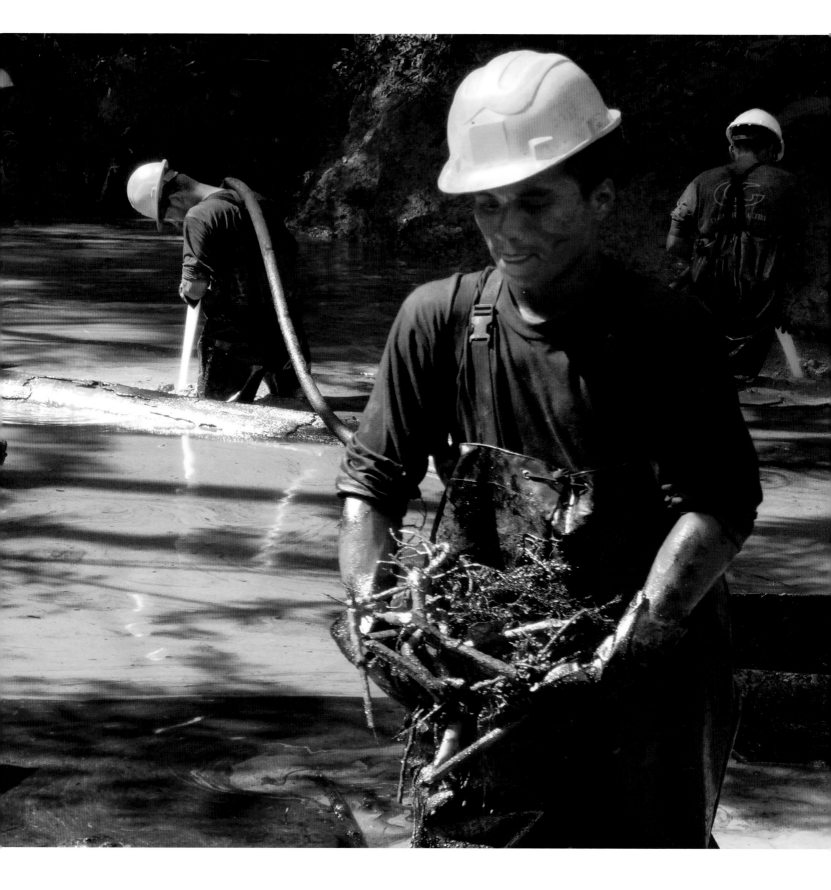

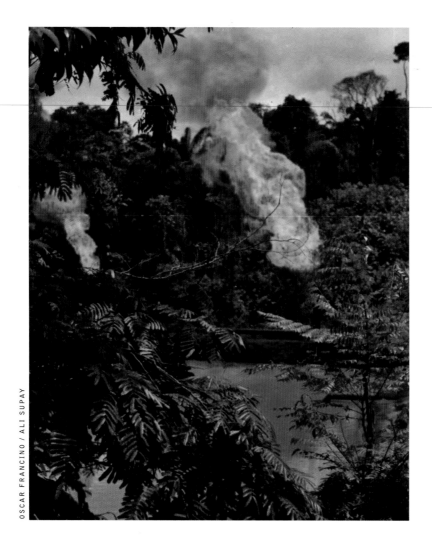

OSCAR FRANCINO / ALI SUPAY

OSCAR FRANCINO / ALI SUPAY

Living near oil pipes and extraction areas is hazardous.

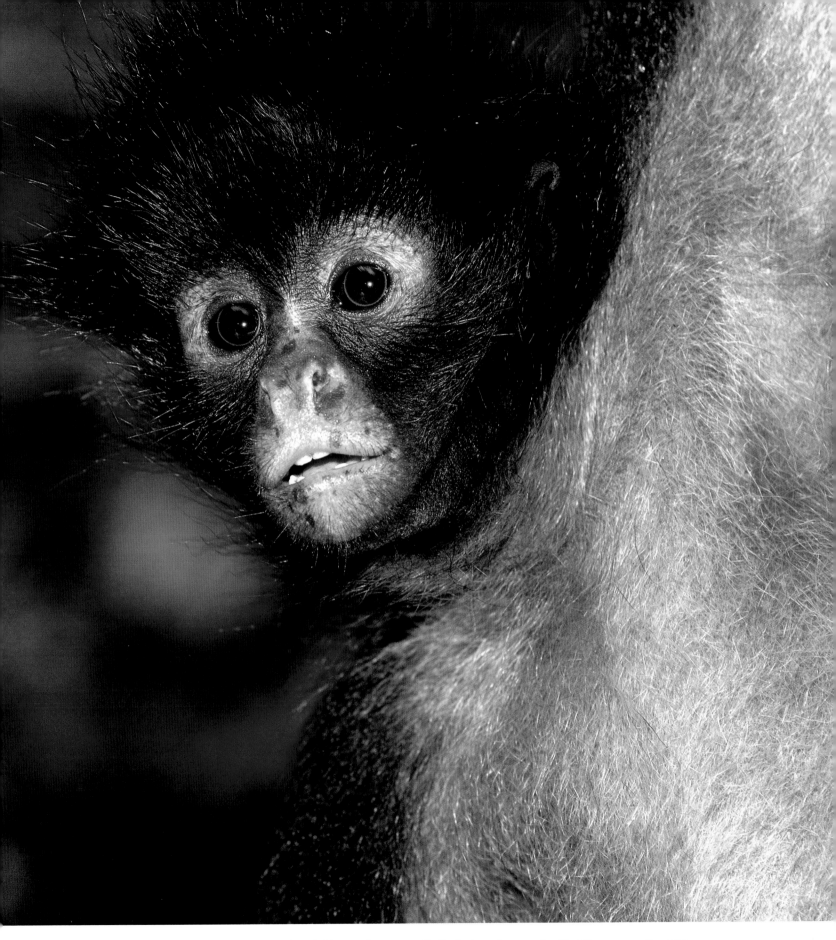

White-fronted spider monkey. Spider monkeys are an 'indicator' species, meaning that they are monitored by biologists to measure the state of the environment. The spider monkey is likely to lose its habitat in the region.

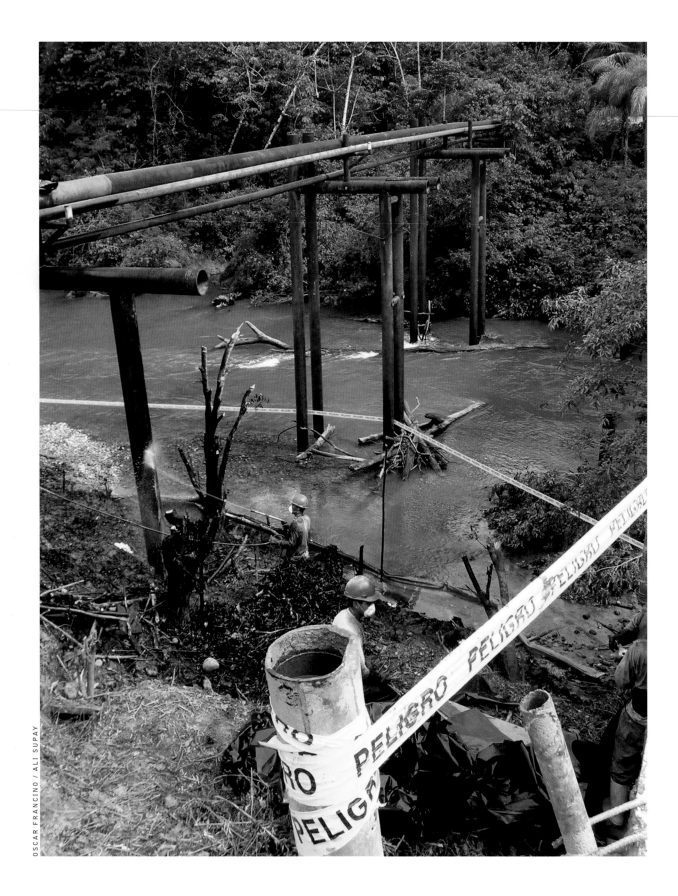

Previous page: Local people coexist with the affects of oil. About half the population is thought to use water that is polluted. The water is used for cooking, bathing, and for drinking. Attempts are made to decontaminate water supplies but generally this is unsuccessful and toxic substances remain in the rivers.

The River Tiputini just by the entrance to the Yasuní. On one side of the oil pipes (left) cleaning work is in process, on the other children play in the contaminated water (below).

MIA ANDERSSON / ALI SUPAY

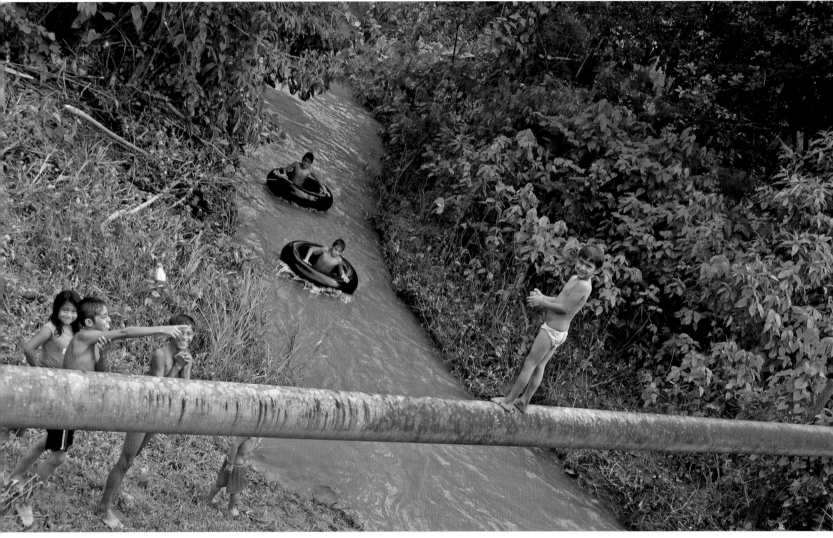

Kids playing on an oil pipe. According to the Pan-American Health Organization, 1 in 5 children suffers from anemia. Polluted water is dangerous for them of course, but animals also drink at the contaminated pools left by the spills; such pools sometimes remain for years. This has led to a high mortality rate in the wild and domestic species living in areas affected by oil leakages.

The opening of an oil well impacts on the forest in various related ways through the construction of pipelines, camps and highways. It is estimated that each new road built adversely affects the surrounding forest for 5 km on each side. Some studies say that for each kilometer of road up to 50,000 hectares of forest are damaged.

OSCAR FRANCINO / ALI SUPAY

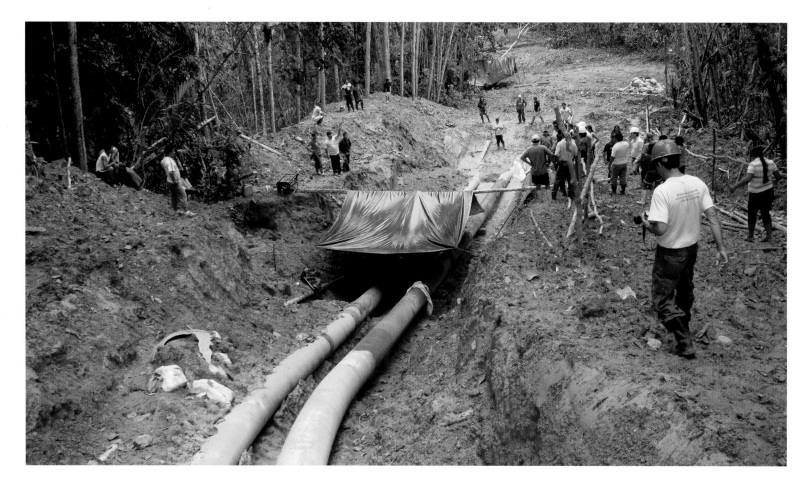

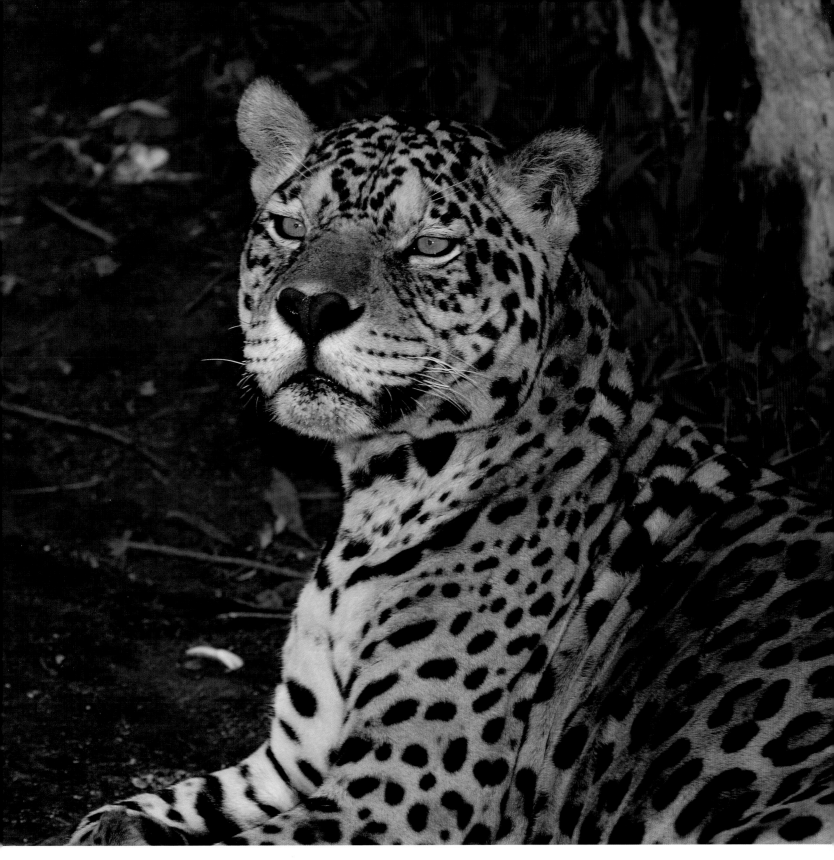

Jaguar. This beautiful animal is the largest and most powerful feline in the Western Hemisphere. It is also a top predator which means that it plays an important role in stabilizing ecosystems and regulating the populations of prey species. The jaguar is a near-threatened species and its numbers are falling due to habitat loss and hunting. The jaguar has featured prominently in the mythology of Mayan and Aztec people. Waorani identify deeply with the jaguar and according to myth, they sprang from a mating between a jaguar and an eagle.

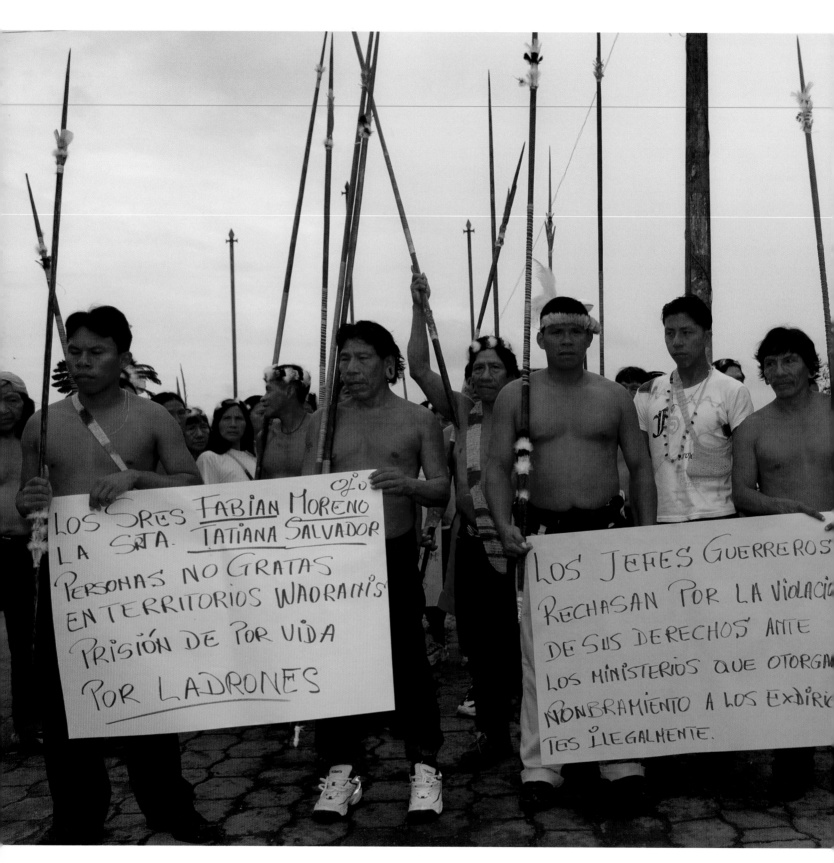

Waorani protesters with placards saying their territories must be safeguarded.

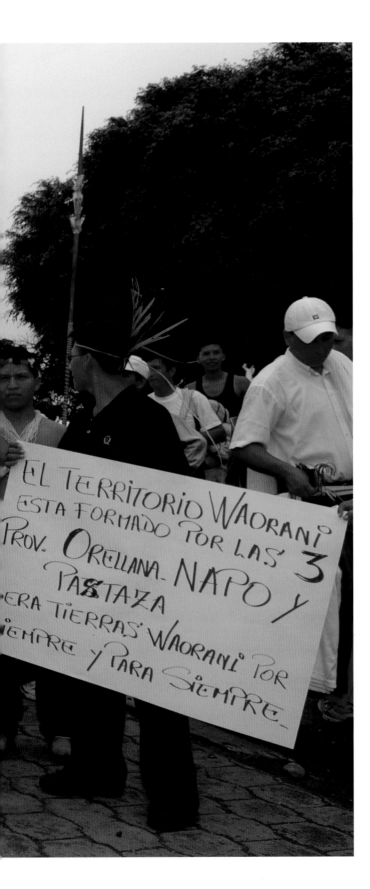

El TERRITORIO WAORANI
ESTA FORMADO POR LAS 3
PROV. ORELLANA. NAPO Y
PASTAZA
ERA TIERRAS WAORANI POR
IEMPRE Y PARA SIEMPRE.

# Chapter 4
# Patterns of resistance

## For more than three

decades, oil has been key to the Ecuadorian economy. For many Ecuadorians, the main result has been widespread pollution and destruction of rainforest, with little to show in the way of improvements in their lives. Resistance by indigenous communities and other people in the region are generally ignored, even within Ecuador, never mind in the wider world.

However, in spite of threats and other repressive measures often carried out at the behest of the oil companies, people continue to fight bravely, with heroism and dignity. Local populations have organized and mobilized to denounce the lack of environmental policies; the broken promises; the flouting of legal obligations; and to publicize the threats and abuse as well as the depletion of the region's natural resources. Since 2000 local governments have organized in the 'bi-provincial Orellana-Sucumbios Assembly' to propose alternative solutions, with some success. However the national government has not fully delivered on its side of the agreement.

The most famous protest against a multinational was the Texaco oil-leak case. After ten years in the US courts, the judgment ruled that Chevron (which had bought Texaco) should be subject to Ecuadorian laws. In May 2003 the hearing took place in the Amazonian city of Lago Agrio ('sour lake'). Among the plaintiffs were five different indigenous nationalities: Siona, Secoya, Cofán, Waorani and Kichwa, who together made up almost one hundred communities with more than 30,000 people affected by the Texaco disaster. Several communities had to abandon their traditional homes as a consequence of the spillage. The case, which is still in progress, is an important precedent as this is the first time that a South American country has taken a transnational company to court in its own country.

Pablo García Fajardo, a member of the legal defense team for local people against Texaco, was in 2008 awarded CNN's Heroes P rize for 'ordinary people, extraordinary achievements'. He was selected from over 7,000 contenders from 93 countries.

The largest mobilization against the oil companies took place in 2005. It was a strike in Orellana and Sucumbíos provinces. For over a month, thousands of people protested

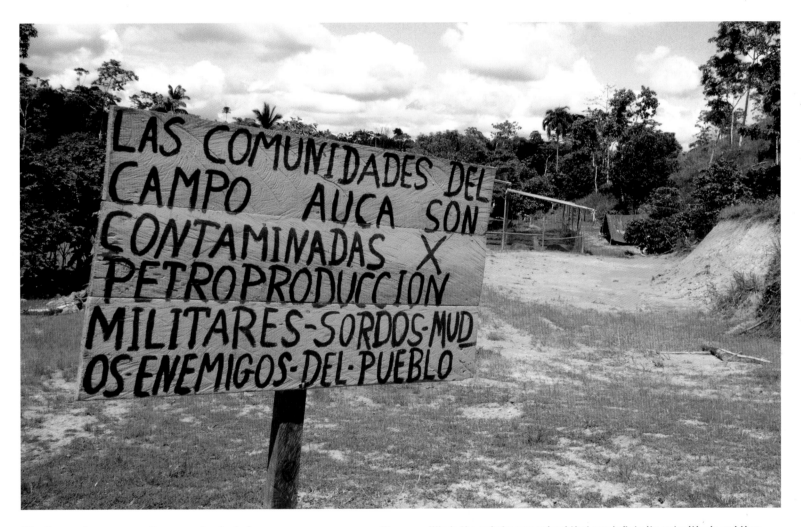

'The Campo Auca community are contaminated by Petroproduccion. The military are deaf and mute – enemy of the people.'

The armadillo is the only known animal that can inflate its gut with air and then float across rivers for up to six minutes. It can also jump 90-120 cm off the ground as well as being able to dig with great speed to escape from enemies. The giant armadillo is one of the endangered species of the Yasuní Park (opposite page).

against the oil companies' activities. Among the strikers' demands were better roads, education and health provision, that oil companies hire more local residents and that income tax and royalty payments be paid directly to the local governments. As a result of the strikes that destabilized the local airport and halted oil production, the Ecuadorian Government declared a state of emergency in the province. Protestors were subjected to political and military repression.

Strikes are usually a last resort for the local people in order to try and get their voices heard and their demands presented. Such actions can take the form of blocking roads to stop the movement of workers and supplies to the oil wells, so halting production. Rarely a month goes by without a community going on strike and these protests can bring together other communities. But sadly the events are often met with repression by the army, which at times seems to be working hand-in-glove with oil interests – such

After more than three decades of neo-colonialism and the close relationships with oil companies who have promoted corrupt practices, indigenous communities have entered into very unequal business relationships – allowing access and exploitation of their territories without environmental guarantees. Some community leaders are very useful to the companies, who have taken advantage of the weaknesses and lack of knowledge of the population. Moreover, in some communities, people have learned the 'usefulness' of practices of extortion and blackmail that the oil companies continually use.

MIA ANDERSSON / ALI SUPAY

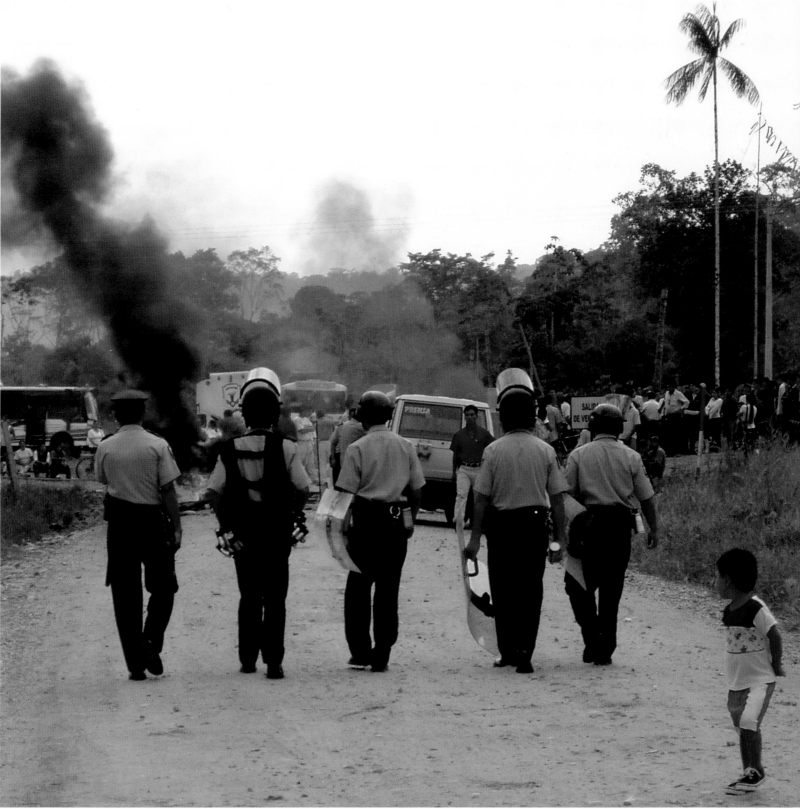

JOSEP GIRALT / ALI SUPAY

**The native population has a deep distrust of the national security forces.**
**'Yasuní no se Vende'/'The Yasuní is not for sale' is a common chant at protests.**

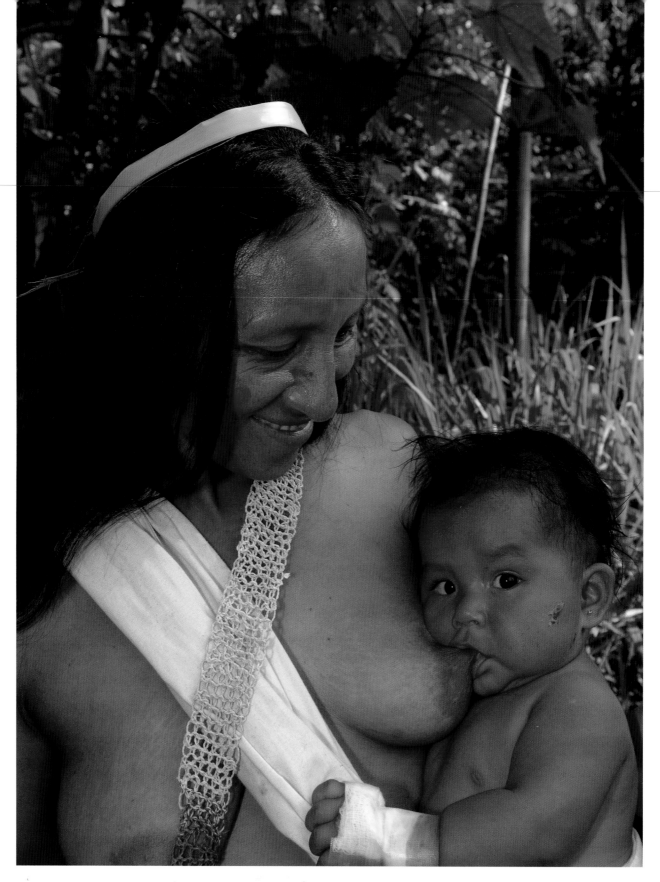

Navame with her little daughter, Bacila. 'What will happen when our children grow up? Where will they live when they are older? Our rivers are tranquil and in the forest we find food, medicines and other necessities of life. What will happen when the oil companies finish destroying what we have left?' *Letter from Waorani community member to the President of Ecuador in 2005.*

as in November 2007 within the Dayuma community in Ecuador's northwest Amazonian region.

In 2007, with the support of most of the national social movements Rafael Correa was elected President. He recognized that one of the key problems for the Amazon region was the lack of government infrastructure. Since his election, he has tried to increase the presence of the government in a positive way there to help heal the social divisions and conflicts in that area. Meausures include trying to improve the way the national oil company operates and getting more favorable contracts with the foreign oil producers. Another aim is to reduce the damaging effects on the environment. His most innovative proposal is to keep oil underground in the ITT oil-field block in Yasuní.

This proposal is a change of approach from previous government policies. Correa is under great pressure from both internal and external oil and other extractive industries. For this reason his proposal allows for some degree of interpretation.

**'Nature sees us born, and oil exploitation will see us die.' A protest mural in oil town Francisco de Orellana.**

# Ecuador's Yasuní-ITT proposal

The proposal, presented by President Correa at the UN General Assembly in 2007, originated from civil society organizations. It is an innovative contribution to overcome the limitations of current carbon trading mechanisms, based on the Kyoto protocol, to mitigate global warming.

Faced with the dilemma of either exploiting the oil at a high cultural, social and environmental cost, or sacrificing critical revenues for development, the Ecuadorian Government decided to try and keep the oil underground. To make this possible it is asking for international compensation, equivalent to at least 50 per cent of the potential revenues of oil extraction, with the state covering the remaining cost. The Government may decide to exploit the oil if the compensation is not forthcoming.

The Kyoto protocol failed to effectively control greenhouse gas emissions. $CO_2$ emissions are still growing at 3 per cent per year, despite the need to curb them by at least 50 per cent by 2050.

The ITT oil field holds the largest reserves inside the Yasuní Park. There are 412 million barrels of proven reserves of heavy oil, and this figure increases to 920 million with the inclusion of probable reserves.

Although some environmental costs, such as the disappearance of an indigenous culture, or species extinction, are not truly quantifiable, estimates can be attempted. A conservative estimate of local environmental costs, including non-timber rainforest services, deforestation, loss of biodiversity and eco-tourism, gives a current value of $1.25 billion. Other estimates on the loss of eco-system benefits are much higher ($9 billion).*

On the global front, burning the oil from the ITT fields in Yasuní will result in the emission of 375 million metric tons of carbon dioxide. With the addition of deforestation, the total rises to 547 million tons. Taking an abatement cost between $14 and $20 per ton, the global impact of ITT emissions will reach between $7.7 billion and $10.9 billion, with a current value between $2.6 billion and $3.7 billion. Obviously values change in the light of prices, extraction technologies and other factors.

Estimates also change according to the discount rate assumed. Several scenarios were devised, and a specific option was selected, based on realistic assumptions. Assuming current oil prices, and a state participation in revenues of 81 per cent with a discount rate of 6 per cent, the present value of oil extraction is $5.7 billion. Subtracting local environmental effects, net revenues are $4.5 billion. As a consequence, the minimal international compensation required, accounting for one half of the oil revenues, would be $2.2 billion.

**Professor Carlos Larrea**

Universidad Andina Simón Bolívar, Quito, Ecuador, advisor on the ITT proposal.

This is a shortened version of Professor Larrea's statement. The full text can be found at
**www.yasunigreengold.org**

---

* Earth Economics presentation on the ITT Project. Workshop 'Keeping the ITT Oil in the Ground'.
Quito: Universidad Andina Simón Bolívar, November 2007.

# About the Yasuní Green Gold campaign

This book emerges directly from the Yasuní Green Gold campaign to raise awareness of and international support for the Ecuadorian Amazon region. The campaign aims to highlight the issues both at a national and international level. The starting point is that there can be no conservation, no truly sustainable development without local commitment and involvement.

The campaign was born with the support of the Government of Orellana, together with some local and indigenous people, and social movements. The campaign hopes to be a loudspeaker to raise the volume internationally for their voices and their concerns about the conservation and sustainable development of the region. Another aim is to support, help develop and implement local solutions for the sustainable development of the Yasuní region. A further goal is to develop more fully an international network of people and organizations who share the belief that Yasuní is Green Gold.

In respect of the official Yasuní-ITT proposal:

The Yasuní Green Gold campaign proudly supports the national government's aims to keep the oil in the ground and so conserve this area of outstanding cultural and ecological importance. We would like to help with this as much as possible.

However, there are some aspects of the original government proposal that in the view of the Yasuní Green Gold campaign urgently need review and further development to safeguard the region and its people.
• If the Government of Ecuador really believes that Yasuní is unique, and wishes to demonstrate its commitment to human rights and environmental protection, then in the campaign's view it must commit, unconditionally, to conserving Yasuní; to respecting its biodiversity and the right to life of the indigenous cultures. The national government needs to put in place all the material, economic and human means needed to achieve this. This requires that the government's actions follow official conservation policies to the letter.
• The national government must respect and protect the human rights of local citizens who – in trying to defend their habitats and livelihoods – present challenges to the oil and extractive industries. Local people, their communities and their political bodies must be consulted and allowed genuinely to participate in building the future of their region.
• The government needs to promise that there will be an international forum to manage any compensation funds deriving from conservation. An international forum, with the participation of local organizations, must be set up to develop sustainable alternatives to the economy of oil exploration in the region. Eco-tourism or scientific-tourism, for example, is one area that could be developed.
• It must be made clear in the official proposal that the pledge to keep the oil in the ground is not reversible. Compensation cannot at any point be repaid and the oil be exploited. The lives and rights of indigenous people, especially the Tagaeri and Taromenane have no price.
• The oil of Yasuní must stay in the ground, whether or not there is international compensation. This is also the view of the majority of people surveyed in the Ecuadorian cities of Quito and Guayaquil. With political will, sustainable development both regionally and nationally can be achieved. There can be no artificial cut-off date or deadline for such important negotiations and decisions.

For more information contact
**www.yasunigreengold.org**

# Resources

Amazonía por la Vida
www.amazoniaporlavida.org

Save America's Forests
www.saveamericasforests.org/Yasuni/index.html

Finding Species
www.findingspecies.org

Acción Ecológica
www.accionecologica.org

Ali Supay
www.alisupay.org

World Rainforest Movement
www.wrm.org.uy

Oil Watch
www.oilwatch.org

Amazon Watch
www.amazonwatch.org

CODENPE
www.codenpe.gov.ec

CONAIE
www.conaie.org

Ecuador National Government
www.yasuni-itt.gov.ec

# Acknowledgements

We have been fortunate to be able to be connected with people and organizations from all over the world who have contributed ideas, skills and resources to the campaign; without them it would have been impossible.

The Local Government of Francisco de Orellana: especially the mayor Anita Carolina Rivas for giving us the opportunity to live and work with them for a while and for trusting us with these beautiful photographs and with the campaign. Juan Antonio Córdoba: sorry for giving you so much extra work. Ximena Narvaez, Alfonso Martínez, Francisco Dutichela and the rest of the local government family. Thanks for everything!

Special thanks to Jane Goodall, Ricardo Carrere, Laura Rival and Carlos Larrea; also to Clair Jones and Mary Lewis of the Jane Goodall Foundation. To Oscar Francino and the NGO Ali Supay, for their social commitment, their kindness and their quick response when we contacted them about the images.

The FORMIA project, for taking us to the doors of Ecuador, for their kindness and for allowing us to meet the 'alternative local indigenous governments'. Luis Robles, thanks for all 'pirate'; Cesar Vizarrea; Julio Yuquilema; Juan José Sanzberro and Isabel Farinango.

To Ramón Bartomeus, from Iwith, for his trust and help with our idea even before we knew we had one.

Consultores Sin Fronteras: Vanessa Ruiz, Salvador García, Lorena Rienzie, Ileana Morales for helping us from the beginning, for their huge contribution and for continuing to support us.

Manuel Acevedo and Ivan Ortiz for their friendship and for sharing our social challenges. ¡Egoglobal!

To Guillermo Corral – all of this started with that coffee in the faculty...

To Ana María Pastor, Germán Haro and Jorge Haro and to Toni, Sally and Nicolas Donati, for so many things...

The whole of the New Internationalist family: Troth Wells, Daniel Raymond-Barker, Andrew Kokotka, Vanessa Baird, Sam Martingel and others, for believing in us, for their kindness and for helping us in so many more ways than simply the editorial. It has been a pleasure to work with and know you all.

Keyla Greciano, Maryem Torres, Emily Bridges and Troth Wells for putting a roof over Ginés' head for a large part of the months we have spent creating Yasuní Green Gold.

Others who have contributed:

| | | | |
|---|---|---|---|
| Joaquín Aviles | Jeremy Rayner | Iona Orengo | Edward Beardsmore |
| Rosa López | Oliver Yeates | Héctor Disseny | Melanie Gill |
| Ana López | George MacDonald | Gustavo Ruiz Llavero | Mª Dolores Lupaiñez |
| Caitlin Ketchen | Ricardo Vinent | Ferran Guallar | Mª José Bell |
| Lydia Taylor | Jose Luis Marti | Josetxo | Asoc. Madre Coraje |
| Lucia Caistor Arendar | Concha Jambrina | Bárbara Janssens | Movimiento IDUN |
| Nick Caistor | Daniel Cibati | Dennis Gruber | |

And to all the organizations, scientists, researchers and other people who have trusted in us on nothing more than our word and our hopes.

And to everyone that we have forgotten, thank you and please forgive us!

Good work guys!

# About the authors

**Georgina Donati**

Georgie has a mixed Croatian/English heritage and grew up between London and a village in Dalmatia. She is a philosophy graduate from Leeds University and her desire to learn Spanish has taken her traveling and working in Spain and all over South America, including a stay in Coca, Ecuador, in 2007.

**Ginés Haro Pastor**

Ginés grew up in Sevilla, Spain, playing sport most of the time. He started to get involved in social movements while he was studying sustainable development issues in Granada. He then worked for the local government of Orellana, Ecuador, for a year. Now he goes with his computer any place where he feels that he could learn and contribute to turning into reality all the different 'sustainable theories'.

# About the NI

The *New Internationalist* communications cooperative exists to report on the issues of world poverty and inequality; to focus attention on the unjust relationship between the powerful and powerless worldwide; to debate and campaign for the radical changes necessary to meet the basic needs of all; and to bring to life the people, the ideas and the action in the fight for social and environmental justice.

We publish easy-to-read, informative current affairs titles and popular reference, complemented by world food, photography and alternative gift books, as well as calendars and diaries, maps and posters. We also publish the monthly *New Internationalist* magazine.
**www.newint.org**

# About Movimiento Idun

Based in Sevilla, Spain, Movimiento's aims are to inspire, educate and support people and organizations so that they may adopt and promote new forms of individual and collective behavior, to enable everybody on our planet to enjoy a healthy and sustainable lifestyle.
**www.movimientoidun.org**

MOVIMIENTO
**IDUN**

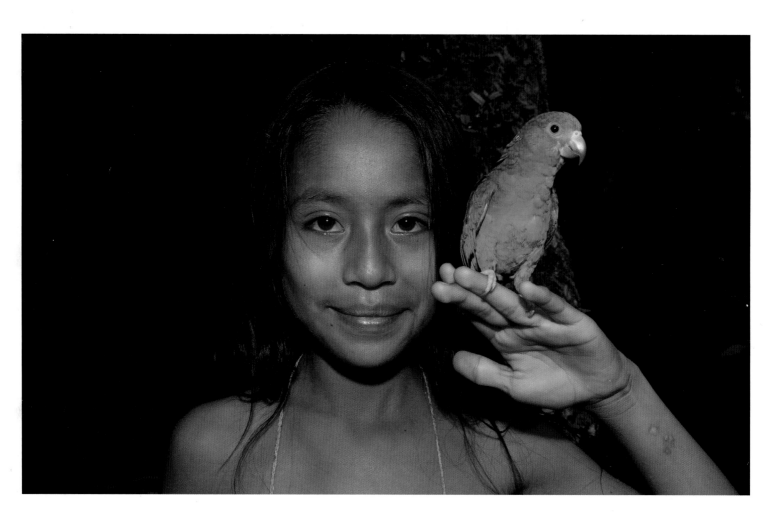

Waorani girl with parrot.